THE
DESIGN
OF
BOOKS

BY
ADRIAN WILSON

FOREWORD BY SUMNER STONE

CHRONICLE BOOKS
SAN FRANCISCO

First Chronicle Books edition 1993.

Printed in the United States of America.

Wilson, Adrian.
 The Design of books / Adrian Wilson : Foreword by Sumner Stone. --
1st Chronicle Books ed.
 p. cm.
 Includes index.
 ISBN 0-8118-0304-X (pbk.)
 1. Book design I. Title.
Z116.A3W54 1993
686--dc20 92-30824
 CIP

Cover design by Gretchen Scoble

Distributed in Canada by
Raincoast Books
112 East Third Avenue
Vancouver, B.C. V5T 1C8

10 9 8 7 6 5 4 3 2 1

Chronicle Books
275 Fifth Street
San Francisco, California 94103

Contents

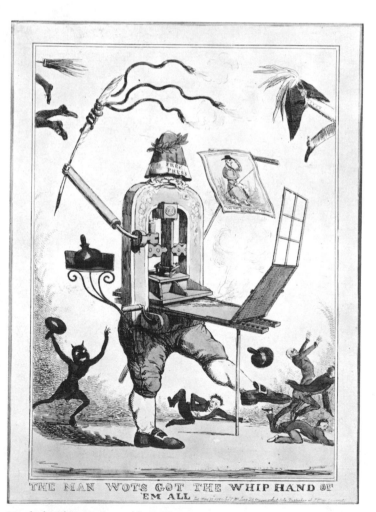

Handcolored engraving published by J. McLean,
26 Haymarket, London, May 30, 1829.
Courtesy of Lewis and Dorothy Allen.

To Joyce
for her love
and her love of books

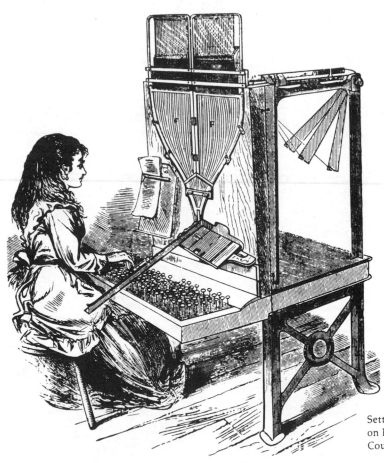

Setting type in the late 1800's
on Fraser's composing machine.
Courtesy of James Moran.

Foreword

I made my first book early in my career as a calligrapher. It was written out, very slowly, in my best attempt to copy a fourth century letterform called Capitalis Rustica. Every aspect of making the book seemed difficult and mysterious. I had very little idea about how to begin, so I wrote out some lines with the smallest size pen I thought I could handle. The letters were about half-an-inch tall, which seemed tiny to me at the time. I had been well indoctrinated with the importance of large margins by my calligraphy teacher, Lloyd Reynolds, so I had large letters and large margins. It turned out to be quite a large book. The book seemed to have grown out of my limited ability to make letters with a broad-edged pen.

Some years later this book came back into my possession, and I realized at once that it had a fatal flaw—it was too large to fit conveniently on a bookshelf. Of course, it had many other flaws as well. The process of planning and making books is a complex one. Decisions abound, and as I found subsequently, there are few written sources to learn from. That is no doubt one of the reasons why *The Design of Books* seemed like such an important find when I first discovered it. It was a new window on the fascinating world of making books. Here were books that were planned and executed with great care.

Making books still seems difficult and mysterious, and there is still little guidance in written form for the incipient book designer. This is, perhaps, reason enough for republishing this book, but there are many others.

The Design of Books is not full of formulas or philosophy. It does not advocate a particular design ideology, as is evident from this passage in the Introduction: "All schools of design have their eventual use, whether it be the Stamp of Authority espoused by the English university presses or the cool rule of the New Bauhaus, the resurrected medievalism of William Morris, or the eclecticism and allusiveness of Bruce Rogers. The criterion is imaginative appropriateness. . . ." Like my first handmade volume, the books described here seem to grow out of the environment that begets them. They are some combination of the constraints of the moment and the momentum of tradition. Stories and history.

Stories and history are the mode of instruction in *The Design of Books*. It contains many landmarks, points of entry, from the *Nuremburg Chronicle* to *The Bald Soprano*. The illustrations are important. They look as fresh and inspiring today as they did when I first acquired the book.

It is, as stated in the original promotional literature from 1967, "more than an exciting how-to-do-it volume." The most likely fate of any how-to book is a short life. A book about how to use a particular program on a personal computer for laying out pages is doomed to a useful life span of perhaps a year or two before it needs to be revised or abandoned. The historical equivalent of such books, like Joseph Moxon's *Mechanick Exercises on the Whole Art of Printing*, originally published in 1693–94, are a rich source of cultural information about the period. They do not, however, contain practical information except perhaps for the hobbyist who wishes to reconstruct an antique technology.

The Design of Books has been out of print since 1988, but it is not being revived as a quaint cultural object or historical curiosity. The technology of designing and manufacturing books has, indeed, changed since its original publication, but the obsolescence of some of the technical material in the book does not detract from its usefulness.

Perhaps the most anachronistic aspect of the original publication was its cover design which depicts the icons of the trade at the time—a T-square and triangle. These have been abandoned in favor of a keyboard and a mouse. The underlying qualities of a good book, however, have changed little. It is these qualities, the structure and spirit of a book, which are clearly and masterfully demonstrated in *The Design of Books*, and herein lies the reason for its reprinting.

Examples are at the heart of this book, and the book itself is one of them. The design of a book about the design of books is obviously important. It is the most complete example of a book design that can be demonstrated. The design of *The Design of Books* was masterfully executed by its author.

A flavor of craftsmanship permeates the book. At least some of this flavor comes from the fact that Adrian Wilson was himself a printer and a part of the tradition of San Francisco fine printers, a tradition that conjures up wooden type cabinets, concrete floors, clanking machinery, and the romantic smell (romantic to me, anyway) of printer's ink.

The Design of Books looks and feels contemporary twenty-five years after its first publication. However, book design is, like the design of text typefaces, inherently conservative. We want our information in clear, direct, predictably organized packages.

Technology has little effect on these requirements. Our experience in making things has a great effect. I frequently get asked, "how can I become a type designer," by young people who own computers. Computers cannot magically make good letters (or good books), and there are very few places in the world where one can get any practical training. My advice is to make letters with some tool other than the computer. Make them with a broad-edged pen, with a chisel, with files and gravers. Any traditional method will do. The important thing is that the experience of making them in some way connects us with the tradition of making them. Lloyd Reynolds' recommendation was to "write your way through the history of the alphabet." Letters and books are, after all, pure history and stories.

—Sumner Stone

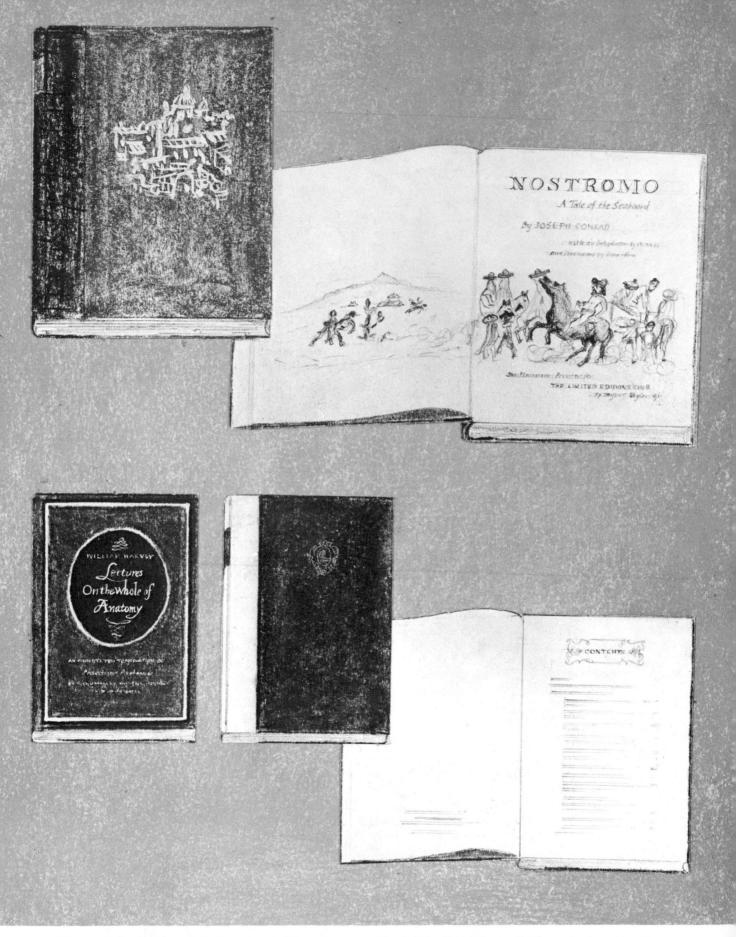

Thumbnail sketches in pastel, lead pencil, and white poster paint for two books designed by the author. The originals were rendered in color at the size shown and established the basic appearance of the final books. For the binding of Joseph Conrad's *Nostromo* a dark brown burlap spine with sea green cloth sides stamped in silver was specified. The title page and cover drawings were developed by the illustrator Lima de Freitas from sketches by the designer.

Introduction

A few years ago a meeting was held in Paris to discuss the design of a special edition of Joseph Conrad's *Nostromo*. One of the participants remarked: "Isn't it amazing—here we are, a publisher from New York, an illustrator from Portugal, a designer from San Francisco, and a typographical advisor from London, come to talk about a book by a Pole who wrote in English about a country that didn't exist!" Eventually the illustrations were executed in Paris. The design was planned in New York and completed in San Francisco. The book was printed in San Francisco on paper shipped from England, and the sheets were freighted to New York for handcoloring of the illustrations, and binding. Two years after the meeting in Paris, the copies were distributed to the members of The Limited Editions Club throughout the world. Such can be the international character of contemporary book design and production.

If this example seems unusual, not to say glamorized, we discovered a similar pattern of operation when an American university press published a typical low-budget book, *William Harvey's Lectures on the Whole of Anatomy*. The three authors were widely scattered: one in California, one at Oxford, and one in Melbourne. Editing was done in the Los Angeles office of the press, and the manuscript was sent to the Berkeley office for production. A San Francisco designer prepared the layouts and specifications, copies of which were sent with representative sections of the manuscript to three printers across the country for competitive bids, a requirement of the university for its printing contracts. The winner appeared in Menasha, Wisconsin. Proofs were dispatched by airmail to the authors in their various corners of the world, as well as to the editor and designer. Six months later finished books emerged, wrapped in jackets printed in Oakland, California. This itinerant volume ended its journey as one of the Fifty Books of the Year chosen by the American Institute of Graphic Arts in New York.

Why are such complex machinations necessary? How can the designer, whether he works in a publishing firm, in a book printing plant or as a free lance, control them to insure a handsome volume, if not an award-winner? To the reader, who is interested in getting at the text, the intricacies of how his book was produced would seem bewildering. He imagined that the publisher simply sent off the manuscript to the printer, who in due course delivered the bound books. Why all this nonsense about layouts, specifications, bids, printers here, binders there, and jackets from God-knows-where? Unless he was an unusual reader with a penchant for the fine print on the verso of the title page, he had probably taken no notice that his book was designed at all. A professor of nuclear physics, the author of several volumes, who was recently introduced to me said quite candidly: "I didn't know *books* were designed!"

Book design is necessary for one reason: to bring to the purchaser a book of the best possible quality for the price he is able and willing to pay. This requires the discriminating use of the vast industrial machinery that man has created, the complex web of modern book manufacturing. It is the book designer's challenge to draw from that machinery a product of precision and beauty. He must, of course, have the cooperation of author, publisher, editor, production manager, and craftsman. But it is the knowledge and imagination he brings to his layouts, and his constant insistence on high standards that will influence the success of the book as a vehicle of communication.

In order to exercise his imagination realistically, the book designer must have a working knowledge of the hundreds of type faces in current use; a familiarity, or even better, a practical skill, with the techniques of book printing, photography, and art; and the ability to render on paper an anticipation of the final appearance of the book. His layouts must be attractive enough to convince the publisher

that the design will enhance the text, that it will be appealing in the bookstore as well as satisfying in the reader's hand. They must be precise enough to serve as an accurate guide for the printer and must be accompanied by specifications which translate every visual element into symbols and words which are not subject to misinterpretation. At the same time, the layouts must be flexible and mechanically feasible, so that, for example, if the printer who is awarded the contract does not possess the types originally specified, the designer can choose equally effective substitutes from the printer's repertoire. In short, the design must be foolproof and contain all of the information necessary for the printer and binder to give cost estimates and to produce the finished edition.

The purpose of this book is to show how the designer goes about preparing his layouts and following the book through the production processes. The tangible results are shown in the examples reproduced, most of them award-winners in competitions, here and abroad.

Recently in France there was published a sumptuous, unique copy of the *Apocalypse* of St. Jean, which was advertised as the most expensive book in the world. The volume consists of 250 full sheets of vellum with the shape of the animal retained. The text is calligraphed in black, the titles are lettered in solid gold, and the illustrations by Salvador Dali, Bernard Buffet, Georges Mathieu, Foujita *et al.* are painted directly on the skins. For exhibition in the galleries of a museum, the sheets were hung on long racks in their own plastic bags, like suits at the cleaner's. In a culminating gallery, encased in a plastic sphere, reposed the "binding," an enormous bronze chest designed by Dali and encrusted with jewels, nails, daggers, forks and a crucifix pinioned in valuable debris. The whole was priced at 1,000,000 francs or $200,000. Perhaps by now, after years of display, the book has found a buyer, some oil tycoon or international banker in search of a unique claim to fame.

One need only cross the English Channel to see the opposite pole of modern book publishing: the incredible Penguin organization. At Harmondsworth, near London Airport, the Penguin distribution center keeps at least 10,000 and often as many as 50,000 copies of nearly 2500 different titles in stock, on skids and in bins instead of Apocalyptic plastic bags. From here go forth not only the Penguin Books, but the Pelicans, the Peregrines, the

Peacocks, the Puffins and more than a score of other series. The executive offices, the typographic design, art and production department are housed in the same building, and at any time 400 books may be in process. Yet there are no roaring presses, no clicking composing machines. Penguin Books are produced by firms throughout Great Britain and frequently in America, Australia, and Holland. To maintain the standards of design, typography, and presswork for which the Penguins are famous requires an extraordinary level of imagination, accurate layout, and specification.

Between the poles of the Penguin and the *Apocalypse* is a world of books, each of which demands individual treatment, the creation of a distinct personality out of the richness of its subject matter. Whether a book is to be produced by a private pressman in his basement or by a major publisher in a printing factory half-way around the globe, a design is needed so that all elements will converge into an integrated whole.

Among the books reproduced in this volume the reader will find little similarity. Each was designed as a response to a particular author's work and to the typographic and printing possibilities allowed by the publisher's budget. If the final result sometimes exceeded the budget, it also sometimes increased the sales. Perhaps the one quality which unites the books included here is vitality: the bold yet sensitive exploration of the numerous typefaces and the myriad colors, textures, and art media at the designer's command. A book on cooking with spices is subtly pungent with the countries of their origin; a book on contemporary architecture is based on a module system, and the photographs and drawings dominate; a book on medicine is direct and sober as befits the clear mind. All schools of design have their eventual use, whether it be the Stamp of Authority espoused by the English university presses or the cool rule of the New Bauhaus, the resurrected medievalism of William Morris, or the eclecticism and allusiveness of Bruce Rogers. The criterion is imaginative appropriateness—that sense of delightful surprise which draws a reader to a book and sends him out of the store or library with it under his arm, which gives the book club or mail-order subscriber a glow of satisfaction and an irresistible desire to read. With the book in hand he should find that the typography communicates, the illustrations illuminate, and the binding enhances and preserves the creator's thought.

APOCALYPSE DE SAINT JEAN

Title page hand-lettering in solid gold by Micheline Nicolas who also calligraphed the entire text of the *Apocalypse* on full skins of vellum. Published by Joseph Foret, Paris.

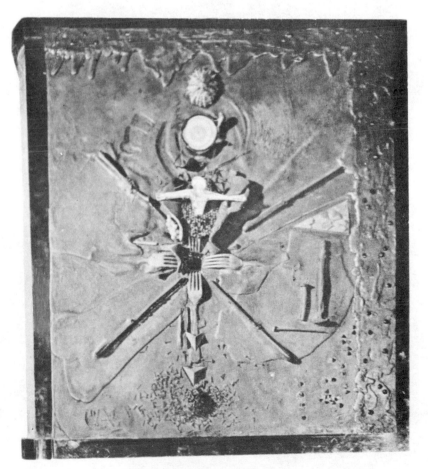

The bronze box designed by Salvador Dali which encases the *Apocalypse*.

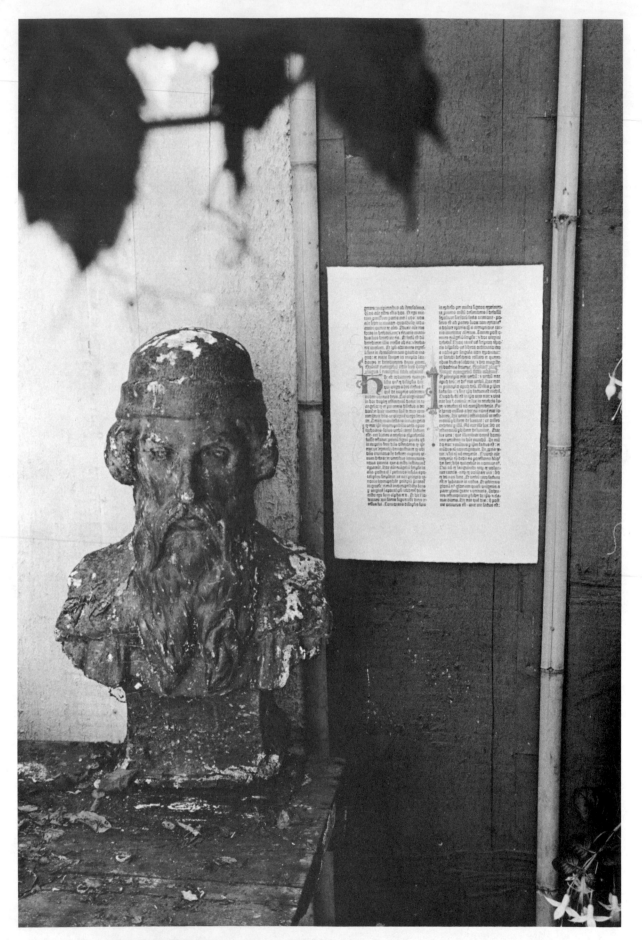

1-1. A page from Gutenberg's 42-line Bible, the first typographic book.
The plaster bust of Gutenberg quietly crumbles in the author's garden.

1 *The Art of the Layout*

The factors which the first major typographic book, Johann Gutenberg's 42-line Bible of 1456, brought so magnificently together were not only interchangeable, reusable, movable lead type, but also paper, the screw press, and printing ink. To be sure, some 30 copies were printed on vellum for those who insisted on the supposedly more durable material of the medieval manuscripts. As late as 1494 Jean de Tritenheim, Bishop of Spanheim, in his *De Laude scriptorum*, published in Mainz like the Gutenberg Bible, urged his monks to continue writing manuscripts: "Calligraphy on parchment can last a thousand years. But how long will an impression on paper last? Perhaps two hundred years. And it hardly would be beautiful." Fine handmade paper, which had made its appearance in northern Europe scarcely more than a century before, was used for the bulk of the edition, some 150 copies, and a page of this paper is as breath-taking and pristine today as when it left the press. Both paper and vellum versions found ready acceptance, unfortunately not benefiting Gutenberg, but his banker, Johann Fust, who foreclosed when the printer failed to deliver on time.

It is assumed that Gutenberg worked out the basic format, which, however, is clearly based on contemporary manuscript Bibles. Peter Schöffer, a manuscript scribe presumably employed by Gutenberg as a typesetter and proofreader, was responsible for the completion of the work. That Schöffer executed some of the rubrication is possible, but copies also were issued with blank spaces for illuminated initials and introductory text lines to be executed by expert illuminators. A vicar of a church at Mainz inscribed the fact that in 1456 he completed the embellishment of the copy now known as the Mazarin Bible (for the library in Paris where it is housed). In any case, Schöffer, who was retained by Fust for the production of many other noble books, married Fust's daughter, and after his father-in-law's death expanded his publishing activities with headquarters in Frankfurt and outlets at Paris and Angers.

Papermaking had concluded a thousand-year journey from China through Samarkand, Baghdad, Cairo, and then into Spain and Italy. Mills still exist at Fabriano in Italy and at Ambert in France which claim their heritage from the thirteenth and fourteenth centuries. Contemporary papermakers in Ambert appear to use the same methods and equipment! As in Gutenberg's time, some of the paper is sized with animal gelatine, making its surface somewhat similar to vellum, and suitable for writing. Probably it was the availability of this hard paper which perpetuated the vellum form of

1-2. An inscription showing the similarity of the hand lettering of the period to the type. It was written by Peter Schöffer, who completed the printing of the Gutenberg Bible. The manuscript, from the Strasbourg Library, was destroyed by fire in 1870.

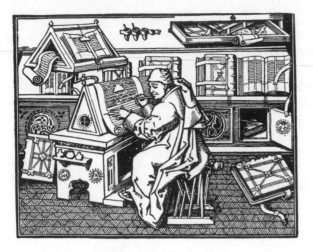

1-3. The prototype of the modern book designer: a scribe at his desk working on ruled parchment.

the book, folded sheets gathered in groups called signatures, stacked, and sewn together through the folds. On the other hand the lighter, unsized papers of the Orient led to books printed by rubbing on one side of the sheet over water-base inked woodblocks and folded in accordion fashion.

As for the Gutenberg printing press, it was perhaps an adaptation of the ponderous press used in paper mills for squeezing out the water from the stacks of newly made sheets. If we care to be romantic about the subject, this press, in turn, was probably derived from the wine press of the Rhine valley, made entirely of wood and activated by a screw mechanism.

The ink which Gutenberg used, if not his own invention, was a recent development. It was made with a varnish prepared by heating linseed oil until it became stringy, and adding resin and soap; the tacky result was then combined with lampblack. Soap was important for helping the ink to adhere to the type and for leaving it clean after each impression. At some point before the production of the 42-line Bible it must have been discovered that moistening or "damping" the paper greatly increased its affinity for ink. Otherwise the astounding quality of the presswork could not have been achieved.

However, the type was the greatest revolution, both in its concept of reusability and in the vitality of its cutting and massed effect. When we consider that the designer of the 42-line Bible type had to cut by hand on the ends of steel punches at least 264 different characters, to drive them into brass bars to form matrices, to place these in an adjustable mold which would provide for many widths and perfect alignment, to pour in molten lead, and to finish the castings so that each would be of

identical height, the magnitude of Gutenberg's accomplishment becomes apparent. Other means have been suggested, such as the matrices being set up in a row and the lead poured into them to form a solid line or slug. But there appears to be no evidence of this in the methods which followed, until the invention of the Linotype in the late nineteenth century.

To be sure there was precedent for Gutenberg's invention. Typography did not spring out of medieval metallurgy like woman out of the rib of Adam. Letters were cut in wood and printed along with woodcut illustrations to form the popular block books, as well as the Heiligen, religious prints dating from at least 1423. There is evidence, if only in the crudeness of the results, that printing was also done from separate metal types cast in molds of sand in Holland by Laurens Coster, to whom the city of Haarlem has erected a monument as the true inventor of printing. Centuries before, movable baked clay types were used in Korea. But the skills of the jewelry engraver and metalsmith which Gutenberg brought to his work in Mainz made immediately apparent the possibility of the manuscript's being supplanted by typography.

The design of the type was a direct derivation of the black letter manuscript of the time, as was the layout: two narrow columns with wide space between them. The similarity of the type, printed entirely in black, to the hand-lettered insertions in red is striking. The major difference is in the ability of the scribe to tie his letters, which the type designer attempted to duplicate with numerous ligatures but could hardly simulate throughout. The generous space between the columns gave the illuminator a rich field in which to flourish initials and flamboyantly decorate frames for the type. So strong was the black letter tradition that it survived for much printing in Germany until 1941 when the Hitler regime decreed that "the so-called gothic type" was a Jewish invention and had to be abolished. The roman, or Antiqua, as it is called in Germany, was instituted as the official type of the nation, and so it continues today.

The Gutenberg Bible, for all its magnificence, lacked that sacred necessity and designer's playground of the modern book, a title page. Most volumes were still catalogued by their first lines, as they had been in the earliest known libraries. Some of the first printed books gave the title, author, printer, and date of completion in a paragraph at the end of the text called a colophon, from the Greek word for "summit," which the early printer surely felt he had reached after hand-casting, handsetting, and hand-pressing every page. It was Peter

Schöffer who devised the first title page, albeit for a papal bull, not a book. Other title pages soon appeared, some involving elaborate borders and laudatory poems. By 1500 the form was established, whether through the demand of readers and booksellers for information or of printers for personal expression is not certain. In any case, every period of art and typography eventually was mirrored in the title page until the twentieth century, when often the design alluded to whatever previous era seemed appropriate to the subject. As for the colophon, it has persisted in limited editions and occasional tradebooks to give details about the book's manufacture: the type, paper, printer, and designer.

1-4. The Decrees of Pope Gregory IX, printed in 1473 by Peter Schöffer and hand illuminated, although by this time he had discovered that illumination could be reproduced through engraving in wood and metal.

1-5. Here reproduced possibly for the first time, is a layout for a double spread for the Nuremberg Chronicle of 1493, the earliest known book designs. This is one of the set preserved in a bound volume in the city library of Nuremberg.

THE NUREMBERG CHRONICLE LAYOUTS

Soon after Gutenberg perfected the synthesis of type, paper, and ink that resulted in his astounding facsimile of a mid-fifteenth-century manuscript Bible, the reign of the scribe was over. For a time his function continued in rubricating the initials, but with the discovery that these could be duplicated with wood blocks, the scribe's practice was limited to deeds, letters, proclamations, and occasional books for noblemen like Duke Federigo of Urbino, who refused to permit a printed volume in his library. For reproductions of existing manuscript books the printers usually followed the format of the original. For an original text, they worked directly with type and spacing material in the established manuscript formulas without following preliminary layouts.

But what if there were a completely new work, intended to be the summation of history from the creation of the world up to the time of publication, printed as a monumental folio, and illustrated with more woodcuts than had ever appeared in a volume before? Such was the plan of two wealthy patrons of Nuremberg for their *Liber Cronicarum*. A carefully worked-out design was needed. Into partnership they brought the painter Michael Wohlgemuth, Albrecht Dürer's master, and his step-son Wilhelm Pleydenwulff, both experienced block-cutters. The author was Dr. Hartmann Schedel, the city physician, who had been working for three years on a history of the world, as seen from Nuremberg in 1493. Whether the layouts were made by the artists, or Schedel himself, or the

1-6. The printed spread for the layout on the opposite page. The printer, Anton Koberger, has modified the layout slightly in accord with the demands of the type.

translator of the Latin version into German, Georg Alt, we do not know, but they are probably the earliest designs for a printed book in existence. Preserved as a bound volume in the Nuremberg City Library, these have, so far as we know, never been reproduced before. Apparently the manuscript for the German version and the layout are here combined, the text having been written in a gothic cursive script approximating the type and "to fit."

Despite the careful work of the designer it is obvious that the printer, Anton Koberger, found the space inadequate. He adopted a wider and often deeper measure and occasionally resorted to continuing text lines where they were not intended, as under the block in Blat XLVII (Folio 47) (Illus. 1-9). Both the Latin and the German edition were printed simultaneously, the former appearing in July and the latter in December, 1493.

Curiously, the Nuremberg Chronicle contains 1,809 illustrations provided by only 645 woodcuts. For example, 44 crowned heads are used to represent 270 kings, and 28 effigies suffice for 226 popes. There are 26 double-spread views of cities, the largest of which is, of course, Nuremberg, the center of Schedel's universe. In the foreground, outside the city walls, stands the paper mill of Ulman Stromer, though Koberger is said to have scorned the local product. For the 69 smaller cities illustrated, only 22 different blocks are used. Naples and Mainz are identical visually, but actually how different: the former is the city of the lyrical aria, the latter the birthplace of the "black art."

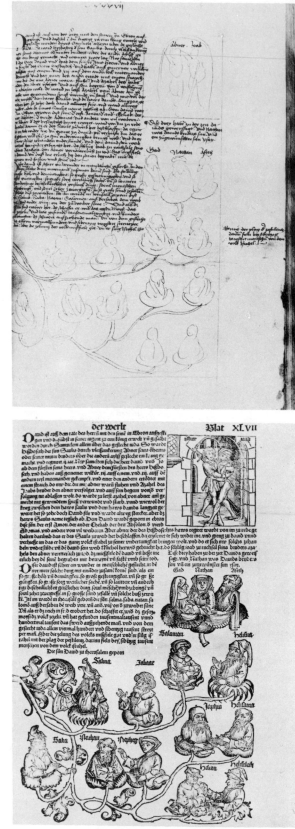

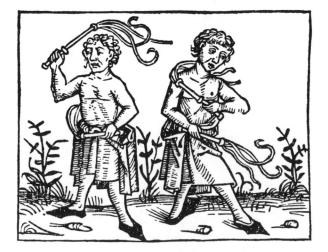

1-7. Members of a flagellant religious sect, a woodcut from the Nuremberg Chronicle.

1-8, 9. Another example of a layout for a page of the Nuremberg Chronicle and below it the printed page. The printer had to squeeze four lines of type above the caption to make his copy fit.

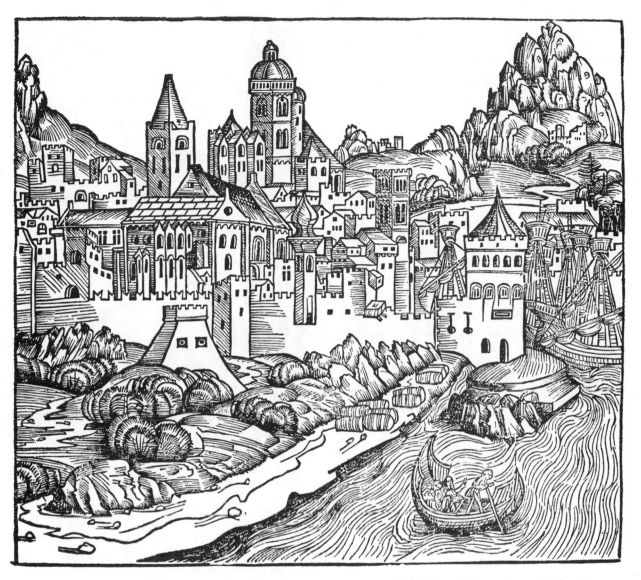

1-10. Both Mainz, Naples, and several other cities are represented by this same woodcut in the Nuremberg Chronicle.

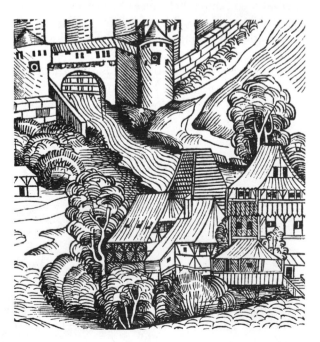

1-11. Ulman Stromer's paper mill outside the walls of Nuremberg.

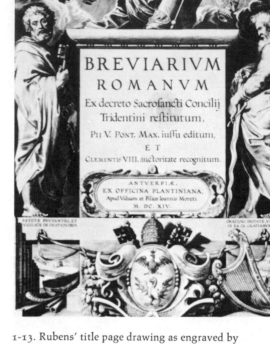

1-12. A layout by Balthazar I Moretus suggesting to Peter Paul Rubens the subject matter for a title page.

1-13. Rubens' title page drawing as engraved by Theodor Galle in 1614. Plantin-Moretus Museum, Antwerp.

LAYOUT FOR A RUBENS TITLE PAGE

The unique Plantin-Moretus Museum in Antwerp comprises the home, the printing house, the type-foundry, the proofreading room, and the bookshop of the great publishing press founded by Christophe Plantin. In 1576 he moved to the present site where the productive life of the press continued for exactly three centuries. With the buildings enclosing a garden courtyard, it is certainly the most beautiful as well as historically fascinating printing museum in the western world.

In 34 years Plantin had published some 1500 works, a phenomenal accomplishment considering the prevailing methods. For a time 22 hand presses were kept busy, equalling Koberger and far exceeding such illustrious printers as Aldus and the Estiennes. Production was reduced by the Spanish invasion but high quality continued to increase and the greatest of atlases, Bibles, music books, scientific and humanistic texts were published.

Plantin's second daughter married Jan Moretus, who carried on the work and whose descendants brought it to even higher production standards and international fame. Their son Balthasar I, a man of extraordinary knowledge and brilliance, was in touch with all the major artists and scholars of his time and was an intimate friend of Peter Paul Rubens, whose fine portraits of the family are hung in many rooms of the handsome home. He induced Rubens to add book illustration, frontispieces, and title pages to his other output.

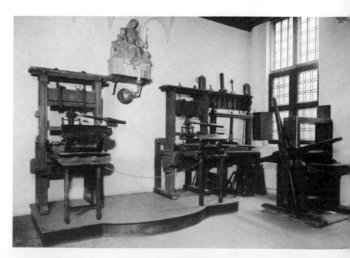

18

1-14. A corner of the Plantin-Moretus Museum today, showing ancient wooden handpresses for type and a star wheel engraving press for illustrations.

THE PRINTING MANUALS

By the eighteenth century, the European book printing trade had divided into a number of specializations, such as that of the typefounder, the master-printer, the compositor, the proofreader, the pressman, etc. Joseph Moxon, already the author of numerous tracts on the mechanical arts, in 1683 published his *Mechanick Exercises: Or, the Doctrine of Handy-Works. Applied to the Art of Printing. The Second Volumne.* in which we have a glimpse of how printed books were designed at the time. Under a paragraph headed *"Some Circumstances a good* Compositer *considers and observes in* Composing," he states:

> A good *Compositer* is ambitious as well to make the meaning of his *Author* intelligent to the *Reader*, as to make his Work shew graceful to the Eye, and pleasant in Reading: Therefore if his *Copy* be Written in Language he understands, he reads his *Copy* with consideration; that so he may get himself into the meaning of the *Author*, and consequently considers how to order his Work the better both in the *Title Page*, and in the matter of the *Book:* As how to make his *Indenting, Pointing, Breaking, Italicking, &c.* the better sympathize with the *Authors* Genius, and also with the capacity of the Reader.

Moxon continues with a description of composing a title page, first by considering which word or words should have the greatest emphasis, then in what type they should be set, how they may be word spaced or letterspaced, and finally how the page should be "justified" in length by increasing or diminishing the "*Whites.*" His approach is technical, and gives no artistic restrictions:

> But the mode of ordering *Titles* varies; as may be seen by comparing the *Title Pages* of every twenty years: Therefore a Lasting Rule cannot be given for the ordering them: only what has been said in general concerning Emphasis, and in particular to humour the Eye, the *Compositer* has a constant regard to.

Martin Dominique Fertel, writing 40 years later in *La Science pratique de L'Imprimerie* (St. Omer, 1723), also says he is hesitant to give any general rules. Nevertheless he launches into a series of specific instructions which leave little question of his intention to formulate a French "house style."

1. The essential words of a first page or title should be of the largest type which is on the page. One should rarely make two long essential lines, which are close together, of the same size . . .

2. When there are two nouns in the title of a Comedy, Tragedy, etc., the second should be in two-line letters [approximately twice the height of the body type, usually equivalent to our 24 point], of large Italic capitals . . .

3. One should never make several lines of two-line letters into a *cul de lampe* [inverted pyramid] . . .

4. Two equally short lines should never be made to follow each other at the beginning of a first page or other title; and when the first is short, the second should be of the width of the measure of the page . . .

5. When it happens that there are three short lines between two long, all in capitals, one should make the second a little longer, and of such type that it will be a little larger than the others, so that the size of the letter will correspond to the two long lines, which are the essential words . . .

Railing against "certain works in bad taste" which set the title words too large for the format and stating that "it is an essential rule" always to make the title pages wider than the text pages, Fertel continues on for 12 more items. If only we could make such precise and all-encompassing statements today!

1-15. A spread from Martin Dominique Fertel's *La Science pratique de L'Imprimerie*, showing his idea of the proper ordering of a title page.

Despite the pronouncements of Fertel and the technical lessons of Moxon, printers continued to devise slovenly and joyless pages; the restrictions of type, the tedium of setting, and the concern for economy had long since wiped out the imaginative possibilities of the manuscript. Almost forgotten, too, was the magnificent heritage of types of the previous centuries, those elegantly proportioned faces of Francesco Griffo for the Venetian publisher Aldus, those of Claude Garamond and Robert Granjon in France, the designs of the Dutch punchcutter Christoffel van Dijck, and those of the Hungarian Nicolas Kis who cut the so-called Janson face while in Amsterdam. Fortunately, today we have excellent recuttings of most of these types for both machine and handsetting. But in 1692 for the purpose of designing a special "romain du roi" type for the Imprimerie Royale, as befitted the "Age of Reason," a committee was appointed and designed the face on a graph of 2304 squares (36 by 64).

In England, however, the types of William Caslon, based on the earlier Dutch models, restored a forthright grace, and his types soon spread to America. Caslon still has its staunch exponents and rides out the tides of fashion with ease.

John Baskerville came to printing by a curious route: teaching calligraphy, cutting grave stones, and japanning trays (in which enterprise he amassed a fortune). In 1750 he set up a private press and typefoundry, from which emerged type faces of his own design strikingly similar to his earlier stone-cut letters. Both his roman and italic faces had an openness and grace which gave the page a light, airy look. His reliance on typography rather than illustration and ornament was a revelation in book design. The monumental Baskerville Bible, his masterpiece, appeared under the privilege of the Cambridge University Press in 1763. Its title page reflects the slate advertising "Grave Stones Cut in any of the Hands," which is presumed to

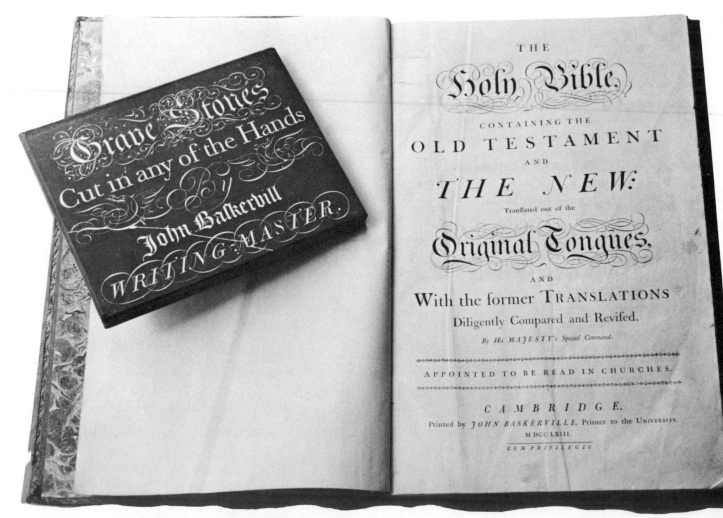

1-16. A replica of John Baskerville's advertising sign cut in slate, together with the title page of his monumental Bible.

same broadside. It was infrequent that these itinerant characters penetrated the precincts of the book, although in the twentieth century nearly every form was revived and made to serve on title pages, jackets, and paperback covers. In fact the sans serif, with the stimulus of the Bauhaus, began to be used for text. Countless skeleton letters based both on classic roman proportions and on the squarer, no-nonsense grotesques of 1832 by Figgins and Thorowgood were produced. Today, under Swiss influence, the grotesques like Helvetica and Univers dominate because they are felt by many designers to have a special affinity for scientific and technological matter, and they are even invading books on the arts and humanities.

In the mid-nineteenth century, as today, there were counter-reactions. The Chiswick Press of London resurrected the "old-face" Caslon type. William Morris had trial pages set in it for his *The Earthly Paradise*. He was dissatisfied, however, and in 1890 founded a private press, the Kelmscott, commissioning his own type design, a rugged version of the Nicholas Jenson roman of 1470. Yet, to match his foliated borders, still heavier types were needed and Morris reverted to black letter. Nevertheless, the impact of his pages, his perfection of workmanship, and his concept of the double spread as a unit, led to a new awareness of graphic design in the twentieth century.

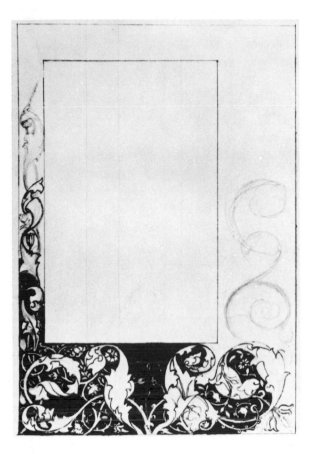

1-17. William Morris' method of sketching a border design in pencil and filling it out in ink. Collection of Joseph Dunlap.

have stood in the window of his shop. Machine-set versions of Baskerville's type are among the most frequently used faces in contemporary books, and types influenced by the Baskerville model, notably Bulmer and Bell, are equally versatile.

On the continent, the types of the Didots in Paris and of Bodoni in Parma underwent a further development, became narrower, and eliminated the bracketing of serifs, i.e., the curving of a stroke into its terminal cross line. Indeed all traces of calligraphic and stone-cut ancestry disappeared. Bodoni was able to make handsome pages of his so-called "modern" types but commercial adaptations of them produced pallid and stiff composition. And in 1855 Théotiste Lefevre published at the Didot printing office his *Guide pratique du Compositeur d'Imprimerie* which set down a style which stultified French title pages for almost a century.

In England especially, new types were developed after 1800 for use primarily in job printing, newspapers, playbills, and posters. Bold and fat versions of existing types, sans serif (otherwise known as grotesque, doric or gothic), script, outline, shaded, three-dimensional and decorated faces appeared like pantomine characters and often at once on the

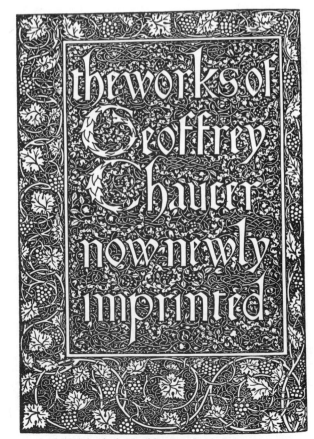

1-18. The left half of a double-spread title page engraving in wood of William Morris' Kelmscott *Chaucer*. The full spread is almost an embarrassment of riches.

1-19. A thumbnail sketch, late 1860's, for "The Story of Cupid and Psyche," one of the tales of William Morris' *Earthly Paradise*, a projected volume by Morris and Sir Edward Burne-Jones. Fitzwilliam Museum, Cambridge, England.

1-20. Bruce Rogers' pencil layout for the broadside for his Centaur type, shown on page 41.

THE REVIVAL OF LAYOUT

One of the first Americans to design books through the use of layouts was Bruce Rogers who came to the field as an artist and not as a trained printer. His books were noted for their exquisite design and subtly allusive typography; and his Centaur type is a constant source of inspiration for astute designers. Like William Morris, Rogers was inspired by the 1470 Nicholas Jenson type and also attempted to create a contemporary version by tracing photographic enlargements, but with a result quite different from Morris'. The face he produced was used first in 1902 for an edition of Montaigne, for whom it was named. Rogers continued work on the design and in 1916 brought out his brilliant new version, named after the book in which it was first used, Maurice de Guerin's *The Centaur*.

In 1929 the British Monotype Corporation began to cut Centaur for machine and hand composition. Rogers thought himself "too indifferent a calligrapher" to draw a companion italic and suggested Frederic Warde's interpretation of the Arrighi version of the chancery cursive, the handwriting used in papal briefs of the early sixteenth century. The types were used for the monumental Oxford Lectern Bible, produced in England under Rogers' direction and completed in 1935. Soon after World War II the San Francisco typefoundry of Mackenzie and Harris imported the matrices for the entire series and commissioned Rogers to do the design for a specimen broadside. His layout is shown above (Illus. 1-20) and the final result is reproduced on page 41. The type still appears to many to be the noblest roman of them all.

Right:
1-21. George Salter's superbly rendered pencil layout for a trade-book title page. Note the ingenious inclusion of the publisher's Borzoi device in the illustration.

Perhaps the greatest influence on the making of books in America after World War I was not a designer but a publisher. Alfred A. Knopf, passionately concerned about the appearance of his books, first commissioned a design, in 1926, from W. A. Dwiggins, a Boston advertising and book artist. For 30 years Dwiggins designed an average of ten books a year for the sign of the coursing Borzoi. His salty typography and ornament were additional hallmarks of the Knopf firm, the assurance of an inviting page and pleasurable reading. Among others who have added their varied and delightful interpretations to Knopf titles are the versatile Warren Chappell, whose Trajanus type has great flair and vigor, Herbert Bayer, the Bauhaus prodigy, Rudolf Ruzicka, designer of Fairfield, and George Salter, who is influential as a teacher, letterer, and book designer as well. His beautifully rendered layout for the title spread of *The Rules of the Game* appears below (Illus. 1-21). A great number of Knopf books have shown the fine influence of the art direction and production management of Sidney Jacobs, who has occasionally put his own hand to the design of books.

Many other designers and printers have created the bridge between the great tradition of typography and the liberating function of the layout. Out of the William Edwin Rudge printing house in Mount Vernon, New York, where Bruce Rogers had his studio in the 1920's, came Joseph Blumenthal whose Spiral Press books exemplify clarity and refinement, and Peter Beilenson whose inexpensive Peter Pauper Press books awakened many readers to the pleasures of craftsmanship and colorful design. Since World War II the university presses through their excellent designers have had an increasing impact on bookmaking and have consistently won awards. Concurrently the clean lines, arresting symbols, juxtaposed images and vivid color of commercial design have enlivened books. Magazine formats have revolutionized photographic book layout and revealed the power of the double spread title page. Even the architect, Frank Lloyd Wright, introduced a new sense of space to the printed page.

THE RULES

OF THE GAME

by ROGER VAILLAND

1958

Translated from the French by PETER WILES

ALFRED A. KNOPF, New York

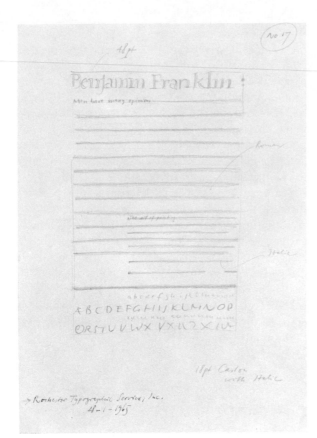

1-22. First rough sketch reduced two-thirds of the page discussed below.

1-23. Completed layout at full scale rendered in pencil and colored ball point pens on lightly ruled graph paper. Note the precise specification of typographic details.

A PAGE FROM HERMANN ZAPF'S MANUALE TYPOGRAPHICUM II

How does a contemporary master go about designing a page and seeing it through production? The typographic manual has often been the printer's playground and masterpiece since those of Fournier in 1742 and of Bodoni issued posthumously in 1818. Hermann Zapf, the noted type and book designer, in his *Manuale Typographicum* of 1954, gave the form an international scope with quotations in 16 languages set in 50 typefaces, many of his own design. In his second *Manuale* he has extended the range of types and authors, employing a vertical format as contrasted with the oblong (or landscape) format of the first, and with the pages composed in several countries.

The width of the composition was determined in layout by carefully tracing the normal setting of the name Benjamin Franklin, with a colon, in 48-point Lanston Monotype Caslon Old Style No. 337. For the text, the 18-point size of the same type justified to the same measure, 28½ picas, was specified. Its continuation was drawn as interlinear lines in red in 10-point Caslon 3371 italic. The measure here was based on dividing the alphabet and figures of 24-point lowercase Caslon 3371 italic into two equal lines and letterspacing them so that their length was in good proportion to the major block, i.e., 18½ picas to 27½ picas or about 2 to 3.

It will be noted that the rendering of the red in the full scale layout is with a red ballpoint pen, ideally fine for 10-point Caslon italic, as compared with colored pencils, which require constant sharpening. For the 24-point italic, the thick strokes are simply doubled and the rendering is somewhat tighter. Zapf always carries with him a four-color ballpoint pen for making layouts, for proof marking where different types of corrections can be color-coded, for manuscript markup and for flamboyant inscriptions in books.

48 pt.

Benjamin Franklin: *

< 2 pt.

18 pt.

Men have many opinions, and printers print them as
part of their business. They are educated in the be-
lief that when men differ in opinion, both sides
ought to be heard by the public; and then when truth
and error have fair play, the former is always
an overmatch for the latter. Hence they cheerfully
serve all contending writers that pay them well,
without regarding on which side they are of the
question in dispute. If all printers were determined
not to print anything till they were sure it would
not offend nobody, there would be very little printed.

The art of printing, which diffuses so general xyza
light, augmenting with the growing day, and of so
penetrating a nature, that all the window shutters,
which despotism and priestcraft can oppose to keep
it out, prove insufficient. October 2nd, 1783

※
Doppelpunkt auf
Höhe des Kleinbuchst.
nicht so: n:

10 pt.

Versal T
und O
aus der 10 pt.
Roman
setzen (also
entgegen dem
Layout)

✻

24 pt.

abcdefghijklmnopqrs

30 pt.

ABC& DEFGHIJKLIM

E C&D

24 pt.

tuvwxyz.1234567890

30 pt.

NOPQRSTUVWXY&Z

z I

&= 30 pt. Caslon Old Style Italic

※ Wenn möglich die Kommas in der 10 pt. Kursiv,
aus einem kleineren Grad setzen.

Opposite Page:
1-25. Revised proof at full scale.

In setting Franklin's quotation, the compositor used for the 48-point lines the American Type-founders Caslon 471 which is cast from matrices made from the original English punches. However, the line runs 29½ picas wide instead of the 28½ picas indicated for Monotype 337 in the layout. Hence the 18-point Caslon 337 lines are also set to the wider measure, and since furthermore they are cast on a narrower set width than normal, the text makes only nine lines instead of the eleven originally shown. But the layout is flexible enough to adapt to the change, and in fact is probably improved since there is more breathing space for the interlinear matter.

One of the advantages of the Monotype is that it permits casting on narrower (or wider) bodies than the character itself, thereby allowing the most subtle nuances of spacing. Here the type achieves the same closeness of fitting and handsome color apparent in the Great Primer Roman of the original Caslon Specimen of 1734, and for that matter in the type still produced by the successors to the Caslon Foundry, Stephenson & Blake. Since occasionally certain combinations of letters appear too close or too separate to the practiced eye, there are indications in the proof for adjustments. The precise amount is usually not specified when one has confidence in his co-workers. And by the same token, the compositor has been permitted to change the measure of the red interlinear text to 17 picas instead of the 18½ picas originally drawn.

Benjamin Franklin:

Men have many opinions, and printers print them as part of

their business. They are educated in the belief that when men

differ in opinion, both sides ought to be heard by the public;

then when truth and error have fair play, the former is always

an overmatch for the latter. Hence, they cheerfully serve all

The art of printing diffuses so general a light,

contending writers that pay them well, without regarding on

augmenting with the growing day, and of so pene-

which side they are of the question in dispute. If all printers

trating a nature, that all the window-shutters, which

were determined not to print anything till they were sure it

despotism and priestcraft can oppose to keep it out,

would not offend nobody, there would be very little printed.

prove insufficient. OCTOBER 2nd, 1783

abcdefghijklmnopqrs

A B C & D E F G H I J K L M

tuvwxyz1234567890

N O P Q R S T U V W & X Y Z

When *La Cantatrice Chauve*, the Ionesco play known in America as *The Bald Soprano*, opened in Paris it received a cold reaction. Only one critic and a playwright gave it favorable notices, and despite the actors' taking to the streets with sandwich boards, the house was often empty. The play closed in six weeks. Eugene Ionesco's attack on conformity and the leveling of individuality needed the subsequent buttressing of the "Theatre of the Absurd" as developed by Beckett, Genet, Pinter, *et al.*, and the success of his other plays for *The Bald Soprano* to achieve acceptance. Eventually *La Cantatrice Chauve* reopened in Paris and played for nine years.

The French publishing house Gallimard was able to launch a special edition of the play in an extraordinary visual and typographic costume by their designer Massin and the photographer Henry Cohen. The book rapidly became the talk of Paris and was recast in English for Grove Press' American edition. Like Ionesco's play itself, it manages to break every rule of conformist book design with a tour de force of explosive image and symbol. All criteria of margin allowance, type combination, spacing, and legibility are violated. Yet it brings the action of the play into electrifying life as though each spread were a frame from a flickering silent film arrested momentarily in startling black and white. As the book continues, the tempo increases with violent enlargements of type, juxtapositions of speeches, and images mounting to a progression of overlapping type blow-ups in which a single serif finally occupies the entire double spread. Then the married couple who began the play with their endless mouthing of clichés and platitudes, return to their seats, the husband behind his newspaper, the wife mending, and the curtain falls with simply the word "Rideau" in white reverse on a solid black page.

1-26. Massin's witty treatment of the binding with the front cover photographs of Ionesco (the comic and tragic O) and the cast, seen from the rear on the back cover. On the spine, for the word *Chauve* (bald) the pate of the author is substituted.

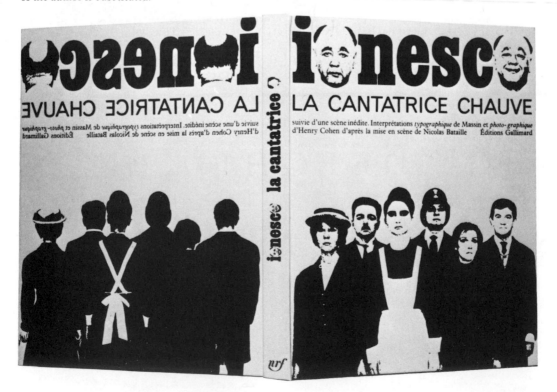

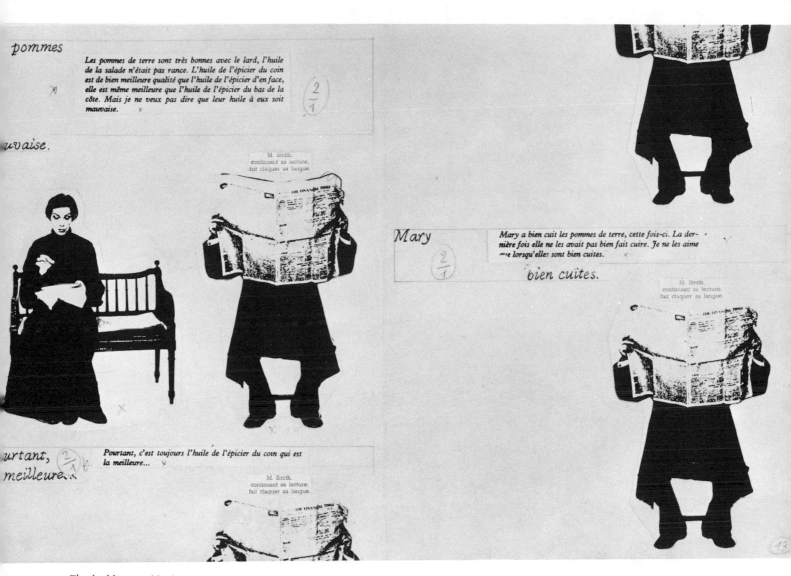

Les pommes de terre sont très bonnes avec le lard, l'huile de la salade n'était pas rance. L'huile de l'épicier du coin est de bien meilleure qualité que l'huile de l'épicier d'en face, elle est même meilleure que l'huile de l'épicier du bas de la côte. Mais je ne veux pas dire que leur huile à eux soit mauvaise.

uvaise.

Mary

Mary a bien cuit les pommes de terre, cette fois-ci. La dernière fois elle ne les avait pas bien fait cuire. Je ne les aime que lorsqu'elles sont bien cuites.

bien cuites.

urtant,
meilleure

Pourtant, c'est toujours l'huile de l'épicier du coin qui est la meilleure...

1-27. The double spread laid out in paste-up form with the degree of blow-up for the type indicated and the line prints of the actors in position.

1-28. The finished result printed by offset lithography.

Les pommes de terre sont très bonnes avec le lard l'huile de la salade n'était pas rance L'huile de l'épicier du coin est de bien meilleure qualité que l'huile de l'épicier d'en face elle est même meilleure que l'huile de l'épicier du bas de la côte Mais je ne veux pas dire que leur huile à eux soit mauvaise

Mary a bien cuit les pommes de terre cette fois-ci La dernière fois elle ne les avait pas bien fait cuire Je ne les aime que lorsqu'elles sont bien cuites

Pourtant c'est toujours l'huile de l'épicier du coin qui est la meilleure

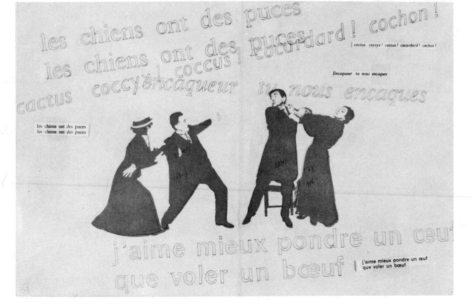

1-29. The paste-up layout for the first spread of a mounting quarrel.

1-30. The next level of frenzy.

1-31. A printed spread of the quarrel scene.

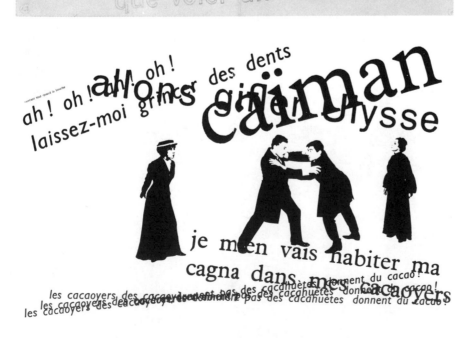

The graphic technique was ingenious. The play was photographed straight-on with the cooperation of the cast of the production at the Théâtre de la Huchette. The photographic prints were transformed into black and white images without grays by using line films. Several head positions of each character were chosen and reduced to a few small sizes to function on the page as speech indicators. After the first introduction of the characters the names of the speakers do not appear again; identification is by visage or figures. As further clue to identity, each character's speeches are set in his characteristic typeface, e.g., M. Smith in Plantin Roman, Mme. Smith in Plantin italic, M. Martin in a Gothic, etc. Stage directions are in light Egyptian and originally all the type was set in 8 point.

Massin grouped the matter for each spread, as he progressed through the book, according to its sense or graphic possibilities. Using an enlarging projector with a movable table, Massin could project down on his double spread layout sheet the photographic actor images he wanted. These he traced off, or if the desired sizes already existed in his stock of photoprints, he pasted them in place. The type lines were then projected down at whatever enlargement or angle he hit upon after much experiment, and traced off. As is the accepted practice in Europe, even with such complex makeup, these layouts served as guides to the offset lithography cameramen in shooting and stripping-in the negatives. For the later American edition, mechanicals were made with pasted-up photoprints for both type and actor images, in accord with American trade practice. In neither case was any effort made to smooth out the rough letter forms resulting from extensive blow-ups of 8-point type.

A few pages in the book reveal type lines which have been suggestively stretched and twisted. For these effects Massin used a kind of fine rubber, which after the type has been printed on it, can be stretched, distorted, curved, and photographed to express the most astonishing and subtle nuances. Quel beau sentiment!

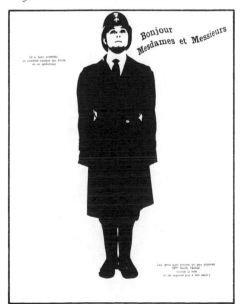

1-32. The arrival of the Fire Chief.

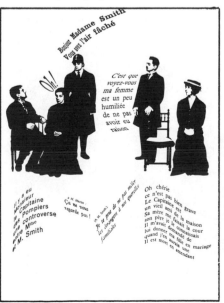

1-33. The Fire Chief with the Martins and the Smiths. The attitudes of the characters are interpreted by the curving lines of type, printed on rubber and photographed.

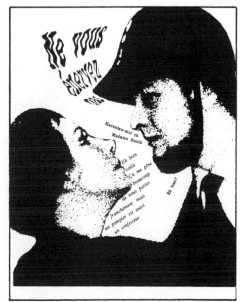

1-34. Mrs. Smith in a tête-à-tête with the Fire Chief.

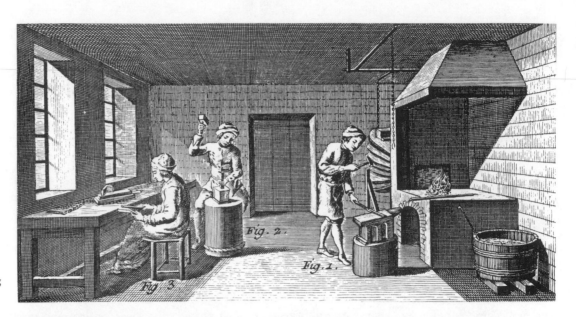

2-1. Steps in creating type punches.

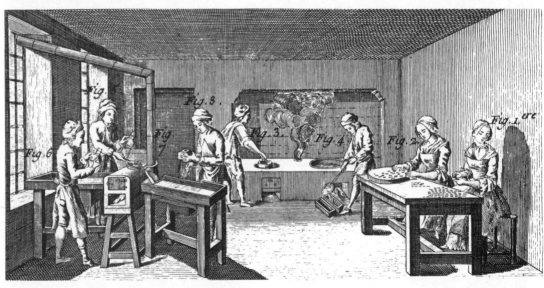

2-2. Casting the type in hand molds.

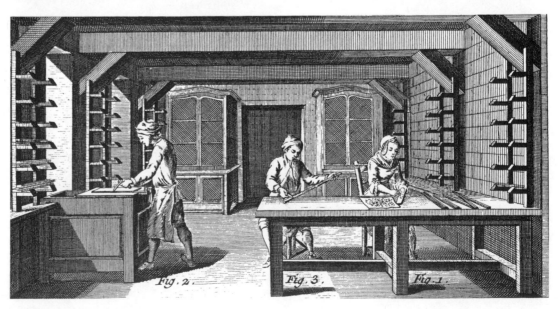

2-3. Finishing the type characters.

A FRENCH EIGHTEENTH-CENTURY TYPE FOUNDRY, CO-EDUCATIONAL.

2 Typography

The choice of typesetting method for the text of a book suggests an architectural analogy. Working on a single great building, the architect might wish each piece of stone to be hand hewn and individually placed, as a book designer might wish the type to be hand cut, hand cast, and hand-set. The budget rarely allows this, however, and the architect settles for brick, which, although ready-made, is placed by hand, as the book designer would settle for Monotype, set by keyboard and cast as separate letters. If this method is too expensive or unavailable, the architect may use poured concrete and the book designer, Linotype. Of course, in some cases, it might actually turn out that the hand-controlled process is neither more expensive nor better than the machine process, especially when the size of the edition is small. A fine sensitivity to the importance of all the factors involved is required to determine the process to be used. Just as there are connoisseurs who claim that no modern building could rival the cathedral of Chartres, so there are collectors who claim that no modern book can rival the Gutenberg Bible. It would be impossible and absurd to attempt to recreate these masterpieces today, nor would they serve the needs of modern man. However, it is possible to create, using contemporary machine methods, books which serve their purposes magnificently. Similarly, with the development of reinforced concrete and structural steel the great monuments of modern architecture have come into being.

Within the major means of typesetting, hand-set, Monotype, Linotype, and Ludlow there are a tremendous variety of typefaces, many of them available for more than one method. Although their differences are often subtle and each designer will eventually develop his own preferences, a knowledge of most of them is essential. Each typeface has characteristics which may make it seem ideal at a certain time for a certain book. Sometimes the historical period, sometimes the audience, sometimes the printing process, or all of these together, will indicate the choice.

Often minute factors will affect the decision: the availability of small capitals, italics, old style or modern figures, foreign accents, kerned letters, ligatures and logotypes, etc. Or if one is thinking in terms of a monumental folio the fact that only a few faces are available in large sizes for machine setting will govern the possibilities. Bold face types are generally avoided, except in works of reference where they have the important function of catching the eye. Of course some types are so abominable that they should never appear in any book, but even these outcasts have been rescued occasionally by wit and imagination.

The designer begins his type selection by studying the prospective printers' specimen books. He must learn what is available. Probably he has a mental list of preferences and prejudices, types that he is eager or willing to use and types that he would use only in desperation. In his searches and ruminations he should discover a body type which seems particularly appropriate to the material at hand by its allusions, its weight, or its design.

As for legibility, every day we read hundreds of yards of printing in badly spaced, narrow columned newspapers and magazines without complaint. It matters little what the type or its setting is as long as the subject matter is interesting and the type face not too unfamiliar. Type, of course, can evoke an aesthetic response which can affect the willingness to buy and the desire to read. This response is equally dependent on the tone, texture, and grain of the paper, the margins, the space between lines and words and around each element. For pleasurable reading, type lines should have a closely spaced strip-like quality which defines each line from its neighbors so that the eye is not confused as it moves from one line to the next. Yet this space and the line length should not be so great as to make the eye jump uncomfortably. "The enjoyment of patterns is rarely the reader's chief aim" as Stanley Morison says, but it subconsciously induces him to read.

Above:
2-4. Steps in producing a type punch.

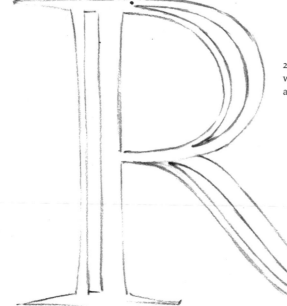

2-5. First sketches, reduced to one-third, of a display type by John Peters, inspired by a Roman inscription in southern France.

2-6. The outlines of the alphabet were enlarged and refined in tracings at size of the letter R.

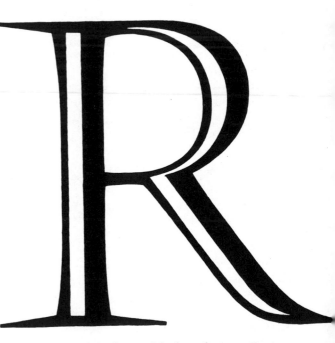

NOCTE
ET DIE
SERVO
EAM

2-7. The letter R after inking and further refinement. Peters temporarily abandoned the curvilinear tail for a straight form. The Monotype Corporation then redrew the alphabet further enlarged, cut patterns and punches, drove matrices and cast trial fonts for the 36-point size.

2-8. The first proof traditionally set in Latin. It will be noted that the original form of R has returned.

EVOLUTION OF A DISPLAY TYPE

A few years ago, while on holiday in southern France, the English book and type designer John Peters came upon a Roman monument with an inscription so magnificent that it immediately broke the vacation spell and set him to sketching a new type. The deeply incised stone-cut characters with their long serifs suggested an open letter of brilliant sun and shade. The basic characteristics of the face were determined on the spot—its elegant proportions, pointed wedge serifs, straight inlines and reverse entasis or slight concave curve of its main strokes.

When he returned to his drawing board in Cambridge, Peters drew in pencil the outlines for the alphabet and figures at large scale. With repeated tracings these were refined, transferred to stout handmade paper, and then inked with brush and India ink. The entasis was made more pronounced, giving both a flow into and a contrast with the precise serifs.

Eventually the drawings were seen by the advisors of the Monotype Corporation, which produced a trial cutting. The first proofs were distinctly gratifying. Nevertheless Peters redrew some characters, notably the R and several figures, before the final punches were cut. He chose to call the face Castellar because it was here, in this hill-top village overlooking the Mediterranean, that he made the first sketches for the design. Today one sees Castellar in use internationally both in tasteful advertising and in fine book work.

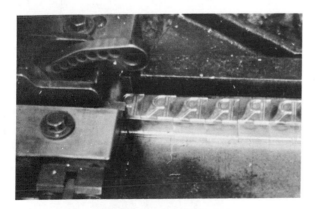

2-9. Casting the 72-point Castellar letter R in San Francisco from matrices imported from England.

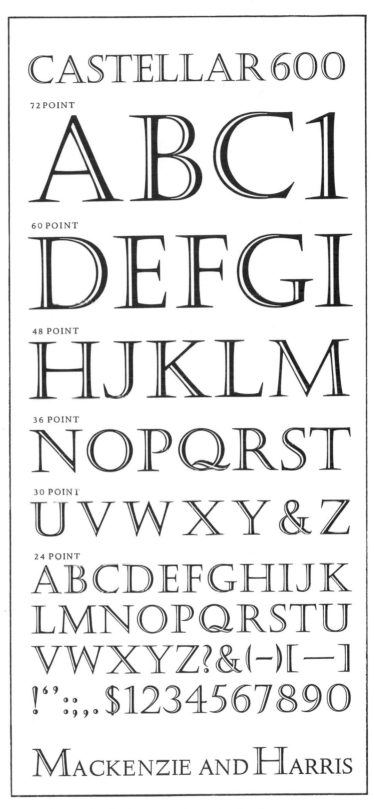

2-10. In the typefounders' specimen sheet, reproduced at full scale, the existing sizes are shown. The number 600 is the Monotype Corporation's identification for the series. Note the variations in several characters from Peters' first sketch but the faithful retention of the original concept.

FOUNDRY TYPE

A piece of foundry type is a rectangular metal block, one end of which carries a mirror image of a letter, symbol, or form in relief. Its function is to accept a tacky ink on the image or face and transfer it under pressure to paper. From the earliest days of typographic printing it was determined that the most convenient height of the block or body for the compositor's fingers should be about 1 inch. But not until 1898 was agreement reached among American and British type founders that the "height to paper" should be .9186 of an inch, and on the European continent it still remains somewhat higher.

For three centuries the question of standard body sizes was not raised. In 1739 Fournier le jeune proposed the point system for measurement of the vertical dimension of the body, and by the late nineteenth century the major typefounding countries were using versions of it. The measurement "point," however, varies in different places. In America it is about 1/72 or .01383 inch. On the European continent the Didot point, among others, is slightly larger. Problems arise in combining types, and for export the continental faces are often cast on American body sizes or sawed down in height.

The designer, however, is concerned equally with the lateral dimension or width of the body, because it affects the critical questions of the space between letters and the number of characters in a line. Extra space can easily be inserted between letters. But to require the space to be decreased in more than an occasional display line would be costly, and the letters, which would have to be hand shaven, might be troublesome to use later.

Foundry type ordinarily consists of about 10 parts lead, 4 parts antimony, 2 parts tin, and sometimes small quantities of copper for extra hardness. Each foundry has its own formula. Even with the best alloys, type shows wear with long runs and hard paper. For letterpress printing either electrotypes or photoengravings are usually made since they are of harder metals and free the foundry characters for other uses. Special proofs on fine coated or other receptive stocks, called reproduction proofs, are printed for photoengraving as they would be for offset lithography or for gravure printing. The quality and evenness of these proofs are among the most important factors for the book designer to inspect if he is to set the standards of the finished product. Unfortunately this is often left to the printer and the relative weakness or over-inking of adjacent proofs is detected only in the bound book.

Today the chief maker of foundry types in this country is the American Typefounders, Inc., but several other companies supply faces cast in hard foundry metal from English and American Monotype matrices. A few small foundries also cast versions of the decorative types of the nineteenth century. Types from European foundries are imported primarily through Amsterdam Continental, Inc. and Bauer Alphabets, Inc. The principal English foundries are Stephenson Blake & Co. Ltd. and Stevens Shanks & Sons Ltd. The book designer should be on the mailing lists of all these firms to keep abreast of the new issues. These are usually extended, condensed, expanded or distorted earlier faces, but he may occasionally find the ideal face for a new design commission.

Before the end of the nineteenth century hundreds of machines were patented for mechanically setting precast foundry type, but all were doomed to failure under commercial conditions, largely because of the difficulty of handling and putting the recalcitrant lead soldiers back in their boxes. The machines had names like the Pianotype, the Unitype, the Kastenbein, the Thorne. Even Mark Twain, who had been a printer in his early years with *The Territorial Enterprise* in Virginia City, Nevada, was drawn into the mania and supported the Paige Compositor. Of it he wrote in 1889, with characteristic flamboyance:

> The new machine will do the work of six men, and will do it better than any compositor who ever handled type from a case. This afternoon the death sentence was passed to all other composing machines because one machine has more brains than all the printers in the world combined.

Yet Mark Twain lost a great fortune on it, not because it did not work, but because of the development of matrix-composing machines. To this day foundry type is still set by hand.

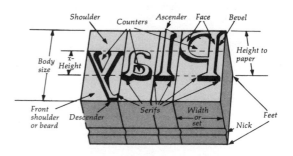

2-11. The anatomy of hand-set foundry type.

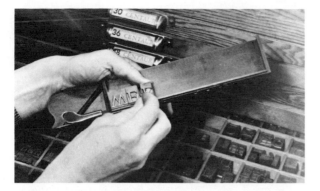

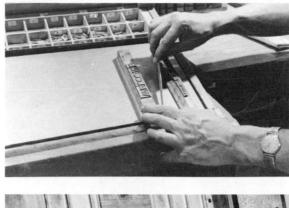

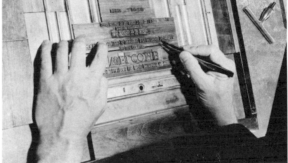

2-12A. Inserting a letter space while hand-setting a word.

2-12B. Leading. Inserting a 6-point slug between two lines.

2-12C. Removing a space between letters with tweezers, from a locked-up form.

HAND-SETTING AND SPACING

Foundry type is set in a "stick," a narrow, three-sided metal tray held at an angle in the left hand while the characters are put in with the right hand in normal reading sequence with the tops of the letters toward the compositor. The nick or pattern of nicks in the bottom side of the type helps the compositor to see and feel that the letter is facing the right way and also is an identification when similar faces of the same body size are set. One side of the stick is adjustable to the line length desired, usually in even or half picas, a pica being almost exactly 1/6 of an inch.

Spacing between words is done with blocks of type metal of the same point size as the body but of a considerably lower height. Spacing widths are based on fractions of an "em," the square of the type body size. In 12-point type the em space, or quad, is 12 points wide by 12 points deep as viewed from above. An en quad is ½ an em, or 6 points wide by 12 points deep. Other spaces for 12 points are the 3 em space, which is 4 points wide; the 4 em space, 3 points wide, which is the average word space with normal roman types. The 5 em space would be 2 2/5 points but is usually rounded off to the nearest ½ point, or 2½ points. The 6 em space is 2 points and is more commonly called a 2-point space. Most of the narrower or thin spaces used in spacing between letters as well as words

are made of different materials. The 1-point space is often of brass, the ½ point of copper and the ¼ point of stainless steel. Thin spaces of paper are also used. Each different common foundry type size (6, 8, 10, 12, 14, 18, 24, 30, 36, etc.) has its own word spacing divided in the same fractional parts but rounded off to ½ point. Filling out of lines is done with multiples of the em quad—the 2 em quad, the 3 em quad, etc. Each line is set to an equal degree of tightness, and the compositor strives to get even, close spacing throughout.

Spacing between lines, or leading, is done primarily with strips of lead alloy cut slightly less than the width of the composition. The strips from 1 point through 4 points thick are called leads, those of 6, 12, and 18 point are slugs, and those of 24 point or 2 picas and larger pica increments are known as furniture whether made of type metal, aluminum alloy, or wood. For interlinear spaces for which no exact thickness exists, such as 5 point, 7 point, etc., combinations are used. As with the thin word spaces 1, ½, and ¼ point "leads" exist in brass, copper, stainless steel, though paper is more commonly used. A basic rule in book work is that the same leading be used throughout each kind of text matter which is set in the same size of type, including between paragraphs.

Ottmar Mergenthaler, who came to America from Germany to assist in his cousin's patent model shop, worked on the development of both a typewriter and a matrix stamping machine. The latter drove type punches into papier-mâché molds for casting a metal printing plate. In 1884, at the age of 28, he developed a machine which, by the action of a keyboard, composed a line of matrices of brass and pressed them against a mold into which lead was poured to create a solid slug. Inevitably it was called the Linotype and it proved to have many virtues. It required only one operator and performed the processes of setting, justifying, casting, and distributing automatically. The slugs were easily made up into pages without disassembling or "pi-ing," and, when printing was completed, they were remelted and used for setting new lines. Today in America, the Linotype and similar Intertype are the chief means of setting books.

The Linotype system of composition with matrices set in a line has inherent problems, most of which, however, have been ingeniously solved. Kerning—the projection of one letter, such as a lowercase f—over the adjacent letter, is impossible with single-letter matrices because the matrix or mat must have sidewalls, however thin, to contain the hot metal. In much Linotype composition one sees the straightened or button-hook f. But the tied fi ligature, for example, is set as a combination of two letters cast in one mat and the same solution has been used for other lowercase f combinations, the logotypes shown on the page opposite. There is still a compromise with full kerning in the lowercase italic f. In the One-letter Italic Logotypes, Special No. 5 (line 19) the bottom of the italic f kerns but the top does not. In the two-letter Logotypes (line 26) the italic f kerns at the top but not at the bottom.

Most Linotype mats are "two-letter." Two separate characters are carried on each mat, as on a typewriter key, usually the roman and italic of the same letter, or the roman and boldface, or other combinations like the fl with the small capital Y in the illustration. With the machine called a Mixer and the addition of other magazines (the cases which contain the matrices) the capacity can be more than doubled. But with two letter mats there is also a compromise: the design of the letter has to be subtly adjusted so that both forms fit on the mat and at the same time fit well with their neighbors.

To meet this problem certain refinements have been designed. The one-letter matrices, such as the Italic Special No. 5 (line 21), are more condensed and closely fitted than the regular italic (line 9) which has been designed to conform to the roman.

The Special Two-letter Small Caps (line 20), another refinement, having slightly more height, weight, and contrast than the regular version, are preferable for running heads, captions, etc. They are accompanied on the same mats by the rare italic small caps (line 22), which can follow one of the swash characters (line 15) and lead smoothly into a paragraph of italic lowercase. The overlapping, or cut-in capital combinations (lines 23 and 24), can be used if they are not too frequent and do not inordinately raise the cost of composition. In specifying these refinements, the designer must determine whether the printer has them available, if not, how quickly they could be obtained, and whether or not the additional expense can be justified. Few composing rooms carry them, and in fact, few designs issued in the last 30 years have these refinements at all, which is regrettable.

Long descenders (line 27) should be used wherever the leading, and hence the body on which the type is cast, will permit, for they help to knit the page together. With pre-nineteenth-century types like Caslon, old style figures should be used, except in instances like a line of capitals containing a date. Here modern or lining figures which come with the normal font of matrices are usually better.

On the Linotype, word spacing is achieved by slender wedges, tapered metal bands that push up between the mats and drive the line out to its preset limit, 30 picas or less on most machines, 42 picas on one model of Intertype. To get desirable 4/em average spacing, the optimum for most book faces, it is necessary to specify "narrow space bands" and to have an agreeable operator. The latter must be willing to hyphenate more frequently than usual and sometimes reset lines to achieve better breaks. Ragged margins are a bit more time-consuming because succeeding lines must never have the same length and hyphenation should generally be avoided. When the margin becomes wildly unkempt, resetting may be required. The letterspacing of capitals can be accomplished by spacebands but for careful optical spacing (i.e., compensation for the different shapes of the letters) fixed spaces are put in by hand. Lowercase is never letterspaced in body sizes unless, of course, one is setting emphasized words in a George Bernard Shaw play, or German in German style.

Caslon Old Face

List of Characters in Two-Letter Fonts
WITH ITALIC AND SMALL CAPS

ABCDEFGHIJKLMNOPQRSTUVWXYZ
ABCDEFGHIJKLMNOPQRSTUVWXYZ
ABCDEFGHIJKLMNOPQRSTUVWXYZ

12345	abcdefghijklmnopqrstuvwxyz	67890
VBCDE	*abcdefghijklmnopqrstuvwxyz*	FGRTJ

, . : ; ? ! (│) * ' ' - — Æ Œ ﬀ & £ $. . . ﬁ ﬂ ﬀ ﬃ ﬄ æ œ

, . s ; ? ! A I Q O ' ' - — Æ Œ ﬀ N £ P L . . . ﬁ y ﬀ w m k h

12345	Z & : () ﬂ ﬃ ﬄ $ æ œ QU Qu	67890	⸲ ⸴	
12345	*u & : () ﬂ ﬃ ﬄ $ æ œ QU Qu*	*67890*	⸲ ⸴	

⅛ ¼ ⅜ ½ ⅝ ¾ ⅞ x z & æ œ @ % † ‡ § ¶ – []

SWASH CHARACTERS
A B C D E G J K L M N P Q R T U Y &
Made in all sizes and may be ordered as extras

OLD STYLE FIGURES
1234567890 *1234567890*
Made in all point sizes, and will be substituted for those regularly furnished with a font, if so ordered, or they may be added as an extra

ONE-LETTER ROMAN LOGOTYPES
SPECIAL NO. 5
fa fe fo fr fs ft fu fy ffa ffe ffo ffr ffs ffu ffy f, f. f- ff, ff. ff- f ff

ONE-LETTER ITALIC LOGOTYPES
FA PA TA VA WA YA Th Wh

SPECIAL NO. 5
f af aff ef eff hf if iff kf lf mf nf of off pf rf sf tf uf uff yf If Of Off

ONE-LETTER ITALIC
SPECIAL NO. 5
abcdefghijklmnopqrstuvwxyz

SPECIAL TWO-LETTER SMALL CAPS
ABCDEFGHIJKLMNOPQRSTUVWXYZ&
ABCDEFGHIJKLMNOPQRSTUVWXYZ&

TWO-LETTER LOGOTYPES
F. P. Ta Te To Tr Tu Tw Ty T. Va Ve Vo V. Wa We Wi Wo Wr W. Ya Ye Yo Y.
F. P. Ta Te To Tr Tu Tw Ty T. Va Ve Vo V. Wa We Wi Wo Wr W. Ya Ye Yo Y.

fa fe fo fr fs ft fu fy ffa ffe ffo ffr ffs ffu ffy f, f. f- ff, ff. ff- f ff
fa fe fo fr fs ft fu fy ffa ffe ffo ffr ffs ffu ffy f, f. f- ff, ff. ff- f ff

LONG DESCENDERS
g j p q y *g j p q y*
Made in 8, 10, 11, 12 and 14 point sizes and may be substituted for regular characters or may be ordered as an extra. These characters cast on a body size one point larger than indicated

SHORT DESCENDERS
J g j p q y 3 4 5 7 9 () *g j p q y 3 4 5 7 9*
Made for all point sizes and may be substituted for regular characters, or may be ordered as an extra. These characters permit casting on a smaller body size than indicated

2-13. The refinements available in the Linotype Caslon Old Face series. Many of these matrices must be hand inserted from a special repository on the machine called a "pi" box.

THE MONOTYPE

Soon after the invention of the Linotype, the American Tolbert Lanston developed a machine which also used the principle of casting in brass matrices, but which, instead of forming solid lines, made individual characters and hence was called the Monotype. It was shown at the Columbian Exposition in 1893, and a few early models were sent abroad in an effort to raise capital for their manufacture. A syndicate was formed in England establishing the foundation of the present Monotype Corporation Ltd. The machine was readily accepted by British printers because it made correction easy and could supply type for hand composition. Through the Corporation's concerted program of recutting many classic types and sponsoring new ones, largely under the guidance of Stanley Morison, and recently John Dreyfus, the Monotype has become the major instrument for the composition of books in England and on the continent. The Lanston Monotype Company, founded in America, introduced many excellent faces by Frederic W. Goudy, Sol Hess, and others before World War II. Since then the company has mainly limited itself to adapting some of the best foundry type and English Monotype designs to American equipment.

The Monotype consists of two machines, each with a separate operator. One is the keyboard which perforates a paper tape, the other a caster which is activated by the tape like a player piano to put the appropriate letter matrix into position under a spurt of hot metal. Word spacing is automatically accomplished in the keyboard stage; when the line is almost full, at the instigation of the operator the remaining space is divided evenly throughout. Each Monotype face has a normal set width which gives a certain amount of space between each character, but this can be adjusted if necessary by using a slightly narrower set width to give the closeness of fitting desirable for book work. Similarly, types can, if desired, be set on a smaller point body than the type size designated. For instance, 16-point Centaur on a 15-point body gives a rich page texture, although there may be occasional conflicts of ascenders and descenders which will have to be adjusted by conciliatory word spacing.

Kerning is a natural feature of Monotype setting, both in the f, y, and j combinations and in the capital and lowercase liaisons. The metal used can be harder than Linotype, permitting these niceties as well as longer press runs with sharper impression. A 60-pica line is the maximum, and with English Monotype attachments, sizes through 24 point can be cast for some faces. The larger sizes are cast on special machinery, for hand-setting.

Nevertheless the Monotype's two-step operation has not encouraged as broad use as it deserves in America. Printers who are used to handling Linotype slugs find working with loose single characters finicky and nerve-wracking. Most American pressmen have a horror of the diabolical "workups," spacing material which rises to the type face level, becomes inked, and prints. With Monotype these can occur between words as well as lines. Printing from plates, of course, eliminates the whole problem.

The Centaur broadside for which Bruce Rogers, the designer of the roman, did the layout reproduced on page 22, shows the complete range of a Monotype series.

2-14A. A Monotype matrix case.

THE LUDLOW

One additional line composing machine deserves mention, The Ludlow Typograph. While its brass matrices are hand-set, the fact that the type is cast in a solid line and that only a small supply of matrices is needed to set many different lines makes it occasionally useful for book work. Several excellent book display faces are available such as the Eusebius Open, used in *The Spice Islands Cookbook* (Illus. 10-10).

Right:
2-14B. Centaur broadside designed by
Bruce Rogers with the text by
Robert Grabhorn, set in the typefoundry
and composing room of Mackenzie and
Harris, Inc., and printed by
Taylor and Taylor, San Francisco.

CENTAUR

❧{ AND ARRIGHI }❧

60 POINT TITLING

IT IS NOW EASY TO OBTAIN

72 POINT

Centaur Roman of Bruce Rogers & Arrighi Italic of Frederic Warde in foundry metal, in all the existing sizes.

6 POINT

THE STORY OF THE MAKING OF THIS CENTAUR TYPE PROPERLY BEGINS IN VENICE IN THE fifteenth century, in spite of Bruce Rogers' years of application to it in the twentieth. It is quite impossible in the space at my disposal to give even the briefest résumé of the great flourish, pure roman, and was undoubtedly a type rendering of a very fine humanistic manuscript letter. Jenson's type bought forth lavish praise in his own time, even from himself; but how much of the archaism was due to the merits of the type itself and how much to Jenson's superb craftsmanship as a printer is material for conjecture that could be just as fruitfully applied to Rogers and his Centaur. If printers copied Jenson's type in the 15th century (and they probably did, since imitation of success is not a new thing), then their accomplishment fell short of his. But printers did not lack other fine models to copy, and the fifteenth century produced many splendid books in type similar, if not superior, to Jenson's. It is in the sixteenth century with THE EVOLUTION OF THE PROFESSIONAL TYPE DESIGNER, OR BETTER, PUNCH CUTTER, THAT TYPE and not manuscript-lettering began to be looked at afresh models for type. Fine printing has existed in every age, as has also the crude and inept. But it was not until the eighteen-nineties, when William Morris and his eye upon the complex book and decided that he would re-awaken the world to the former grandeur of printing, that printers again heard of Nicolas Jenson. "There was only one master from which to take examples of this perfected roman type, to-wit, the works of the great Venetian printers of the fifteenth century, of whom Nicolas Jenson produced the completest and most roman characters from 1470 to 1476. This type I studied with most care, getting it photographed to a big scale, and drawing it over many times before I began designing my own letter; so that though I think

8 POINT

UPON A REEDIMENT OF IT WAS ARRICHI CETTLED, IN THE TYPE WHICH IS now known as Centaur." Centaur gets its name from the title of the book in which it was first used: "The Centaur," by Maurice de Guerin. The thin book, small folio in size, was first issued in 1915 by Bruce Rogers from the Montague Press of Carl Rollins which was in Montague, Massachusetts. Only one hundred and thirty-five copies were printed, the large proportion of which were given away. Today, in the rare book market, it commands a price exceeded by few, if any, of even Rogers' most elaborate productions. The fame of this book, however, in spite of ITS EXCELLENCE AS AN EXAMPLE OF THE WORK OF AMERICA'S FOREMOST BOOK designer, rests on the fact that it was the first use of a type that has since been employed successfully not only by Rogers, but by other printers as well, in so many notable volumes. From that first cutting of 1915, until its completion as a series in 1929, individual letters of Centaur have undergone modification and improvement. ITS FIRST USE IN A BOOK WAS IN THE 14 POINT SIZE; AND IT WAS LATER USED IN THE SIZE

9 POINT

"IT APPEARS TO ME ONE OF THE BEST ROMAN FONTS YET DESIGNED in America and, of its kind, the best anywhere." Mr. Rogers' own modest imputation of unoriginality must be ignored since complete originality of letter design is of doubtful merit or even attainability; and the success of his endeavor is admitted when he says: "It will be seen that no claim for originality can be put forward for my type; neither is it an accurate reproduction of Jenson's letter. Having no reputation as a designer of types, I HAVE ENDEAVORED ONLY TO PRODUCE A CLEAR AND A LEGIBLE LETTER that may be used in printing either ancient or modern works without attracting undue attention to itself." Since an italic letter was required to accompany the Centaur and because Mr. Rogers considered himself incapable of designing a suitable one he selected, as a companion face, a type which Frederic Warde had ADAPTED FROM A LETTER OF THAT EARLY SIXTEENTH CENTURY MASTER OF WRITING,

10 POINT

I MASTERED THE ESSENCE OF IT, I DID NOT COPY IT SERVILELY; in fact my roman type, especially in the lower case, tends rather more to the gothic than does Jenson's." Morris was correct. His type was quite different. It might be doubted that he had ever seen Jenson's type except in a worn and over-inked specimen. But Morris did send his followers and disciples to his source. The most successful of these were Cobden-Sanderson and Emery Walker, whose Doves Press type is much CLOSER IN COLOR TO JENSON'S; BUT IN ADDITION TO ITS MONOTONOUS *evenness of modelling, it is marred by an eye-catching lower-case "y." In a nice-time, with errors of imitation only, I twist, in Bruce Rogers' struggles with the noblest Roman of them all. In 1902,* while at the Riverside Press, he produced Sir Walter Raleigh's "Last Fight of the Revenge at Sea," SET IN A TRIAL FONT OF THE TYPE WHICH LATER BECAME KNOWN AS MONTAIGNE

11 POINT

SEVERAL TIMES BY ROGERS IN BOTH ENGLAND & AMERICA. In 1929, matrices for all sizes, from ten to seventy-two point, were made by the English Monotype Corporation, thus for the first time making Centaur available to printers everywhere. Since then the smaller and odd sizes have also been issued. Although a typefounder's specimen seems an odd place for Carl Purington Rollins' pungent comment on the availability of Centaur, I *CANNOT REFRAIN FROM REFERRING TO IT HERE BECAUSE OF THE* implied challenge to its prospective users. I quote only in part: "Mr. Rogers' fine roman has now been cut for the monotype machine by the English house. This is a situation not AT ALL COMMENDABLE. ONE OF THE CONDITIONS OF MODERN PRINTING SEEMS

12 POINT

LUDOVICO DEGHLI ARRIGHI DA VICENZA. THIS TYPE IS known as Arrighi. Undoubtedly Mr. Warde's original intention was the creation of a cursive letter for independent use; that is, it was not meant to accompany a roman, and as such it offers great possibilities, especially when generously leaded. That it also happily combines with *CENTAUR GIVES THEIR POSSESSOR A DOUBLE-EDGED TOOL.* It was originally designed only in the size here shown in 16 point AND THERE IT APPROXIMATES, IN MY MIND, MORE EFFECTIVELY THAN

14 POINT

FROM ITS USE IN THE ESSAYS OF MONTAIGNE issued in 1903. The Montaigne seemed indeed a noble Roman, with none of the defects of its predecessors, or of its progenitor, but evidently not to Mr. Rogers. His dissatisfaction is better stated by himself: "The type known as Montaigne, but which *I HAD BEEN SO LARGELY RESPONSIBLE, HAD MET HIS* [Alfred W. Pollard's] warm appreciation; for in those days we all liked *heavier and cruder types than our reconsideration of the matter now leads*

16 POINT

TO BE THAT EVERY PRINTER, ANYWHERE, shall be able to buy any type face which exists, whether he knows how to use it or not. I am no believer in any kind of censorship, but I believe firmly in what James Truslow Adams has so recently pointed out in 'Harper's' *THAT WHICH EVERYONE CAN GET TOO EASILY ceases to have value for anyone." Nevertheless, counting the years*

18 POINT

ANY OF ITS FELLOWS, THE EFFECT OF the work of the great Venetian, Nicolas Jenson. A careful examination of individual letters will reveal *THAT, IN THE LARGE SIZES OF MR. ROGERS' Centaur the calligraphic qualities of the lower case become*

22 POINT

SOME OF US TO PREFER. IT MAY be that my eye reacted earlier than most from the type made popular in the nineties by the so-called revival of printing; at any *RATE MONTAIGNE SOON SEEMED TO me unsatisfactory, and I began to consider means for*

24 POINT

SPENT ON THE MONTAIGNE, it is evident that a great book designer and craftsman has devoted most of his *MATURE YEARS IN GIVING US A letter built on the best traditions of calligraphy*

30 POINT

MORE APPARENT & THE capitals are positively majestic. *ITS FAULT IS A VIRTUE & makes Mr. Rollins' concern trifling; it*

36 POINT

IMPROVING UPON it; but for various reasons *ALMOST TEN YEARS had passed before actual work*

42 POINT

& TYPEMAKING. This about Centaur *WAS WRITTEN BY Daniel Berkeley Updike:*

48 POINT

JUST CANNOT lend itself well to *COMPOSITION of the mean and cheap.*

This is 60-pt. Centaur. The largest Arrighi is 48-pt.

ABCDEFGHIJKLMNOPQRSTUVWXYZ

This specimen broadside, designed by Bruce Rogers, was set under his direction in the composing room of Mackenzie & Harris, Inc., Typographers & Typefounders, at 659 Folsom Street, San Francisco, where you now can obtain these types in all sizes, in fonts, cast in foundry metal, and in machine-set or hand composition to order.

The text is by Robert Grabhorn of The Grabhorn Press. The title word CENTAUR is a reproduction from original patterns used in making the matrices for Centaur. The initial and the designer's mark are from original drawings by B. R. This specimen is printed on Worthy Charta in October 1948 by Taylor & Taylor, San Francisco.

PHOTOGRAPHIC COMPOSITION

The weight and expense of lead alloy types induced composing machine manufacturers to develop new methods. The first approach was to encase a photographic negative of a character in a brass matrix for use in the existing form of the machine. Instead of metal jetting into the matrix, a beam of light shot through it exposes a strip of film at various degrees of enlargement. The film can then be used for making plates for printing, and the image is definitely sharper than that of metal type. Both the Intertype Fotosetter and the Monophoto have adapted their hot metal systems in this way. The Intertype Fotomatic and Fototronic machines, however, use punched tapes, originally pioneered by Monotype. Meanwhile the Mergenthaler Linotype Company's Linofilm uses a grid matrix similar to the Monophoto except that each character has a tiny shutter that opens on an impulse from a perforated tape. The genealogy of any of these machines is tangled, to say the least!

Each composing machine company has its own faces, although they overlap those of other companies, and many of these faces are available on the new photographic machines, with the additional advantage of full kerning. The European Lumitype, known here as the Photon, uses a whirling negative matrix disk and sophisticated electronic means of producing character images on film. The American Typefounders' Phototypesetter also operates with a disk.

For excellent descriptions of all the important contemporary composing machines I refer the designer to *Bookmaking* by Marshall Lee (New York: Bowker, 1965) and *The Composition of Printed Matter* by James Moran (London: Wace & Co., Ltd., 1965).

COMPUTER COMPOSITION

Eventually it will be possible for a device to scan a typewritten manuscript, feed its impulses into a machine and have camera-ready copy for an entire book spew forth in a matter of hours. Even today, vast indexes, concordances, and quarterly stock exchange price listings are composed on standard punch cards. When these are fed into a computer they can be automatically alphabetized and the print-out from the machine used as camera copy. In several plants, computers produce paper tapes which can be run into typesetting machines without the intervention of a keyboard operator to cast type slugs. Whether the brave new vision of such computers harnessed to television screens or to rapid multicopy devices will impinge on or supplant books entirely remains to be seen. In all likelihood they will continue side by side.

TYPEWRITER COMPOSITION

For works which because of cost might otherwise never appear typewriter composition is a possibility. The composition is done by any good typist on special machines such as the Varityper and the Composaline. Matter should be set flush left, ragged right, since none of these machines as yet offers satisfactory justification on a first typing. Pages are reduced photographically to sharpen the image. The carbon ribbon assures solid type characters. Many attempts have been made to adapt metal typeface designs to typewriters but have failed because of the limitation of letter widths. Perhaps IBM's Bold Face #2 face is clearest and least obtrusive. Typewriters, I feel, will increasingly supplement other methods of composition.

A main consideration in writing for the piano is that the piano "absorbs" sounds very well—it minimizes dissonant structures. Consequently, a chord which would be terrifying in its impact if voiced for brass will be mildly tingling when played on the piano. This fact can be turned around: much clear and clean wind instrument writing sounds weak when played on the piano. The piano is inadequate as the sole criterion of orchestral writing. It does not give a representation of the orchestra.

2-15. Typewriter composition for Bill Russo's *Composing for the Jazz Orchestra*, The University of Chicago Press, 1961. Designed by Adrian Wilson.

2-16. Intertype Fotosetter composition for a college textbook, *Psychology: A Scientific Study of Man*, by Fillmore H. Sanford, Wadsworth Publishing Company, 1961. Designed by Adrian Wilson.

serving as the center for the right halves of the two retinas of the two eyes and the left of the lobe as center for the left halves of the two retinas. Direct stimulation of these cortical areas produces visual sensation, and injury to tissues here can produce blind spots in the visual field. If one whole side of the occipital lobe is destroyed, the person will be blind in half of each eye.

A significant aspect of visual projection in the brain is that each point on the retina is represented by a corresponding point both in the thalamus and in the visual cortex. When light falls at a particular point on the retina, electrical activity can be recorded at the corresponding point on the cortex. Such a correspondence between the retina—and presumably the visual field —and areas of the cortex helps account for such psychological phenomena as space perception and the discrimination of complex patterns; there is no evidence, however, on the matter of specific brain processes connected with the sensing of such things as hue or saturation.

If the visual cortex of an animal is removed, he cannot make fine discriminations, as between a square and a triangle, but he can still tell the difference between the presence or absence of a light (Klüver, 1942). Such evidence suggests that the visual cortex is necessary for spatial discriminations but that intensity is registered at a subcortical level. We already have seen that the removal of the visual cortex in man produces total blindness.

The Auditory Centers

The projection areas for hearing are located on the temporal lobes at the sides of the hemispheres. Both ears are projected on both sides, so the destruction of one temporal lobe will reduce hearing only slightly. As is the case with vision, when electrodes are placed on the auditory center, electrical activity occurs at one place for low tones, at another for high; thus there is a topological correspondence between the brain and the cochlea. The thalamus and the midbrain, it will be remembered, also have auditory centers and these very probably play a significant part in auditory experience.

Sensory Input as Arousal

Physiological psychologists have, up until recently at any rate, been primarily interested in the

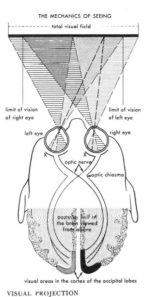

THE MECHANICS OF SEEING

VISUAL PROJECTION

Fig. 20-15. The visual field is projected very precisely on the visual cortex. Light waves coming from the right strike the lefthand side of each of the two retinas, and retinal activity is projected, over the optic nerves, to the left side of the visual cortex in the occipital lobe. A single point of light, acting on confined areas of the two retinas, activates a single, confined area of the cortex.

506 CHAPTER TWENTY

2-17. A page from the computer-produced *ISL Daily Stock Price Index*. The standard ruled form with headings is preprinted on rolls by offset lithography. After the statistics are punched on cards and imprinted by the computer the rolls are photographed to make offset plates for printing books.

156

	INTERNATIONAL SALT CO				INTERNATIONAL SHOE CO				INTERNATIONAL SILVER				INTERNATIONAL SILVER PF				INTL TEL & TEL					
	TICKER SYMBOL		THOUS SH OUTSTANDING		TICKER SYMBOL		THOUS SH OUTSTANDING		TICKER SYMBOL		THOUS SH OUTSTANDING		TICKER SYMBOL		THOUS SH OUTSTANDING		TICKER SYMBOL		THOUS SH OUTSTANDING			
	ILS		484		ISS		3688		INR		1362		INR PR		59		IT		18502			
	VOL	HIGH	LOW	CLOSE	VOL	HIGH	LOW	CLOSE	VOL	HIGH	LOW	CLOSE	VOL	HIGH	LOW	CLOSE	VOL	HIGH	LOW	CLOSE		
629	1	85	85	85	13	31-6	31-3	31-3	63	46-1	□44	46			39-4	40-4	49	57-7	□57	57-4	629	
30	1	84-7	□84-7	84-7	7	31-6	□31-2	31-6	20	45-5	44-7	45-1			39-4	40-4	49	57-7	57-5	57-6	30	
7/1	1	□85-4	85-4	85-4	34	□32-3	31-6	32-3	6	45-4	45	45-4			39-4	40-4	68	58-2	57-7	58-1	7/1	
2	5	85-4	85-4	85-4	24	32-3	31-4	32	25	□46-4	45-4	46-4			39-4	40-4	94	□58-6	58-1	58-6	2	
3		HOLIDAY				HOLIDAY				HOLIDAY				HOLIDAY				HOLIDAY			3	
	8	10.16		84-2	78	3.80		27-5	114	5.53		42-1					260	6.98		56-1		
6	2	85-4	□85-4	85-4	17	32-3	32	32-1	12	□47-2	46-5	47			39-4	40-4	68	□58-6	57-6	57-6	6	
7	2	□86	85-4	86	10	32-1	32	32-1	12	46-7	45-6	45-6			39-4	40-4	32	57-7	57-6	57-6	7	
8	3	86	85-4	85-4	40	□32-6	32	32-3	6	46-2	45-6	45-6			39-4	40-4	41	57-7	57-4	57-4	8	
9	1	85-6	85-4	85-6	21	32-2	□31-4	31-4	10	46-2	46	46			39-4	40-4	84	57-5	57	57	9	
10	5	86	85-6	85-6	7	32	31-6	31-6	32	45-6	□45-3	45-4			39-4	41	49	57	□56-4	56-4	10	
	13	10.15		84-5	95	3.73		27-6	72	5.44		42-3					274	6.74		56-2		
13	1	85-6	85-6	85-6	13	32-1	□31-3	32-1	11	□46-6	45-6	46-6			39-4	40-4	55	56-6	56-4	56-6	13	
14			85-4	86	20	32-5	32-3	32-3	7	46-5	45-6	45-6			39-4	40-4	86	56-6	56-4	56-4	14	
15	4	□86-4	□85-4	86-4	22	32-7	32-4	32-7	7	46-2	46	46-2			39-4	40-4	253	□57		56-4	56-5	15
16	3	86	85-4	85-4	46	□33-3	33	33-2	11	46-2	46	46-2			39-4	40-4	53	56-6	□56	56	16	
17	2	86	86	86	15	33-3	33	33	30	46	□45-4	45-4			39-4	40-4	25	56-3	56	56-2	17	
	10	10.09		84-7	116	3.92		28-1	66	5.46		42-6					472	6.61		56-2		
20	1	86-4	86-4	86-4	41	33-7	□33	33-7	8	□45-6	45-2	45-2			39-4	40-4	40	□56-4	56-1	56-2	20	
21	1	86-4	86-4	86-4	104	34-4	33-7	34-4	6	45-2	□45	45			39-4	40-4	41	56-4	56	56	21	
22	23	□86-6	86-4	86-4	46	34-4	34-2	34-3	8	45-2	45	45-2			39-4	40-4	87	56-1	56	56	22	
23	8	86-5	86-4	86-4	37	34-3	34-2	34-2	1	45	45	45			39-4	40-4	54	56	55-2	55-2	23	
24	3	86-6	□86	86	33	□34-5	34-4	34-4	8	45-4	45-2	45-2			39-4	41-3	75	55-3	54-5	54-6	24	
	36	10.22		85-2	261	4.05		28-3	31	5.32		43					297	6.53		56-3		
27	8	□86-4	86	86-4	47	□34-4	34-3	34-6	11	45-2	45	45			39-4	41-3	51	55	□54-3	54-3	27	
28	5	86-4	86-4	86-4	14	34-5	34-3	34-4	3	45	44-6	44-6	1	□39-4	□39-4	39-4	33	54-7	54-3	54-6	28	
29	14	86	85-6	86-4	12	34-5	34-2	34-2	8	□45-4	45-1	45-4			39-4	41	45	□55-2	54-7	54-7	29	
30	3	85-6	85-6	85-6	28	34-2	□34-1	34-2	6	45-3	44-6	44-6			39-4	41	38	55-1	54-6	54-6	30	
31	1	85-4	□85-4	85-4	18	34-4	34-1	34-1	5	45-1	□44-5	45-1			39-4	41	34	55	54-6	55	31	

Virtuosa	*Inebriate*	Perpetua	Tyger
Bembo	Inebriate of air am I, And debauchee of dew, Reeling, through endless summer days, From inns of molten blue. <div align="right">EMILY DICKINSON (1830–1886)</div>	Times Roman	Tyger! Tyger! burning bright In the forests of the night, What immortal hand or eye Could frame thy fearful symmetry? <div align="right">WILLIAM BLAKE (1757-1827)</div>

Optima	Pike	Walbaum	Blackbird
Trump Mediäval	Pike, three inches long, perfect Pike in all part, green tigering the gold. Killers from the egg: the malevolent aged grin. They dance on the surface among the flies. <div align="right">TED HUGHES (1930-)</div>	Waverly	O blackbird! sing me something well: While all the neighbours shoot thee round, I keep smooth plots of fruitful ground, Where thous may'st warble, eat and dwell. <div align="right">ALFRED LORD TENNYSON (1809-1892)</div>

Craw Clarendon	**Jabberwocky**	Thorowgood Italic	*The Yak*
Eldorado	'Twas brillig, and the slithy toves Did gyre and gimble in the wabe; All mimsy were the borogroves, And the mome raths outgrabe. <div align="right">LEWIS CARROLL (1832-1898)</div>	Caledonia	As a friend to the children commend me the yak, You will find it exactly the thing: It will carry and fetch, you can ride on its back, Or lead it about with a string. <div align="right">HILAIRE BELLOC (1870-1953)</div>

Grotesque No. 1 Bold	**The Eyes**	Palatino	Losers
News Gothic	Free us, for we perish In this ever-flowing monotony Of ugly print marks, black Upon white parchment. <div align="right">Ezra Pound (1885-)</div>	Aldus	If I should pass the tomb of Jonah I would stop there and sit for awhile; Because I was swallowed one time deep in the dark And came out alive after all. <div align="right">CARL SANDBURG (1878-1967)</div>

Union Pearl	*The Kiss*	Solemnis	**A TOAST**
Janson	"I saw you take his kiss!" " 'Tis true." "O modesty!" " 'Twas strictly kept: He thought me asleep — at least, I knew He thought I thought he thought I slept." <div align="right">COVENTRY PATMORE (1823-1896)</div>	Trajanus	Here's to ye absent Lords, may they Long in a foreign country stay Drinking at other ladies' boards The health of other absent Lords. <div align="right">Anonymous</div>

2-18. Examples of machine-set body types combined with different display types, mostly hand-set. The choice of faces depends largely on the individual designer's response to the atmosphere emanating from each poem.

TYPE CLASSIFICATION AND COMBINATION

The most useful ways for the designer to group typefaces are:

1. General use: book, jobbing, advertising, etc.
2. Setting method: hand-set, Linotype, etc.
3. Historical period: Venetian, Old Face, Transitional, etc.
4. Serif form: bracketed, square, hairline, etc.
5. Drawing style: calligraphic, engraved, brush, etc.
6. Weight: light, bold, etc.
7. Distortion: condensed, wide, fat, etc.

The designer will become familiar with the classifications just as he learns to know the faces of people. Through favorable or unfavorable reaction to book pages, some of which will be his own design, he will develop his preferences and his ability to identify many faces. It is the same process that builds discriminating choices in any field, whether in wines or works of art or people.

The safest course is to choose, when possible, the display face of the typeface used for the body text. But often it is a refreshing challenge to find a display type from a different series which, in combination, creates a richer whole. The farther apart the sizes of the display and body types are, the more freely one can break across historical or drawing classifications. Depending on the content the contrast can be more or less sharp. For an outrageous text it can be outrageous.

In the verses on the opposite page the headings and bodies have been set in types which I think harmonious or which contrast in ways that seem to me appropriate to the subject. Probably no two typographers would agree.

A	A	A	A
Centaur	Bembo	Garamond	Janson
A	A	A	A
Bulmer	Perpetua	Palatino	Optima

M	M	M	M
Centaur	Bembo	Garamond	Janson
M	M	M	M
Bulmer	Perpetua	Palatino	Optima

T	T	T	T
Centaur	Bembo	Garamond	Janson
T	T	T	T
Bulmer	Perpetua	Palatino	Optima

e	e	e	e
Centaur	Bembo	Garamond	Janson
e	e	e	e
Bulmer	Perpetua	Palatino	Optima

g	g	g	g
Centaur	Bembo	Garamond	Janson
g	g	g	g
Bulmer	Perpetua	Palatino	Optima

t	t	t	t
Centaur	Bembo	Garamond	Janson
t	t	t	t
Bulmer	Perpetua	Palatino	Optima

2-19. Some key letters with their contrasting characteristics which the designer's eye seizes on in identifying various type faces. Other factors such as weight, stress, serif form, etc., figure in any final determination, of course.

Size and Style of Type

wf // — Wrong font (size or style of type)
Repeat stop mark for each additional identical error in same line

lc // — Lower Case Letter

lc — Set in LOWER CASE or LOWER CASE

⏄ — Capital letter

caps — SET IN capitals

caps + lc — Lower Case with Initial Caps l.c + lc

sm. caps — SET IN small capitals

caps + s.c. — SMALL CAPITALS WITH INITIAL CAPS

rom. — Set in roman (or regular) type

ital — Set in italic (or oblique) type

L.F. — Set in lightface type

bf — Set in boldface type

bf ital — Bold italic

⌄ — Superior letter or figure[b]

/₂ — Inferior letter or figure₂

Position

⌐ — Move to right ⌐ } Ragged
⌐ ⌐ — Move to left } margin
center ⌐ — Put in center of line or page ⌐ ctr
⌐ — Lower (letters [or] words)
⌐ — Elevate (letters [or] words)
— Straighten line (horizontally)
fl L or // — Align type (vertically) Square up — justify — flush right and left
tr # — Transposes pace (transfer)
tr — Transpose enclosed in ring (matter)
tr // — Transpose (order letters of or words)
tr — Rearrange words of order numbers in 3 2 4 1
run over — Run over to next line. (A two-letter (di-over vision should be avoided)
run back — Run back to preceding line. (This divi-sion is incorrect)
reset — A syllable or short word stand-ing) alone on a line is called a
up — "widow"; it should be eliminated
up

Spacing

solid — Means "not leaded"
leaded — Additional space between lines
lead — Insert lead between lines
ℐ ld — Take out lead or tr lead
⌣ — Close up entirely; take out space
— Close up partly; leave some space
⌣ or ⌣ — Less space between words
✕ or eq # — Equalize space between words
thin # — Thin space where indicated hair #
l/s — LETTER-SPACE
— Insert space (or more space)
space out — More space between words
en quad — ½-em (nut) space or indention
⬜ — Em quad (mutton) space or indention
⬜⬜⬜ — Insert number of em quadrats shown

Insertion and Deletion

OUT
see copy — Insert matter omitted; refer to copy (Mark copy Out, see proof, galley 0)
the /l — Insert marginal additions
ℐ or ℐ — Dele — take out (delete) (Orig. ð)
ℐ — Delete and close up
stet — Let it stand — (all matter above dots)

Diacritical Marks, Signs, Symbols

ü — Diaeresis or umlaut
é — Accent acute è — Accent grave
â — Circumflex accent
ç — Cedilla or French c
ñ — Tilde (Spanish); til (Portuguese)
use lig — Use ligature (affix—ffi) Logotype—Qu
/ — Virgule; separatrix; solidus; stop mark; shill mark
⋎ — Asterisk * ⅋ — Ampersand &
⁂ — Asterism *⁎* Leaders........
⊙▢○▢○ — Ellipsis . . . or * * * or_____

Paragraphing

¶ — Begin a paragraph
no ¶ — No paragraph.
run in — Run in or run on
2 ¶ — Indent the number of em quads shown
flush ¶ — No paragraph indention
hang in — Hanging indention. This style should have all lines after the first marked for the desired indention

Punctuation

⊙ — Period or "full point."
∧ or ⸴/ — Comma ⊙ or :/ Colon
;/ — Semicolon
⌄ or ⌄ — Apostrophe or 'single quote'
⌄/⌄ or ⌄⌄ — Quotation marks "quotes"
?/ — Question mark or "query"
!/ — Exclamation point
-/ or =/ — Hyphen ēn or /en/ En dash
ēm or ⊢ — One-em dash ⊢2/em Two-em dash
(/) — Parentheses
[/] — Brackets (crotchets) } Brace

Miscellaneous

e/ — Correct letter or word marked
e/⊗ k/⊗ or ✕ — Replace broken or imperfect type
⊙ — Reverse (upside-down type or cut)
⊥ or ⊤ — Push down space or lead that prints
SP — Spell out (20 gr)
G? — Question of grammar
F? — Question of fact
Qu au: or ? — Query to author Qu ?
Qu Ed — Query to editor Qu Ed
A ring around a marginal correction indicates that it is not the typesetter's error. All queries should be ringed.
OK w/c
or OK a/c — OK "with corrections" Correct and print; no
or "as corrected" revised proof wanted
⌐ — Mark-off or break; start new line

MARKUP OF LAYOUT, TYPESCRIPT, AND PROOF

The indications used in markup are an extension of the ancient proofreader's symbols and are used by the designer to show exact type styles, sizes, and spacing. He ordinarily repeats his markup in three ways, in the margins of his layout, on any typescript pages for which he has done individual layouts, and in the general specification sheets that accompany his work. Once his layouts are made, he marks up the typescript pages to clarify any possible ambiguities. General type indications, sizes, and setting methods can be shown at the top of the copy page. The common practice of running lines or "strings" into the text to connect the marginal symbol with the appropriate point should be avoided. Indications should be made close to and in alignment with the copy so that instructions can be grasped quickly. Color coding for different typesetting methods and type sizes is useful. On the layout and copy, type names are written out completely the first time they are used, but they can be omitted thereafter if only the size is changed, or abbreviated following copy in a different face. Markup of the typescript for Monotype usually requires only the series number and letter. On both the layout and typescript the designer should markup for all spacing which is not clearly shown or which varies from an agreed upon general style.

If the arrangement of words in the typescript so

MARKUP AND PROOFREADING SYMBOLS IN USE

Type specification key: point size / (on) body size including extra leading / (on) line length or measure in picas, the setting method or foundry, type name, number, style, word spacing and letterspacing. If amount of leading is in doubt a smaller body should be specified with leading inserted by hand as shown in the last example.

LAYOUT	MARKED UP COPY	CORRECTED PROOF
THE DESIGN OF BOOKS	THE DESIGN OF BOOKS 10/16/6 Mono Bulmer, no l/s * * also abbreviated lsp or l#	½ pt # THE DESIGN ⟵ 2 pts ld OF BOOKS ½ pt #
THE DESIGN OF BOOKS	THE DESIGN OF BOOKS [ctr 12/14/6 Centaur 252E caps, l/s 2 pts optically * also written 12/14 × 6 or 12/14 / 6	ctr THE [wf DESIGN ↄ ec 1 pt ld OF ec 1 pt ld BOOKS ec ½ pt #
The Design of BOOKS	THE DESIGN OF BOOKS 12/14/6 Arrighi 252G ulc 12/14/6 252 F sc, l/s 1 pt opt.	The Design of reset 10pt 252G BOOKS X
The Design of Books	THE DESIGN OF BOOKS ‖ 12/16/6 Lino Janson u + lc *, 4/em wd # * also abbreviated ulc or caps + lc	The Design of Books [to align use kerning †
THE DESIGN OF BOOKS	l/s to 6 picas opt. l/s to color * THE DESIGN OF BOOKS 12/14 + 2 / 6 Lino Caslon Old Face or equivalent Mono or hand set * i.e. same amount optically as previous line	This is 10 pt Inland Caslon Reset 12 pt ATF Caslon 471 THE DESIGN OF BOOKS ec 2 pts ld ½ pt #

The

Rocky Mountain Journals

of

William Marshall Anderson

THE WEST IN 1834

EDITED BY DALE L. MORGAN
AND ELEANOR T. HARRIS

THE HUNTINGTON LIBRARY, SAN MARINO, CALIFORNIA

1967

30 pt
Goudy Hand tooled

24 Bulmer
letter #

14 Waverly sc
letter # 2 pt

11 Waverley
letter # 2 pt
18 Goudy
Hand tooled

differs from the layout that markup is extremely difficult, the matter should be retyped according to the line breaks and capitalization of the layout, but can be flush left whether the word groups are to be centered or not. The designer does not, of course, correct editorial errors, but should certainly call them to the editor's attention.

Numerical or alphabetical keying of subheads and other internal matter according to style and level of importance is often done by the editor before the manuscript is turned over to the designer. If not, the designer or markup man can do it himself, color coding for each type size. The numbers or letters can be indicated in circles in the margin with colored lines extending along the relevant copy. Then only a sheet of keyed type specifications or sample pages need be referred to by the typesetter.

When galley and/or page proofs are sent to the designer for correction he designates in the margins, in a similar manner as in typescript markup, any errors or changes in spacing or type usage which he wishes made. It is usually the editor's or printer's responsibility to incorporate these in the master set of proofs.

Diary

MARCH 13—SEPTEMBER 29, 1834

MARCH 13, 1834

68

Narrative

MARCH 11—JUNE 20, 1834

69

2-23. In the text pages the original Diary is set in italic facing the longer Narrative in roman. The additional space under the Diary allows the editors' Notes to be blocked at the bottom of the page for ready reference and creates a varying and relieving white space in each spread. Again the types and the inner margin have been clearly indicated.

Right:

3-3. Seventeenth-century printers working with candles on their crania. One worthy at the left is working the ink balls while the other is cranking out the type form with his left hand while releasing the impression bar with his right. A typesetter searches for a letter in the background.

3-1. A nineteenth-century English Albion Press with the royal arms as counterweight, perhaps in competition with the American Columbian which sported an eagle.

3-2. An eight-man offspring of the original cylinder press invented by Friedrich König, powered by steam and first installed at *The Times* of London in 1814. The type and wood engravings on a flat bed moved back and forth under rollers which coated their visages with tacky ink. Meanwhile the paper was hand-fed to cylinders which then rolled the sheets over the type.

3 Printing Methods

LETTERPRESS

At the beginning of the nineteenth century book manufacture stood almost where it had 350 years before. Gutenberg would have had little difficulty in performing all the operations of a printing house. But the nineteenth century brought radical changes.

The first improvement came in the construction of the press. About 1800, Lord Stanhope, of the illustrious family of politicians, military men, and intellectuals, had a screw press constructed of cast iron, the strength of which permitted the printing of two folio pages at a time. In the American-made Columbian press, also cast in iron, levers replaced the screw mechanism and a defiant eagle hovered jauntily above as a counterbalance. The ultimate development of the hand-press was the Albion, beloved of the private press movement, which stemmed from William Morris' Kelmscott Press of 1891-1898. Many private presses today employ Albions, Columbians, Acorns, Stanhopes, and even more ancient survivors. When printing on handmade rag papers their proprietors claim and often show superior results to any motor driven machine.

Cylinder Presses

However, to satisfy the ravenous appetite of the increasingly educated masses for reading, far more productive presses were required. Friedrich König, a former apprentice in a music publishing house in Leipzig, built a wood prototype of an iron press in which a cylinder rolled across the type. Not only was far less strength of impression required because only the fraction of the type form in contact with the cylinder was printed at any one instant, but the mechanism could be harnessed to a source of mechanical power, the newly invented steam engine. In 1806 König went to England and enlisted the support of the London *Times,* which then had a circulation of 10,000. By 1814 two of his steam-powered iron cylinder presses, incorporating inking rollers made of glue and molasses, had been secretly installed. They were able to turn out 1100 large sheets per hour and *The Times* said on November 29, 1814 that it "relieved the human frame of its most laborious efforts." Soon a press was devised that employed four feeders and four men at the delivery points and turned out 4000 copies per hour. *The Times* raved: "Such ease, rapidity, and accuracy united could hardly ever before be ascribed to any fabric constructed by the hand of man; neither is it possible, we conceive, for the printing machine to receive any further improvement." Improvement came, however, in the form of a press which fed the paper from a roll at 12,000 copies per hour. The printing surface was a stereotype which had been cast in a curved papier-mâché mold of the type form and wrapped snugly around the cylinder. This is basically the means of printing newspapers, many magazines, and very large editions of books today. There is perhaps no sound in civilization more exciting than one of these rotary behemoths starting up, especially when the matter being reproduced is of one's own design.

Before becoming too enthusiastic, we must remind ourselves that most letterpress books are still printed on elaborations of König's early models. To be sure, additional cylinders have been added, each with its own inking system so that multicolor work can be printed with one pass through the press. Automatic feeding and inking, dryers, anti-offset sprays (or set-off as it is better called in England—i.e., the transfer of ink from one wet sheet to the back of the following sheet),

and electric power have, of course, eased the burden of the pressman. There are even presses that print both sides of a sheet successively in one pass, though they are mostly of the rotary type. At the other end of the scale most proof presses, whether for galley or for reproduction proofs, are also of the cylinder type, but activated by hand.

Platen Presses

Despite the introduction of the cylinder press, some mid-nineteenth-century inventors continued to explore the handpress principle, a flat platen pressing the paper against the type form. The first models eliminated the clumsy tympan and frisket. In the Adams Press the sheets were separated by a bellows and fed by hand onto moving tapes. Then the type, inked by rollers, was raised by a knee joint to meet the paper, the mechanism being powered by steam. Sixteen book pages could be printed at once, and 6000 sheets per day. In another press the paper was fed directly to the platen, usually for small jobbing work like business cards and bill heads, and the type form positioned above earned it the name Upside Down Press. The closing of the press was activated by a treadle-powered flywheel. Later the bed and platen were placed vertically so that the type had less tendency to drop out, and one or the other was hinged at the lower ends of the supporting legs to impart a clamshell squeeze. But for better work, a heavier, parallel impression was required and a platen was invented that slid on lubricated tracks directly toward the form. This style of hand-fed press has been the workhorse of many fine printing houses which have produced some of the noblest limited editions of this century.

Photoengraving

The mid-nineteenth century also brought the invention of photoengraved plates, which tremendously stimulated the development of presses at a time when the use of photography was accelerating. It was found that a light-sensitive bitumen could be used to coat a metal plate which when exposed to light through a negative could be etched. A line could then be produced in relief. Next it was discovered that a tonal image, when photographed through a fine screen, resulted in dots of various sizes which the eye reassembled to recreate tones of corresponding density, i.e., the halftone process. Both forms of plates, or cuts, could be combined with type and the entire form stereotyped or electrotyped to make a solid printing plate, usable whenever a reprint was needed.

LITHOGRAPHY

Of the alternative methods to letterpress printing, lithography has had the broadest impact on the book. For the designer it has made possible flexible and extensive use of illustration combined with text and the reproduction of almost any art or photographic subject on textured book papers without appreciable distortion. Lithography has spurred the use of photographic composition and photographically prepared plates and has influenced their adoption in letterpress. In short, it has freed the designer from the strictures imposed by thinking in terms of the square blocks of typographic printing and allowed him to concentrate on composing his pages with the shapes of the images, whether art or type. This does not mean, however, that the discipline of the typographic book can be abandoned, that its underlying rhythm can be forgotten, but that fresh combinations, juxtapositions, and interrelationships of type and picture can be introduced.

Lithography, literally "stone printing," was discovered by Alois Senefelder, a young actor and playwright of Munich in 1798. In his attempts to reproduce his own dramatic works, Senefelder experimented with etching limestone. He describes his discovery as follows:

I had just ground a stone plate smooth in order to treat it with etching fluid and to pursue on it my practice in reverse writing, when my mother asked me to write a laundry list for her. The laundress was waiting, but we could find no paper. My own supply had been used up by pulling proofs. Even the writing-ink was dried up. Without bothering to look for writing materials, I wrote the list hastily on the clean stone, with my prepared stone ink of wax, soap, and lampblack, intending to copy it as soon as the paper was supplied.

As I was preparing afterward to wash the writing from the stone, I became curious to see what would happen with writing made thus of prepared ink, if the stone were now etched with aqua fortis [nitric acid]. I thought that possibly the letters would be left in relief and admit of being inked and printed like book types or woodcuts . . .

The test succeeded, but with crude results, so Senefelder continued his trials:

. . . it was natural that in my many experiments with such various ingredients I should observe that a mucuous fluid, as for instance the gum solution, resisted the adhesion of the greasy ink.

A sheet of an old book was drawn through thin gum solution, then laid on a stone and touched carefully everywhere with a sponge that had been dipped into a thin oil color. The printed letters took the color well everywhere and the paper itself remained white. Now I laid another clean white sheet on this, put both through the press, and obtained a very good transfer . . . I found I could make fifty or more transfers from the same sheet . . . and this process, depending solely on chemical action, was totally, fundamentally different from all other processes of printing. . . Could not a stronger material, perhaps the stone plate itself, be so prepared . . . ?

It could! But soon Senefelder was experimenting with coating metal plates with clay and chalk compositions to substitute for the cumbersome limestones. Later it was found that plates of zinc, iron, brass, and copper could be ground with pumice and chalk, wrapped around a cylinder, and produce results similar to stone. With the development of photographic emulsions the plates could be made sensitive to light and an image fixed by exposure through a photographic negative. The invention of a press in which the image first prints onto a rubber blanket, which in turn makes the impression, allowed the plates to wear much longer. It was first used on tin, glass, etc., and later on paper. From this invention the term "offset" was created, but "photolithography" better describes the modern process.

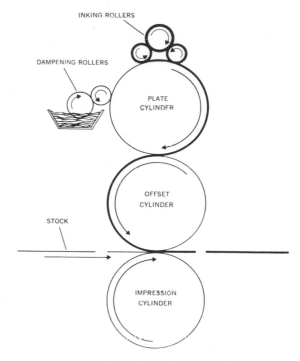

3-4. Diagram of an offset lithography press. The plate, carrying an image, is dampened and inked. The image transfers to the offset blanket which in turn prints the paper.

3-5. A contemporary rotary offset press fed from a roll, capable of printing four colors in one pass. The "web" is automatically cut into sheets and folded into signatures.

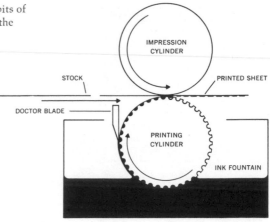

3-6. Diagram of a photogravure press. The recessed pits of the image in the printing cylinder (or plate) pick up the liquid ink. The blank areas are scraped clean by the doctor blade and the image transfers to the paper.

IMPRESSION CYLINDER

STOCK

PRINTED SHEET

DOCTOR BLADE

PRINTING CYLINDER

INK FOUNTAIN

PHOTOGRAVURE

As with lithography, a slowly developing accident led to the discovery of photogravure, the other rapidly emerging method of book printing. Intaglio or recessed copper plates had been combined with type for title pages and illustrations since the seventeenth century, but, among other factors, the necessity for separate impression from the type curtailed their use. In 1814 the inventor of photography, J. Nicephore Niepce, produced a metal printing plate with recessed lines by photographic means. He coated it with light-sensitive bitumen, placed an engraved print over it and exposed it to daylight. The areas of bitumen which had been unchanged because they were protected by the lines in the engraving were washed away with solvent, but the blank areas, hardened by the light, still remained and resisted the etching acid. A plate which accepted ink in its pits resulted and produced a creditable facsimile of the original print.

However, the problem of how to control the printing ink in the broad etched areas and evenly support a "doctor" blade which would scrape the nonprinting portions clean challenged many experimenters. In 1879, Karl Klic (or Klietsch or Klitsch), a Viennese photoengraver, discovered that a coating of asphaltum solved the problem. Later he substituted a fine screen to create cells of different depths in which the ink was held and produced a copper cylinder for use on a rotary press.

Today gravure is capable of printing on materials as varied as newsprint, foil, and metal. Its highly volatile inks are dry by the time the printed material leaves the press. For bookwork its popularity is due to its wide tonal range in photographic and art reproduction. Furthermore, reproduction of type has been greatly improved with the introduction of a 300-line screen. The best results have been achieved on sheet-fed presses, but roll-fed presses are increasingly used for pictorial books, provided the runs are in excess of 50,000. For the designer the process has great fascination, but he must be especially certain that his plans and specifications are precise. Changes made in a plate or cylinder, once it is etched, are extremely expensive, and often impossible.

OTHER PROCESSES

Although most often used commercially for greeting cards, posters, and textiles, silk-screen or serigraph printing has increasing relevance to the book. Opaque colors and metallics can be printed effectively on dark papers and binding materials at less cost than foil stamping. The introduction of photographically prepared screens has given surprising fidelity to the original image in all but delicate details. Several striking examples of the use of silk-screen printing are shown in Illus. 3-9, 6-16, and 7-5.

Collotype, or photogelatin printing, developed about 100 years ago, is now produced by only a few companies in the world, but the process is still unsurpassed for rendering the finest details of art and photography. See Illus. 11-24. No screen is involved. The printing surface, usually on a flat glass plate, is a light-sensitive gelatin which, when exposed through a film negative and soaked in water, accepts more ink in the darker areas and less in the lighter areas. Since the plates are fragile and the press speeds are slow, only small editions are practical. However, rotary collotype has been used successfully in Europe for large runs.

The application of electrostatic printing or xerography to books is an intriguing possibility, but at present the process is too coarse to render type and pictures with sufficient precision. Basically, an ink in dry powder form is charged negatively and adheres to a positively charged paper (or metal plate or drum and then to the paper) in the areas where an image has been projected. Copying machines such as the Xerox, so useful for reproducing typescript and designers' layouts, are being introduced in models which may eventually be competitive with conventional printing methods. Even

3-7. Section divider printed in metallic gold and white on dark blue Fabriano paper by silk screen. Numeral by Arnold Bank, book design by Adrian Wilson for Nietzsche's *Thus Spake Zarathustra*, The Limited Editions Club, New York, 1964.

presses large enough for book work have been built, but the first applications have been on rough materials such as corrugated cardboard, soft drink bottles and edible potato chips.

If I write at length on machines and processes in a book devoted to design it is because they govern the limits and potentials within which the designer must work. In some ways they have narrowed his horizons, in others broadened them infinitely. They have established the accepted standards, deplorable as they often are, of our books as physical objects. Their precedent will set the norm for the products of the faster electronic and photographic reproduction devices now being developed and used. If designers, publishers, and production personnel are not concerned, the standards will yet go down further.

We now have the ability to make a range of type sizes from a single or a few master patterns. We have the means to place type images in any juxtaposition with illustrative material on photographically prepared plates, whether relief, surface, recessed, or otherwise. We can print effortlessly on precision machinery in a virtual spectrum of color. But who is to say what is creative or cliché, taste-ful or tasteless, appropriate or abysmal? The designer is usually faced with a wall of silence once his book has appeared. The publisher rarely gets a complaint about the physical properties of his editions, or if he does he simply labels the copy defective and sends a replacement. The printer and binder are no wiser than before. There is not a decent critical review of bookmaking in the world today, alas.

It is futile, except for the private pressman, to go back to methods of elaborate makeready and scrutiny of each sheet, though the typographic image of machine printing may never be as satisfying as that produced on a hand-press by foundry type and woodcuts biting into a sheet of rich handmade paper. However, the advantages of contemporary reproduction of art media and breadth of distribution fulfill vital needs of our times and our peoples. Why, with our vaunted technology, can we not have both high physical and aesthetic standards in mass printing? Granted, the handmade paper mills have almost entirely disappeared and hand composition of texts is rare indeed; but it is possible for the book designer to build a bridge of taste, knowledge, and daring between the handcraft tradition and modern technology.

4-1. Four venerable watermarks in laid handmade papers. Top left, the chained unicorn of the J. W. Zanders mill, Germany. Top right, the hammer and anvil used in the papers of many Kelmscott Press books of William Morris. Bottom left, the stylized bull's head (or is it a crossed heart?) of the Moulin Richard de Bas, France. Bottom right, the elegant arabesque of Canson & Montgolfier, France.

4 Paper

By the year 1800 the extraordinary consumption of the presses required a matching source of paper. Fortunately, around this time the papermaking machine was invented by Nicholas Louis Robert, a supervisor at a French mill. Discouraged by the interminable bickering of the handmade papermakers, Robert in 1797 built a model of a machine that consisted of a woven wire screen revolving around drums and receiving a constant flow of rag pulp from a vat below. As the resulting sheet moved along with the screen it was given a side-to-side shake to further cross the fibers, which partially duplicated the shake of the hand papermaker and his wire mold. At the same time the water drained back into the vat and the crossed fibers remained on the screen eventually reaching an absorbent felt roller.

Robert's invention was immediately acclaimed and patented. He finally sold the patent to his sponsors, the Didots, but they lagged in their payments and Robert was forced to take back the rights. Meanwhile, the Didots had interested the London stationers, the Fourdriniers, in building the machine according to Robert's plans. No sooner had they done so and applied for English patents when the invention was widely plagiarized, resulting in their enormous loss. Its fate in America was no better: the second machine imported in 1827 was erected by a mechanical genius, Charles Spafford, who immediately copied it. Spafford's business failed, however, in the depression of 1837. The final irony is that such machines are not called "roberts" or "didots" or "spaffords" but "fourdriniers."

It was not long before the scarcity of rags to feed the machines became critical. Scientists had suggested wood fibers from as early as 1719 but no way was found to disintegrate raw wood sufficiently. In the meantime, every conceivable substitute was tried from asbestos to jute, from seaweed to caterpillar cocoons, from straw to the wrappings of Egyptian mummies. At last, in 1840 Friedrich Gottlob Keller patented a machine for grinding wood pulp, of which much coarse paper is still made.

For books, however, paper less subject to yellowing and disintegrating was needed. Several chemical processes were tried in the 1850's involving boiling chips of wood under pressure. In one method caustic soda was added to dissolve the impermanent intercellular material—the lignin, gums, and resins which hold the papermaking fiber, cellulose. This development was due to the enterprise of two Englishmen who, unlike König in the press field, found their countrymen insufficiently supportive. They came to America in 1854 and their process was used to make the first soda pulp paper at a mill in Pennsylvania.

In another process the action of sulphurous acid on wood was used to produce sulphite pulp paper. It was the accidental observation of the American chemist, Benjamin Tilghman, that the corks of soft wood in barrels used to store sulphurous acid became pliable and fuzzy. In his attempt to adapt this reaction to papermaking he was finally defeated by technical problems. However, in Sweden, England, Germany, and America, others working to produce sulphite pulp paper perfected the chemistry and the machinery, the necessary blowers, screens, beaters, suction boxes, calender rolls, and dandy rolls which impress the finish and "watermarks." Today the sulphite process and the sulphate process are the major means of producing book papers for the market.

4-2. A laid mold with the watermark of bent wire attached, and the deckle frame which supports the woven wire of the mold and provides the limits of the sheet or "deckle edge."

4-3. Three romantic watermarks in sheets of wove handmade papers. Top, a Spanish black letter exquisitely twisted in wire for a Catalonian mill. Center, a light-and-shade watermark made by pressing the mold between male and female dies, for the American authority on paper making, Dard Hunter. Bottom, a watermark for the prodigious San Francisco printer, John Henry Nash.

The designer's first concern in choosing paper is that it have a character and surface which pleases, that it evoke a positive response in the hand and to the eye. His second concern is that it be suitable to the printing method he has chosen for this book. Consulting the production manager or the printer should reveal whether the sheets under consideration feed easily on the press, absorb the ink well, do not have excessive show-through or off-set (setoff) the type image.

Machine-made paper categories include:

1. *Antique:* the soft, obviously textured papers made originally for letterpress, many of which are now surface sized for offset lithography. Two appealing varieties are wove and laid. The latter are really wove papers which have been passed through dandy rolls to impart the laid pattern of close-spaced wires across wide-spaced chain lines, and usually watermarks.

2. *Machine finish:* English finish and Super-calendered: papers which have varying degrees of smoothness.

3. *Coated:* papers which have been flooded with fine clays and adhesives to make them particularly receptive to halftones. They can be either dull, matte, or glossy. One variety is "clay cast" with especially high gloss for fine halftone and art reproduction, but it produces glare.

4. *Impregnated:* also known as pigmented or film coated, these papers are surface sized, lightly coated, and calendered so that they have a pleasant feel and still receive halftones well, especially by lithography.

5. *Text:* distinctively textured and colored varieties useful for limited editions, jackets, endpapers; they are generally deckle edge on the two long sides, usually 25 by 38 inches or 26 by 40 inches.

6. *Cover:* heavier varieties of text and other papers useful for pamphlet binding and paperback covers. Standard sizes are 23 by 35 inches, 25 by 38 inches, 26 by 40 inches, 35 by 45 inches.

7. *Moldmade:* papers made by machine resembling those made by hand, with deckle edges. Splendid ranges of colors and textures are available for binding sides, endpapers, jackets or, on occasion, whole books; there are deckles on two or four sides. Standard sizes are 20 by 26 inches, 26 by 40 inches.

In addition, there are still the handmade papers produced by a few mills in Europe and several hundred in Japan. The Western varieties are primarily those exquisite textures which were and are the staples of the great private presses. The Oriental examples are useful for volumes requiring an interior of tasteful delicacy and/or an exterior with an exotic flair.

Machine-made paper, like wood, has grain which must be considered in choosing stock for a book. Unless the grain is parallel with the spine, the pages will not turn easily or lie flat. Grain is designated in the paper merchants' catalogues with a small underline as shown below in some common sizes of book papers and the books which are made from them.

Sheet size	Book trim size	Common uses	Maximum form size
35 x 45″	5½ x 8½″	scholarly works	32 pages
38 x 50″	6⅛ x 9¼″	major nonfiction	32 pages
44 x 66″	5⅜ x 8″	fiction and minor nonfiction	64 pages
45 x 68″	5½ x 8¼″	major fiction and nonfiction	64 pages
35 x 45″	8½ x 11″	children's books, texts, manuals	16 pages
38 x 50″	9¼ x 12⅛″	art monographs, children's books	16 pages

I prefer not to answer for the novice designer what the distinctions are between major and minor fiction, or nonfiction.

Of course, horizontal shapes can be adapted to any of these papers. Common sizes are: 9¼ by 6⅛ inches out of 38 by 50 inch sheets, 8¼ by 10¼ inches out of 35 by 45 inch sheets, etc. And special makings can be had for odd sizes, colors, etc., if the quantities and time are sufficient.

Much concern has been expressed in the trade press about the impermanency of our papers. After World War II, especially, it became obvious that many book papers tended to yellow, brown, and disintegrate within a generation. The culprit was acid, and in recent years several mills have begun manufacture on an acid-free basis, a complicated technical change because the various coating and sizing processes which affect opacity were made difficult. We are now assured that under normal storage and use, as in a library, these newer papers will last many generations. At the same time the ease of reproducing existing books by offset lithography has made the value of absolute permanency questionable, at least in terms of perpetuating culture if not bibliophily.

The number of paper manufacturers and their distributors is so vast that I hesitate to mention any specifically. Their literature is boundless and their generosity with samples is munificent. One must acquire the taste to distinguish the appropriate sheet for a book and the strength to fend off the lures of others. Neither tone, texture nor thickness must be excessive, yet all three must be present to some degree. The illustration technique may determine the choice. For books primarily of type and line drawings, woodcuts, or old photographs, a warmth of tone and mellowness is desirable. But with contemporary photographs the paper must have a certain brilliance for the reproductions to approximate the original print.

For further information on paper the reader is referred to: *Papermaking, Second Edition*, by Dard Hunter, Alfred A. Knopf, New York, 1947; and *The Dictionary of Paper, Second Edition*, Published under the Auspices and Direction of the American Paper and Pulp Association, New York, 1951.

4-4. A jacket printed on characterful, inexpensive "oatmeal" stock, sometimes known as Dawnflake. For the book itself a 70-pound impregnated sheet was chosen, warm in color, without excessive shine and capable of rendering the finest detail in photographs and early engravings. Printed by offset lithography by The Meriden Gravure Company, Meriden, Connecticut.

5 The Anatomy of the Book

THE SEQUENCE OF PARTS

Despite the influence of the magazine, the cinema, advertising, and industrial design, the book in America has developed an order which, while not inexorable, should generally be followed. The book form in itself confers importance, distinction, and the implication that the text has been written, edited, and printed with authority and care. Its design should express the same authority and care as does the text, with the enhancement of graphic imagination and taste.

In the venerable tradition of the book there is a hallowed sequence of parts. Ordinarily there is a jacket, and inside the jacket, a binding and inside the binding there are endpapers. Glued to these endpapers with further invisible reinforcing is the body of the book. Its content traditionally follows the sequence listed below, together with the sides of the new pages on which they occur or begin. The right or recto is considered dominant, the left or verso is subordinate.

FRONT MATTER OR PRELIMINARIES	NEW PAGE
Blank Leaf or Leaves	
Bastard Title or Series Title	right
Advertising Card	right or left
Frontispiece	left
Title Page	right
Copyright	left
Dedication	right
Foreword	right
Preface	right
Acknowledgments	right
Contents	right
Illustration List	right or left
Abbreviations	right or left
Quotations (if separate pages)	right or left
Introduction (if not by author)	right

TEXT	
Half Title or Part One Half Title	right
Introduction (if by author)	right
The Text (including other Part Titles on rectos and Chapters on new recto or verso)	right
Illustration or Plate Section	right

BACK MATTER	
Appendix	right
Notes	right
Bibliography	right
Illustration Credits	right
Glossary	right
Index	right
Colophon	right or left
Blank Leaf or Leaves	

5-1. A playful bastard title spread for Apollinaire's
Basne Obrazy, Prague, 1965. Designed by Oldrich Hlavsa.

The Jacket

The jacket is primarily a small poster wrapped around the book which the bookseller can display in his store. Its immediate legibility and impact are vital. No longer can it be considered simply a "dust wrapper," a protection for the binding. Often it remains on the book throughout its functional life. In a surprising number of books reproduced in this text the jacket and the binding have become one.

The Binding

In its broad sense the binding is any means by which the leaves of the book are held together, protected, and at the same time permitted to be opened easily. Usually the binding carries an identification, from the simplest short title or author name to the elaborate poster of the paperback; it can be a work of art collected for its own sake. Whether for case binding or perfect binding, the leaves are usually gathered into signatures of 12, 16, or 32 pages because these are convenient for sewing and opening the book, and moreover, because the sheets are commonly printed in forms of 2, 4, 8, 16, 32, 64, 128 pages, etc. In the multiples above 16 pages the sheets are sometimes cut or slit apart before or after folding into signatures convenient to the type of binding. The leaves of the signatures are sewn together through the folds and to each other and then glued and reinforced at the back with a cotton mesh material called "crash" or "super." The group of signatures are then glued to the binding case, made of cardboard covered with cloth, paper or other materials. Although some paperbacks are sewn in the same way as books with hard-cover bindings, most of them have their folds at the back edge trimmed off and a layer of adhesive applied to attach the leaves to the spine of the cover (i.e., perfect binding). Whether or not the book contains identification on the cover, it should, of course, do so on the spine.

5-2. Stages in case binding. Left: sheets folded into signatures, gathered and sewed. Center: top, bottom and front trimmed, back rounded and glued, lining and head bands affixed. Right: case, prefabricated of cover boards and cloth and stamped and/or printed, pasted to endpapers.

Endpapers

Endpapers serve as a structural bond between the body of the book and the case. Therefore, the material must be strong and resistant to tearing and cracking. For the endpaper to be a good transition between the exterior and interior of the book it must be integral to the design of the whole, carrying out its color, typographic, or artistic themes. In contrast, a stark white endpaper between a warm, textured cloth and a mellow book stock has ruined many an otherwise well-designed volume.

Blank Leaf or Leaves

The first and last blank leaves provide a major physical support of the body of the book to the endpapers and hence the binding case. In order to have something expendable when the book is rebound, and perhaps to allow for personal inscriptions, more than one are sometimes included. In a subtle sense the awareness of the quality of the paper is established at this point. Commercial exigencies have steadily reduced the number and significance of these leaves.

Bastard Title (right-hand page)

This page is often referred to, incorrectly, as the "half title"; or, euphemistically, as the "false title" to identify it as the page immediately preceding the legitimate title page. From the standpoint of binding and eventual rebinding, the bastard title serves as an additional protection for the title page.

Advertising Card (new left-hand page)

The advertising card is a list of the author's works or of the works in a series. It can face the title page or can occasionally be placed on the blank back of a frontispiece.

Frontispiece (left-hand page, facing the title page)

In traditional bookmaking a pictorial page often appears facing the title page. In letterpress books it is often a plate printed separately and tipped in, i.e., glued in along an edge, or bound in as a two-page (single leaf) wrap with a ½-inch stub.

Title Page (new right-hand page or double spread)

The copy for the title page should contain the full title and, if any, a subtitle, the author's name, and sometimes the names of the editor, translator, illustrator, and on rare occasions even the designer. At the bottom appears the name of the publisher, if any, the place and the year of publication.

Copyright (left-hand page, verso of the title page)

For a book to be legally protected from plagiarism, it is necessary for it to carry on the title page or its verso a notice preceded by © giving the date and holder of the copyright. But its appearance on the title page is a sure sign of amateurism and adds clutter. Often other matter is grouped with the copyright notice, such as the Library of Congress Catalogue Card Number, the location of the publisher, co-publishers, restrictions on public use, the country of manufacture, the printer, and possibly the name of the designer, and so the full page on the verso of the title page is devoted to this material. The lines are best sunk to the bottom, to align with the bottom line of the normal text page and to back up the last line on the title page. Sometimes a short advertising card list or the dedication can appear on this page, if space elsewhere is severely limited.

Dedication

If possible the dedication should be a separate right hand page and, according to the whim of the author, may vary from the full blown poesy of Shakespeare's publisher, "To the onlie begetter of these sonnets" to, "For Mom."

Foreword (new right-hand page)

Usually conceived to be a short introduction by a recognized authority in the field, the foreword points out the special features and importance of the work. If the foreword runs more than one page the continuing pages should carry running heads and folios.

Preface (new right-hand page)

The function of the preface is to give the author's rationale for writing the book. If it is short and the author's acknowledgments are brief, the latter may be included at the end of the preface.

Acknowledgments (new right-hand page)

If the author's gratitude is boundless toward his aiders and abettors, and if their number is great, several pages may be devoted to listing their names and contributions in the acknowledgments.

5-3. A book designer trying to bite off more than he can chew. Linoleum print by Joseph Low.

Contents (new right-hand page)

The contents should include an accurate listing of all textual matter which follows it and the pages on which the parts of the book commence. It is especially important that, through spacing and grouping, the structure of the book can be easily seen. In British books it usually appears after the copyright or dedication, a placement which should be adopted in America.

Illustration List (a new page, right or left)

The illustration list should consist of the captions, or short versions of the captions if they are long, designated usually by arabic numbers, but in some books by roman numerals. In books with many illustrations printed with the text the indication might be by the page number followed by the number of the illustration on it, such as 243-3. When illustrations are handled as special sections, often called plates, or as inserts, printed separately from the text, they are often not numbered, and in the illustration list are indicated by a preceding phrase such as "following page 48 of the text." It is the designer's business to know and to tell the author and/or editor where such illustrations may be placed, since this is entirely dependent on the breaks in signatures. In certain books with illustrations requiring additional captioning, such as architectural credits, locations, details, photographers, etc., the list may be placed at the back of the book.

Quotations

At the beginning of almost any of the parts the author may wish to include quotations. Sometimes they can be given full pages; at other times they will follow the major heading.

Introduction (new right-hand page)

If the introduction is written by someone other than the author it is usually considered part of the front matter and treated typographically in the same way as the foreword and preface. Like them, its breakover pages should carry running heads and pagination in lowercase roman numerals, and the signature of the writer with the date and place of composition at the end. If, however, the introduction is by the author it would ordinarily be considered a part of the text. It might be preceded by a half title which exactly duplicates the bastard title used to herald the main title page. The arabic pagination of the book would begin with this half title page.

THE TEXT

Included within the body of the text are the half title, part title, introduction, chapters, all other part titles, and illustrations or plates, each of which is described separately.

Half Title (right-hand page)

This page repeats the book title, and is often identical with the bastard title. When the half title is used, usually after much preliminary matter, it precedes the first chapter opening to reinforce the beginning of the text proper. It can also be used to fill out the book to even signatures, or in a book divided into major sections, to announce the titles of the various sections immediately preceding their first text pages.

Part Titles (new right-hand page, or double spread)

If part titles consist of a title as well as the part number indication, they deserve at least a new right hand page. However, if they consist simply of the number, they can be placed at the head of the first chapter of the section, distinguished by space or by typography. The decision is sometimes dependent on the need for rounding out the book to even signatures.

Chapter Openings (new right-hand page for first chapter)

The major divisions of the book are usually the chapters, but if the text is divided into larger sections or parts, the chapters are still numbered consecutively from the beginning to the end of the volume. If there are not too many chapters and the book has classical allusions, or if the chapters contain numbered sections, roman numerals may be preferred. Otherwise arabic chapter numbers are more practical. In a book of monumental scale the chapters might all begin on a new right page, but ordinarily they may begin on either the recto or the verso, and in books with many short chapters, they may "run-in," i.e., begin on the same page as the end of the previous chapter.

Subheads

Chapter text may be divided into sections and subsections with headings of descending weight.

Extracts

Quotations from other works which are of such length that they are not run into the text are set off separately in some manner, either as an indented block, or by a different type style or size. One or two points less than the body size is usually enough to make a clear distinction.

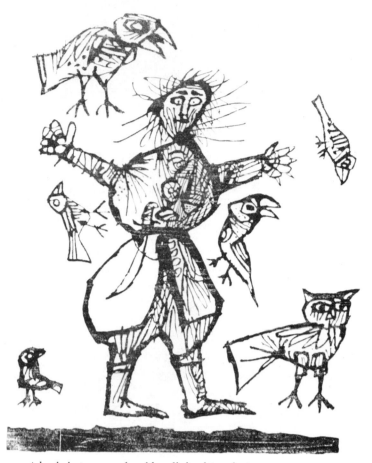

5-4. A book designer confused by all the things he is expected to remember. Linoleum print by Joseph Low.

Charts and Tables

Usually these are set into the body of the text but if very extensive they may be grouped as a separate section.

Footnotes

Footnotes are placed, naturally, at the bottom of the page and if long, may breakover onto the foot of the following, or even a third page. The makeup man or compositor will determine what proportion of the page will be text and footnotes, unless the editor or designer has made a dummy of the galley proofs. If the footnotes are extensive they are frequently placed at the back of the book under a section headed "notes," a location which very nearly insures that they will never be read but which allows the reader to follow the flow of the text without interruption.

Marginal Notes and Sideheads

Marginal notes (explanatory) and sideheads (as subheads or running heads) have a decorative as well as useful function. They are, however, expensive in page makeup and therefore are usually handled as footnotes, subheads, running heads, etc. The margin may also be used for numbering, for example, the chapters and verses in a Bible.

Illustrations

From the standpoint of sequence, almost any kind of illustration today can be incorporated close to the appropriate text matter. But in letterpress the sacrifice which the designer usually makes for this freedom is that smooth or coated papers must be used for the whole text. Therefore many letterpress books are still produced with the halftone illustrations printed on separate sheets of coated stock, and inserted, so that a more pleasing and often more economical paper can be used for the text. Line matter, drawings, wood engravings, and woodcuts, of course, can still be printed with the type matter on textured book paper, as they have been since the first years of printing. With offset lithography and gravure these limitations are solved, as they are with full page letterpress plates. The placement of separate illustrations is governed by the structure of the signature.

A B C D

5-5. As viewed from above: A, 4-page wrap; B, 4-page insert; C, 4-page tip; D, 2-page inside tip.

Appendix (new right-hand page)

This part of the book, consisting of documents, letters, and miscellaneous matter, is placed directly after the text.

Notes

Notes usually have the character of footnotes which, because of their extent, are placed at the back of the book. Often the section is divided into chapters, sometimes with the page numbers as subheads.

Bibliography

This listing of the books and periodicals, etc., which the author has used as source material or which he recommends as supplementary reading matter, is usually placed at the back of the book. The bibliography can, however, follow each chapter, and then is often headed "References."

Glossary

The glossary, a list of definitions of terms used in the text, is located in the back of the book. On occasion it can be usefully combined with the Index.

Index

Usually, the index cannot be made until the rest of the book has reached the page proof stage. It is therefore the last, or almost the last section of the book and serves to catalogue, with page indications, all the references which the author wishes to identify.

Colophon

This term has been corrupted to mean the publisher's or printer's device, which may be placed occasionally on the title page. Properly the word colophon refers to the inscription, appended to those books in which publisher, printer, and designer have special pride. They may wish to include in the colophon the identification of the book's type, paper, ink, and binding materials, to credit the manufacturers of these materials, and sometimes to proclaim the edition size to distinguish it from the mass product. If the edition is quite limited, a blank is often left for the insertion of the number of the copy and space for the autographs of the illustrator, printer, or designer.

Running Heads (at the top or bottom of text pages)

The main purpose of running heads is to tell the reader at which book, part, chapter, or other subdivision he is looking. They may enhance the pages from an aesthetic standpoint and aid the binder in the event of rebinding. Where the matter flows continuously from the beginning to the end of the text they are often omitted, as in novels or in books of poetry by a single author. Running heads are also omitted when they conflict with the design, as in the front matter, chapter openings, etc. For the sake of economy they are usually placed in the same line as the page number or folio. When running heads are placed at the foot of the page they are termed "running feet," useful in texts that contain many headings, such as poetry and cook books, and in books of photographs.

Page Numbers or Folios

Page numbers or folios are best placed toward the outer edges of the text blocks so that they can be easily seen, and for economy on the same line as the running head. For chapter or section openings the running heads are omitted and small folios placed at the bottom of the page. These numbers are called "drop folios." A folio appearing at the bottom of each page throughout a book is a "foot folio." In most trade books foot folios are avoided because they require an extra line of typesetting and extra care in letterpress printing.

The front matter of the book is often paged independently with lowercase roman numerals, since it may be set and paged after the text and much of the back matter have been completed. The extent of foreword, preface, and acknowledgments is frequently not known until well along in the production process. After this explanation, it may seem ridiculous that so few page numerals appear in the front matter. The blank leaves are usually called a, b, etc., so that the first numbered page is the bastard title. But the "i" is never printed on the page, though it may have been used there in proof form as an identification for the printer. Nor are roman numerals ever printed on the verso of the bastard title, the advertising card, the frontispiece, the title page, the copyright, the dedication or its verso. The first place one might come upon a page numeral is at the foot of the foreword if it carries over on to succeeding pages, and the same usage would apply to the preface and acknowledgments, with the succeeding pages carrying running heads and the roman numeral folios. The first page to take arabic numbering is the half title or part title, or if these are lacking, the first chapter opening page, where it might appear at the foot.

If this seems confusing and archaic it will be comforting to learn that many contemporary books are numbered with arabic figures beginning with the first blank leaf. A greater attempt is made today to get all the parts of the manuscript in at the start, and avoid the troublesome tag ends which resulted in the roman numeral system for front matter. Furthermore, consecutive arabic numbering from the start has the advantage of giving the buyer the illusion that he is getting a larger book for his money!

A typical pagination for both methods is shown below.

	Front matter paginated separately	All pages paginated consecutively	16-page signatures
Blank (1 leaf. 2 pages)	a and b	1-2	
Bastard Title or Series Title	i	3	
Blank	ii	4	
Advertising Card	iii	5	
Frontispiece	iv	6	
Title Page	v	7	Sig. 1
Copyright	vi	8	
Dedication	vii	9	
Blank	viii	10	
Foreword (2 pages)	ix-x	11-12	
Preface (2 pages)	xi-xii	13-14	
Acknowledgments (2 pages)	xiii-xiv	15-16	
Contents (4 pages)	xv-xviii	17-20	Sig. 2
Illustration List (3 pages)	xix-xxi	21-23	
Blank	xxii	24	
Introduction (not by author, 6 pages)	xxiii-xxviii	25-30	
Quotations (1 page)	xxix	31	
Blank	xxx	32	
Half Title (repeats Bastard Title)	1	33	Sigs. 3-10
Blank	2	34	
Part One Title	3	35	
Blank	4	36	
Text—Chapters 1-5 (124 pages)	5-128	37-160	
Illustration Section (16 pages)	129-144	161-176	Sig. 11
Chapters 6-7 (32 pages)	145-176	177-208	Sigs. 12-13
Part Two Half Title	177	209	
Blank	178	210	
Chapters 8-12 (124 pages)	179-302	211-334	
Appendix (8 pages)	303-310	335-342	
Notes (12 pages)	312-321	343-354	Sigs. 14-25
Bibliography (16 pages)	323-338	355-370	
Glossary (14 pages)	339-352	371-384	
Index (12 pages)	353-364	385-396	
Colophon	365	397	
Blank (3 pages)	366-368	398-400	

6-1A. The author of *Cities*, Lawrence Halprin, Reinhold, New York, 1963, in the happy situation of having the collaborating designer at his elbow. Photograph by Joseph Ehreth.

6 Design Approaches

The design of a book begins in the mind of an author. While he gestates the contents he conceives some idea of its form and internal structure. Often this will be based on an existing book or the distillation of many books. He may think of the book first in parts and chapters, although the organization of these segments may not be determined until he has finished. He may intend to use pictures interspersed throughout the text to illustrate particular passages, but he may be disappointed to find that illustrations may have to be grouped in sections far from the relevant text for technical reasons of process or material. Nevertheless, the text has, by its very completion, become an entity in itself. The designer's responsibility is to create through the design a liaison between author, publisher, and reader.

It is my thesis that to each designer every book has a particular personality and form. The ingenious book designer will search until he finds that personality and form and will give them fullest expression in his own terms within the limits of the publisher's plan and budget. Ideally, the designer will have an acute sensitivity to the nuances of types, their periods and their shapes, a concept of appropriateness of illustration styles, of the dynamics of space, of the evocative power of color, and the way in which paper can enhance these elements.

In the great majority of cases he will be dealing with a book devoted to text. One picture may sometimes be worth a thousand words, but one word is often worth a thousand pictures. Words can express philosophical and religious concepts, they can reason, they can move, they can outrage. They have as special a magic as do pictures and through their vast power have been the primary means by which our Western cultural and scientific heritage has been shared and carried forward.

Nevertheless, increasingly we are producing the kind of book that is predominantly pictorial or graphic, the book whose visually oriented author thinks in terms of the photograph or diagram and how it can be clarified in the text or caption. Today, this method has special currency and vitality because of the competition and power of television, the cinema, and the picture magazine. Contrary to the book in which the author prepares a complete manuscript this kind of book can be designed and illustrated before the text has been written. As in copy for advertising or magazine design the text can be written to fit the layout, often an exciting discipline in itself. The designer here becomes an active collaborator, as described on page 118.

6-1B. A finished spread from *Cities*, an example of the integration of text, illustration, and book design.

There are some excellent book designers of my acquaintance who practice with as simple tools as the itinerant Asian dentist who carries only a chisel, some pincers, and gold, and advertises his extracting abilities by wearing a necklace of teeth. A designer can function with only a pad of tracing paper, a ruler with pica and inch scales, a lead pencil with an eraser, a type specimen book, and a folder of samples of his printing designs. However, his tools must be varied enough to meet the level of rendering required to convince the customer, and they can be very elaborate. If he is separated from his publisher or printers by a continent or an ocean or two, his layouts must be extremely precise and his rendering as nearly foolproof as he can make it. He may need materials for color rendering the jacket, if that is part of the commission, or perhaps even a proof press.

In addition to the standard equipment of any draftsman's table, the book designer will need the following:

Printer's line gauge for picas and inches
Haberule Visual Copycaster with type gauge
Stabilo and China-marker pencils
Kneedable rubber eraser
Drafting pencils, 6B (soft) through 9H (hard)
Colored pencils, standard and erasable
Pastel chalks and pastel pencils
Spray fixative
One-coat rubber cement, dispenser jar, brush,
 dispenser can, thinner and pick-up
Opaque watercolors
Inks and pens
Gold Mark foil
Proportion wheel
Paper-cutter, hand operated table model, at least
 15 by 20 inches
Ink color sample books
Type Specimen Books and Supplements: Loose
 leaf specimens of text types with various leadings and of display types are especially useful.
 (See *Literary Market Place* for addresses.)
 The Merganthaler Linotype Company
 The Intertype Company
 The Lanston Monotype Company
 The Ludlow Typograph Company
 The Monotype Corporation Ltd. (England)
 Amsterdam Continental (European types)
 Bauer Alphabets, Inc. (European types)
 American Type Founders Company, Inc.
 Potential suppliers: book manufacturers,
 trade type composition houses, foundries

Samples
 Book publishing paper
 Text and commercial papers
 Imported and decorative papers
 Endpapers
 Cloths and other binding materials
 Foil stamping and headband materials

Books
 The Encyclopaedia of Type Faces, Third Edition, by W. Turner Berry, A. F. Johnson, and W. P. Jaspert (Pitman, New York, 1962)
 ABC of Lettering and Printing Types, 3 vols., by Erik Lindegren (Museum Books, New York, 1965)
 Preparing Art for Printing, by Bernard Stone and Arthur Eckstein (Reinhold, New York, 1965)
 Bookmaking, by Marshall Lee (Bowker, New York, 1965)
 Methods of Book Design, Second Edition, by Hugh Williamson (Oxford University Press, 1966)
 Studies in the Legibility of Printed Text, by Bror Zachrisson (Almqvist & Wiksell, Stockholm, Göteborg, Uppsala, 1965)
 Webster's Third New International Dictionary (G. & C. Merriam Company, Springfield, Massachusetts)
 Literary Market Place (R. R. Bowker Co., 1080 Avenue of the Americas, New York, New York)
 About Alphabets: Some Marginal Notes on Type Design by Hermann Zapf (The M.I.T. Press, Cambridge, Massachusetts, 1970)
 Manuale Typographicum by Hermann Zapf (The M.I.T. Press, Cambridge, Massachusetts, 1970)
 Printing It by Clifford Burke (Wingbow Press, Berkeley, 1974)

Depending on his taste, the type of book he is producing, and the level of finished rendering he presents to the client, the designer will surround himself with appropriate periodicals and reference materials, as well as his favorite tools. Frequent browsing in the art supply houses will reveal new working materials, and he can examine there, for example, the weights of tracing papers, acetates, etc., in order to select those most suitable to his work.

THE DESIGNER'S QUESTIONNAIRE

In accepting a commission to design a book, whether on a free-lance basis or as a member of a staff of a publishing or printing house, the designer should have answers to at least the following questions:

1. What is the audience for which the book is intended?

2. What is the price range in which the book is to sell?

3. What are similar or competing books in the field?

4. Are there illustrations with the manuscript? If not, can they be introduced?

5. What budget is allowable if special art work or photography is to be commissioned?

6. Can a second color be introduced? Is there a possibility of using four-color process?

7. Who is to print the book? If it is to be put out for bids, which firms are to be asked to submit quotations?

8. What types do the potential printers have available?

9. Would it be possible to introduce special types from other sources?

10. Would it be possible for the printer to introduce text composition matrices for a special or new type series?

11. What printing processes do the potential printers have available? Would combining processes be possible, such as gravure for illustrations with the type by offset lithography?

12. Does the publisher have a house style, or a device which must be used?

13. Is the manuscript complete and in good order? If not, when will it be available; or could tentative copy be supplied in the interim?

14. Is the wording of the book's title final?

15. Is the designer to do a character count to determine the length of the printed book? Must he keep the length to a number of pages already established?

16. If the book is heavily illustrated will the designer participate in the selection, placement, and scaling of the illustrations?

17. Who will give approval of the design? What foibles, preferences, or special wishes do the approvers have?

18. To what degree of finish should the layouts be rendered to assure approval?

19. When are the design and specifications needed?

20. At various stages of the book will the designer be given the opportunity of seeing proofs: sample pages, galley proofs, page proofs, folded printed sheets before binding, and a sample binding case, stamped and/or printed?

21. Will the designer's name appear in the book?

22. What is the projected size of edition?

23. Will a jacket be required and will the book designer be asked to do it?

24. What is the fee budgeted for design?

Most of the questions must have a satisfactory answer before a designer can take the responsibility for a commission. In working with or within a well-run publishing house he will have many points answered by standard policy in specification sheets from the production department or by an editor's checklist. Sometimes there may be answers only after years of working with a publisher, often with grief and soul-searching in the process. It will reward the designer to go over the list carefully at the inception of each commission. He can conscientiously undertake a work only if he knows that he will have all those areas which he considers vital under control.

6-2. With a sandpaper block a flat calligraphic point can be formed, particularly useful for rendering letters.

If the independent design of books is reputedly the lowest paid form of design work, the designer is as responsible as anyone. Perhaps he assumes that because he is creating a less ephemeral product than most graphic forms he is staking out a piece of immortality and therefore should be paid less. Furthermore he tends to sympathize with the publisher who, he feels, is in a highly speculative business. If the design does not help to sell the book, the designer feels that he may be responsible and so he accepts whatever is offered. But do the printer, the binder, and the paper maker think in this way? Certainly not, and the publisher accepts the ever increasing production costs. It is rare indeed that the designer who participates in a gamble has a share in the winnings if the book succeeds.

Design is basically an indispensable production cost, as is architecture to building, and should be figured as a percentage of the cost of producing the first and all succeeding editions. The amount should depend on the edition size and the production plan, at least 5 percent for trade editions over 10,000, 7½ percent for editions up to 10,000 and 10 percent for bibliophile and pictorial books. For reprints, 2 percent; and 3 percent for series in which the same design is used for more than three volumes. A similar fee schedule has recently been adopted by ATYPI (Association Typographique Internationale) and is making headway in Europe.

MAKING THE CHARACTER COUNT

The designer must begin with the character count in order to determine the number of pages the book will have with a tentative type size, line length, and the text block depth. The count includes punctuation and word spaces as well as letters. It is best done with the use of a pica ruler and an adding machine. The manuscript in hand, one hopes, has been typed on a single machine and is double-spaced. With the pica stick a vertical line is drawn at the end of the line having the average length on the first typed page. Measuring from the beginning of the typed line to the pencilled vertical one will give the length in picas. Since elite typewriter type measures two characters per pica, the average line length in characters is double the pica measurement. Pica typewriter type measures ten characters to an inch and is figured accordingly. A check must be made through the succeeding pages, with vertical lines drawn to assure the accuracy of the average line length.

The pica stick is again used to determine the number of lines to the page by placing it so that number 2 on the pica gauge aligns with the bottom of the first type line. With most double-spaced matter succeeding lines are two picas apart. The number on the gauge at which the bottom of the last line appears is then double the number of typed lines on the page. A count of lines must also be made of each page. The number of lines on each page of each chapter is multiplied by the average number of characters per line as determined in the preceding paragraph. If line lengths are noticeably different from chapter to chapter new averages must be figured. Often one finds a great variety of line lengths, page lengths, sizes of typewriter type, as well as the complication of extracts, quotations, footnotes, etc. These must be separately calculated and totalled. Totals are generally written out on a work sheet. The same work sheet is often used after the typefaces are chosen to calculate the number of pages of the finished book (Illus. 6-5). This would be dreary work except that it gives the designer the opportunity to become well acquainted with the matter to which he must give form.

6-3. Determining the number of characters per line in a block of prose. A vertical line has been drawn at the average length of the lines at the ragged right edge. Measuring with the inch gauge reveals that the typing has been done with pica characters at 10 per inch. Therefore we have 52 characters per line since the average runs two characters beyond the 5-inch mark. Multiplying by the number of lines would give the total characters: 12 x 52 = 624. The short lines of poetry are counted as full lines.

CHOOSING THE SIZE AND SHAPE

In many cases the publisher will dictate the size of the book to conform to one of his standard formats or to the books in a series. Even if the designer is to choose it himself he will still elicit a suggestion from the publisher. The scale may be influenced by several factors: the material, an effective size of type for the text, the publisher's budget, the character of the illustrations provided, the need for marginal notations or pictures. The designer must consider the length of the manuscript, whether it will require more than one volume, and how it will fit into the available paper and press sizes. In the list of common paper sizes on page 59 it will be noted that the most frequent book proportions are 2:3 and 3:4. Not only are these the most economical trim sizes but also the most attractive basic proportions. Nevertheless, the square format is especially useful for the photographic or art book.

6-5. Typical character count worksheet, with totals divided by the number of characters in a page of the chosen type size to determine the number of printed pages.

6-4. Precisely the shape the designer might want for a delicate subject. Sixteenth-century manuscript "Hjertebogen," The Royal Library, Copenhagen.

CHOOSING PROPORTIONS WITHIN THE PAGE

It is a basic principle of traditional bookmaking that for reasons of graphic clarity and rhythm, as well as economy, the typographic matter will generally occur within the same rectangle in the same position on each double spread. In well-made books the page blocks will be placed so that each type block on one side of the sheet backs up the matter on the verso. In fact, ideally each line of text should back up the corresponding line perfectly on the x-heights. This prevents show-through both of color and impression and gives the page a crisp clean look. True connoisseurs have been known to hold the pages to the light to ascertain the perfection of line back-up before judging any other aspect of the book! In commercially made books perfect back-up is rare indeed, and is an impossibility with certain complicated matter.

Several systems have been developed for establishing well-proportioned pages. Each is interesting to experiment with and each has its use in those rare cases where a classical feeling is desirable. Four of them are shown in the diagrams, page 72.

Although individually the systems have their claims to superiority, they do not provide for several practical factors and inevitably require the scrutiny of the experienced eye for final determination. For instance, the bulk of the volume affects the inner margin. Usually this margin should be increased with the number of pages and the weight of paper to make reading easier in the curves of the gutter. Only a bound dummy with sample pages pasted in will show exactly how much inner margin is needed. Layouts and specifications, however,

are needed before a bound dummy can be prepared, and so experience and reference to similar books are the chief guides. The weight of the type, its leading, and the way it is set—i.e., the closeness and evenness of word spacing—all have an effect. Also, the addition of running heads and folios requires subtle adjustments in the margins.

The main case against literal application of proportional margin systems, divine, geometric, or otherwise, is that we have become accustomed to a fuller page. Whether advertising design, where type is blithely run to within a hair's breadth of any trim edge, or paperbacks, where the margins are minimal, are the cause we cannot say. Today classical margins appear almost an affectation in a book intended for a broad readership. All we can offer is the recommendation that the margin be proportioned in a pleasing balance and that differences in height and breadth be obvious.

For most typical hardbound trade books today in the 6 by 9-inch size range a gutter margin of ⅝ inch is minimum. This margin is determined first and the others evolve from it. The top margin can be the same width because when the book is bound the gutter margin appears narrower. Rather than skimp on the outer and bottom margins the designer should consider reducing the body type size to meet the publisher's page limit.

6-6. Four methods of arriving at "nonarbitrary" margins, based on page proportions of 2:3 and used by the best scribes and early printers. The first two, A and B, were rediscovered by Jan Tschichold, the third, C, by Rosarivo, the fourth, D, by van de Graaf.

CHOOSING THE TYPEFACE

Now the designer, with measurements in hand and proportions partially decided must choose a typeface, or faces, which will express the essential quality of the text, will suit the page dimensions and please the eye, at least of the designer. He will need to have copies of the type specimen books of the major book manufacturing plants and he may take the opportunity to evaluate and assess the appearance of pages of many books in his own library before he makes his choice. The problems are more specifically discussed in the chapter on typography.

AVERAGE CHARACTERS PER PICA FOR VARIOUS SIZES OF MACHINE SET TYPE

LINOTYPE	8	9	10	11	12	14
Baskerville	3.15	2.9	2.6	2.43	2.32	2.05
Bodoni	3.07	2.83	2.55		2.36	2.14
Caledonia	3.07	2.83	2.57	2.43	2.28	2.04
Caslon Old Face	3.1	2.95	2.78	2.41	2.21	1.94
Electra	3.2	2.88	2.68	2.5	2.4	2.18
Fairfield	3.15	2.95	2.75	2.58	2.43	2.23
Garamond 3	3.23	3.03	2.85	2.68	2.58	2.3
Granjon	3.35	3.07	2.88	2.67	2.47	2.26
Helvetica	3.07	2.74	2.46		2.06	
Janson	3.03	2.75	2.57	2.43	2.33	2.11
News Gothic	3.02	2.87	2.61	2.44	2.21	1.88
Optima	3.3	3.1	2.77		2.52	
Palatino	3.0	2.77	2.57		2.21	
Scotch	3.05		2.68	2.52	2.24	1.89
Times Roman	3.08	2.85	2.68	2.5	2.33	2.15
Waverly	3.11	2.73	2.56	2.34	2.13	1.8

MONOTYPE	8	9	10	11	12	14
Baskerville 353	3.2	3.05	2.72	2.48	2.28	2.12
Bembo 405	3.5	3.2	3.1	2.8	2.6	
Bell 402	3.4	3.0	2.8	2.6	2.4	
Bulmer 462	3.3	3.05	2.8	2.62	2.5	2.24
Centaur 252	3.7	3.5	3.2	3.0	2.8	2.4
Fournier 403	3.6		3.1		2.6	
Garamont 248	3.4	3.02	2.7	2.43	2.22	1.97
Janson 401	3.27	3.1	2.78	2.58	2.33	2.08
Perpetua 239	3.6	3.3	3.0	2.8	2.5	2.2
Times Roman 362	3.2	3.0	2.75	2.5	2.2	1.9

Note: Since the figures above vary with the individual operator or plant, the designer can only approximate the length of the book.

DETERMINING THE LENGTH

At this point the designer will draw out on tracing paper a double spread basic text page showing the tentative area of the type block on the page including running heads. By measuring the width and number of text lines he can compute the number of characters which will fit into this area. The number of characters per pica often given by the printer's specimen book, is multiplied by the line length. This figure is given directly by the Haberule (Illus. 6-7), and the result is multiplied by the number of lines in the page. Charts in some book manufacturers' type specimens give the full page figure too, but the average characters per line are often somewhat less than the Haberule shows and than the number given by a close setting line. This total number of characters per basic page is then divided into the total character count for the book. The result is the number of full pages of straight text. To this must be added the number of chapters to allow blank space for the beginnings and ends of chapters.

For extracts and footnotes, depending on the typeface chosen, calculate the number of characters in a full page and find the quantity of full or part pages needed. To each of these add the amount of extra space required for each separate entry; for extracts, say, allow one extra text line per entry and the same for footnotes, etc. Subheads must be considered too, unless they have already been counted in the text along with their surrounding space, which happens to be equivalent to what the designer wants in type. All these text pages are added to the front matter and back matter, estimated or existing, in accordance with the work sheet sample (Illus. 6-5).

6-7. Finding the number of characters in a line of type 23 picas long with the Haberule Visual Copy Caster.

MAKING THE LAYOUTS

The design for a book should include a representative layout for each page that presents a different problem. Since every page is viewed with the page opposite in the finished book, the layouts should be presented as facing pages or double spreads. As well as the presentation to the publisher they are the "blueprint" for the printer. The designer strives for a design scheme that will standardize the elements involved in order to reduce not only the number of layouts he must make but also the complexity of the composing room operations.

Thumbnail Sketches

One of my first typographic design commissions was for the renowned European architect, Eric Mendelsohn. When I presented my laborious layouts to him he glanced at them, shook his head and roared, "You suffer from the same fault as the rest of your countrymen. You do not sketch enough!" He took a roll of cheap yellow tracing paper, quickly drew some lines with a soft pencil at very small scale, ripped off the sheet and handed it to me. "There is your design! Better, isn't it?" I had to admit that it was, despite the days I had spent on my meticulous rendering. And I never forgot the lesson: to realize the power of a quick small sketch in forming a broad concept.

In book design every problem should be approached with thumbnail sketches, by which a gamut of possibilities can be explored until a satisfying solution emerges. At first I work loosely on a pad of tracing paper. I roughly draw page outlines at about one-third scale. The title page is a good place to start. I find that I first sketch whatever occurs to me as a possible major focal element, either a type line or some artwork which I place in the upper area of the page. A straight line represents type, more or less heavy according to its emphasis, a free linear form indicates a graphic shape or drawing, a rectangle with a squiggle or some flat tones in it represents a photograph or painting. With these elements I build up a composition to reflect the copy, and keep in mind the need for balance and variety of forms and spaces. If the page outline conflicts with any element it is a simple matter to erase it and redraw the rectangle. Of course, the proportions of the text block as already established for estimating have to be considered, and the composition is usually made to fall inside its limits. Sometimes I may hit upon a solution on the first try; at other times many sketches are needed to reveal the best choice.

Sometimes, sketching different letterings and arrangements, I begin with the title itself. In desperation I may even set some lines of type and pull proofs on the press. Working in the rich three-dimensional medium of type, paper, and ink can clear many a bottleneck. It is regrettable that so few designers have access to the tools and the practice of printing, which seem to bring one back to essentials. Whatever means are used to arrive at a design, the underlying concept must have strength, balance, and something unique about it. This can best be recognized in the thumbnail sketch and evaluated quickly against other schemes before hours of full-scale renderings are done.

Once a promising title page thumbnail sketch has been achieved, the rest of the book can be sketched out in small scale. The method I use is to put as many double spreads as will be needed in the full-scale layouts on a sheet of layout bond. For example, a dozen spreads for a 6 by 9-inch book can nicely be accommodated at one-third scale on a 14 by 17-inch sheet. I then lightly rule the page and text block limits with T-square and triangle and assign the copy to the spreads. Then using ruled lines, I draw in the title page and perhaps even the words of the title. Next the chapter heading is sketched as a variation on themes begun in the title page. Here the sinkage of both the heading and the text block on the chapter openings is established and lightly ruled across each spread, so that a guide is given for the foreword, contents, introduction, etc. In this way a complete picture of the book is soon revealed and any changes can easily be made.

In fact, such a set of thumbnails plus the specifications and precise manuscript markup might be sent to the printer and result in a satisfactory book. But there are usually many details which must be handled at full scale. Compositors make hard use of the full-scale sheets to check their makeup and they come back liberally fingerprinted. Both client and designer prefer to see the design in production size.

6-8A. The first thumbnail approach to a title page spread for *The Oresteia* of Aeschylus. The racing chariot is from a Greek vase painting as is the key motif border.

6-8B. The second thumbnail sketch using one of illustrator Michael Ayrton's first paintings for the book. The heavy Sistina type has replaced the lighter roman of the first sketch to balance the strength of the artwork.

6-8C. An attempt to work three segments of Ayrton's illustrations into a simpler O form with the exotic Codex type. Finally it was decided not to run any illustration in the O and to design a special hand-lettered uncial for the title and other display lines. For the result see pages 142-144.

Bastard Title

Title

Freedom
School
Poetry

Foreword

Foreword

Contents

Contents

Opening of Poems
Example of Untitled Poem

Poems with Titles

Night Flyer

Lonely

Copyright Dedication

End Contents Paintings
Same layout for 3 other painting pages

November 22, 1965

Breakover Poem

6-9. A set of thumbnail sketches for *Freedom School Poetry,* written by students in the summer program sponsored by the Student Nonviolent Coordinating Committee (SNCC) in the South. Economy was essential since the materials and printing processes were to be donated. In the end more urgent matters in the Civil Rights movement intervened, and the book never appeared.

The question in the designer's mind when he begins his layout work is how far to go to convince the client. He should never do more work than will assure cheerful acceptance and be properly paid for, but he must do enough to prove his points. If the layouts are intended only for the publisher's production office or the printer's use, the simplest are the best: rectangles representing text blocks and illustrations, abstract shapes for nonrectangular forms, and rapid but accurate sketching of the letters for headings, etc. The diagrams must be precise enough for estimating and composition. The specifications accompanying the layouts should confirm the major details written on them and add any other vital statistics.

For more elaborate rendering, major type lines, chapter titles, for example, can be traced or drawn to suggest their final appearance. One must capture the essence of the letter, the contrast between thick and thin, the serif form, the weight. Secondary lines such as subheads can be drawn more quickly but still should give the effect of the typeface to be used. Blocks of text are represented by ruled double lines according to the "x" height of the chosen type. The first lines of chapters should be lettered in as well as running heads and page numbers. Pencil or pastel crayon representations of typical illustrations are drawn. (See page 86 for other levels of illustration rendering.)

For the Chairman of the Board only the most finished work is presumed to be presentable. I have seen comprehensive dummies for the purpose of snaring a publisher so carefully lettered, text lines so ingeniously "greeked" or "noodled" (that is lettered without using actual words) and pictures so perfectly faked that it would have been cheaper to set type, have cuts made, and proofs pulled! It is really a matter of feeling one's way with each client and deciding what will captivate and convince.

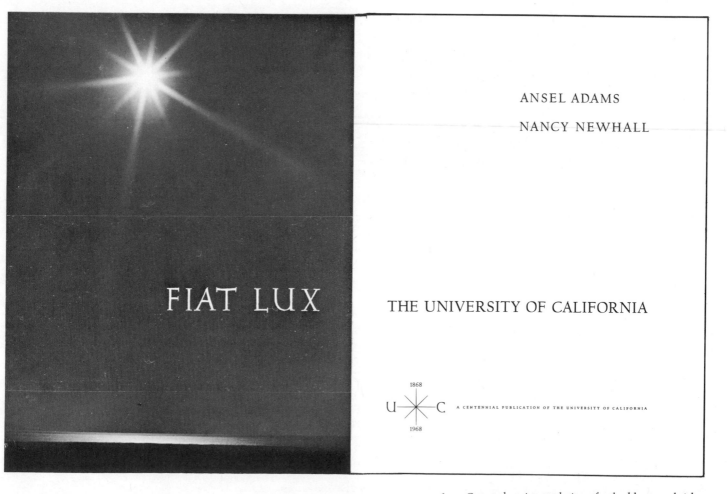

ANSEL ADAMS

NANCY NEWHALL

FIAT LUX

THE UNIVERSITY OF CALIFORNIA

1868 U ✳ C A CENTENNIAL PUBLICATION OF THE UNIVERSITY OF CALIFORNIA 1968

6-10. Comprehensive rendering of a double-spread title page, the white lettering painted on an acetate sheet laid over a proof of the photo. The right page is a proof from type. Weiss Series I Initials and Goudy's University of California Old Style (Monotype Californian). Design by Nancy Newhall and Adrian Wilson.

BASIC TEXT DOUBLE SPREADS

The double spread originally drawn up for determining the length of the book can be further developed into the basic layout which shows the text grid, the running heads, folios, major subheads and extracts. A second text double spread layout can show such additional features as footnotes, descending levels of subheads, and typical illustrations. First the designer plots the running head in the established text area. If its type is to be the same face as the text it should be set in a style which is definitely distinguished from the text, for instance, italic, or small capitals, or capitals with small capitals. If the same style is also needed for subheads one can use a different size for the running heads, or letterspace small capitals, for instance.

If one is using transparent tracing or layout paper, the simplest way to plot the "x" height is to place a loose-leaf specimen of the body type, set with the desired leading, under the layout sheet and lightly rule guide lines. The lettering is then sketched in, not tediously by tracing each character but quickly, yet carefully according to the widths of the letters. I use a chisel-pointed pencil if the type is of calligraphic ancestry, pointed if not, doubling the lines for thick strokes. Then, if the body type size is assumed to be the same as the running head, the specimen is moved down slightly to give the desired space between the running head and text, and double lines are ruled to form the text grid. If projecting guide lines are distracting I banish them with the kneaded rubber eraser. Alternatively, one could begin by drawing the guide lines on the back of the sheet and erasing them after lettering so that the type line stands free as it will on the printed page.

If one is working on opaque paper, however, such as that used for more finished presentations or for a combined double-spread layout and file folder, the "x" heights are plotted with the point scale or line gauge. Another method is to use dividers, as shown above, and it has advantages when loose-leaf specimens of the chosen type are not available. One ticks off in pencil the top "x" height for each line in the text block. The base of the "x" can be marked by moving the gauge down the exact measure of the "x" height. All these marks for establishing the grid should be made along the far left edge of the left text block. The double lines representing type lines are then ruled.

6-11. Measuring the x-height of a type with bow dividers. The setting is then pricked with the points into the layout.

6-12. Measuring the ascender height. The setting is usually pricked into the layout sheet to establish the x-height base line for the running head or first line of text.

Having solved the text page problems, the designer can approach the title page. Here he can establish the typographic and decorative themes of the book. If he allots a double spread for the title page he will find ample room for his graphic flights, but he must meet the challenge of the gutter division in some unifying way. Often the frontispiece material can be used graphically in combination with the title page copy. Ordinarily, however, the single right hand title page is demanded by the text itself. For instance one does not throw in a double-spread title page for *Tatting in the East Midlands*, but one might do so for *Space, Time and Architecture*. Depending upon the audience to which it is addressed, the title page should carry the period, the scope, and the temper of the text. A book on brain surgery demands a clinical precision, a book on Chaucer should reflect the Middle Ages. But these associations must be subordinate to the fact that the book is designed by a contemporary man for the modern world and produced by today's methods. There is, of course, the special area of limited editions or those produced by hand primarily for collectors, where deliberate "period pieces" are frequent.

On the title page the designer may wish to adapt elements from the illustrations or evolve graphic devices, but usually the title itself must be dominant. If the title is long and cumbersome the designer may dare to suggest a change, but this is rarely accepted. Above all the designer must be sure that the wording of the title is firmly set before making his final layouts. A change of title after the design is complete can be costly, and if the title is in doubt the designer should go on to the chapter openings.

On the title page the designer will determine whether the design scheme throughout is to be centered or asymmetrical, bold or restrained, elegant or rugged. His use of space on the title page will be reflected in the rest of the book. The composition may be conceived in long flowing lines and open spaces, or in compressed vertical structures. Whatever is done should be done with flair and conviction.

6-13. Chapter opening for *The Pyramids* by Ahmed Fakhry, The University of Chicago Press, 1961, using a hieroglyphic panel and Codex type for the headings, themes carried throughout the book. The text type is 11/13 Monotype Bembo. Design by Adrian Wilson.

The first chapter opening is on rare occasions treated more elaborately than the others. It can vary from displaying a monumental initial as in the medieval manuscript to involving cuts and devices or simply to making the statement of the chapter number or title. In any case it should reflect, in less forceful fashion, the design theme set up in the title page. If an initial is desired to begin the first paragraph it can be one of three varieties: a drop, a stick-up, or a marginal initial. Since the fitting of any of these is a finicky and often costly matter, they are best avoided in low budget books. Sometimes attention is drawn to the first word or phrase by the use of capitals and small capitals, occasionally letterspaced. Ordinarily the first line of the first paragraph should begin flush left, and the following paragraphs should be indented. The amount of indention of the latter is usually 1 em, but when the line measure goes beyond 30 picas a greater indention is needed, for example, 1½ or 2 ems.

At the point when the layouts for the basic text double spread, the title page, and the chapter opening have been done sample pages are often ordered for the publisher's scrutiny. Even the author may be allowed to examine these.

6-14. Dramatic double-spread title page by Alvin Eisenman
for *Eero Saarinen On His Work*, Yale University Press,
New Haven and London, 1962.

6-15. Title page for *The Pyramids*. A triangle of tan Fabriano
paper, folded and tipped in, with hieroglyphic panels printed
on one side and a photograph of a pyramid on the reverse.

Front Matter

BLANK LEAVES

The blank leaf or leaves at the beginning of the book do not, of course, present a layout problem, but they provide a moment of rest and anticipation after the force of the jacket or binding and before the usually subdued announcement in the bastard title of what is to come. The verso of the last blank leaf appears on the same layout double spread as the bastard title.

BASTARD TITLE

This page subtly announces the typographic style of the book. It is intended as a discreet calling card presented to the reader before the door is opened to the title page. In modern times the bastard title is often considered an archaic vestige of a more courtly era and is omitted, a distinct loss. Here the designer will show in a modest size, either the text or the display type to follow, with perhaps a foretaste of the type of illustration to be included. The placement of the title line, usually the only element present, is traditionally high on the page, perhaps about the level of the chapter title. This page must relate harmoniously to the title page in position and character. Its layout is on the right hand page facing the verso of the last blank page.

6-16. A dastardly bastard title for two Aesop fables printed by the Gaberbocchus Press, London. Drawing by Franciszka Themerson. For the cover see page 147.

ADVERTISING CARD

Usually this matter should be set smaller, and certainly not larger than the text size of the book. Taken into consideration are the number of lines of copy and their consequent weight compared to the title page. Titles by the same author are usually set in italic, and a series title perhaps in small capitals. The card may sometimes be placed on the copyright page but generally it appears on the right page after the bastard title or on the verso of the latter.

FRONTISPIECE

This illustration, sometimes the only one in the volume, also can be a foretaste of others to come, or a guarantee that the author is, or was, flesh and blood. Its heritage is long, honorable and rich. Occasionally it quietly smothers the title page opposite, although it should not; and sometimes it is placed crosswise so that the reader is annoyed before he has even encountered the text. At times it is impossible for the frontispiece to be given a graphic unity with the title page, and the designer must cunningly try to relegate it to another part of the book. Usually, however, the illustration can be well integrated into the design scheme on the double title page spread.

COPYRIGHT

The copyright is customarily set in small unobtrusive type in comparison with the type of the text, apparently on the assumption that the fine print does not need to be read and that the printer and designer, who are sometimes listed here, are modest men. On the double-spread layout it is always on the left page, the verso of the title page, and often faces the dedication or contents.

DEDICATION

Obviously the dedication is no place for flamboyant typography or an abundance of graphic art, but the designer carried away by sentiment might be forgiven for including a bouquet or flourish. The dedication is nearly always on a right hand page. If space is very limited it can be placed at the top of the copyright page.

FOREWORD

The designer usually should designate the same type size for the heading words "foreword," "preface," "acknowledgments," and the parallel ones in the back matter. He may also use the same size for the chapter titles. The beginning of the foreword, whether it runs on for more than a page or not, must be laid out on the right page of the double spread. If there is a dedication the foreword faces the blank verso of that page; if there is no dedication it may face the copyright page. The body matter should ordinarily be the same size and style as that of the book itself.

PREFACE

Being the author's initial statement, the preface is usually given the importance of a chapter opening; the type size of its heading and text is the same as in the text of the book. The opening of the preface should always be laid out on the right-hand page of the double spread.

ACKNOWLEDGMENTS

When the author's acknowledgments are made in a few sentences the designer might suggest that they be included at the end of the preface if additional space is needed for other parts of the book. Otherwise, as a distinct unit, the acknowledgments should be laid out to begin on a right-hand page and be treated exactly like the foreword and preface.

CONTENTS

Typographically the heading of the contents can have the same treatment as the foreword, but in its layout an effort should be made to compress the material laterally so that there is a minimal space between the titles and the page numbers even though this creates a contents block whose width is less than the text page width. Thus processions of dots can be avoided or kept to a minimum. Parts of major sections should be arranged for maximum visual clarity.

It is often within the designer's province to change numbering from roman numerals to arabic figures or vice versa, and he should not hesitate to do so. The kind of numbering should correspond with that of the chapter openings and be related to the subject of the text. Above all legibility should not be sacrificed. Roman numerals above x are barriers for the reader.

ILLUSTRATION LIST

If the list is of the short caption variety and follows the contents, it should be set in the same size as the contents, but if it is placed at the back of the book it should be set in somewhat smaller type. The type size will depend on whether the list is meant to be read consecutively or only to be used for occasional reference.

QUOTATIONS

Quotations that are not part of the text of the book but that are used in connection with a heading or alone on a separate page should be set smaller than the body text. Often they are in italics, and the author's name is in capitals and small capitals letterspaced.

INTRODUCTION

Here the typography of the heading and text reflects the chapter opening, but without the chapter number. If decorative or symbolic devices are being used with the chapter titles one would logically be used here to give the introduction the same status as the rest of the text. The matter may be divided into parts, in which case a Part One half title would precede the opening either in place of, or following the book half title. The introduction begins on the right-hand page of the double spread.

6-17. Copyright and contents spread for *The Pyramids*. Composition width is narrower than the text page block and the lines heavily leaded to avoid connecting dots.

83

Fotosetter Bulmer throughout x 26 picas

Subhead ① SIMPLE LEARNING *14/16 caps, letter # 1 pt, flush left*

② Classical Conditioning *11/12 caps, letter # 1pt, indent 3 picas*

③ Conditions for Acquiring Conditioned Responses *11/12 Ital u&c, flush left*

Additional Aspects of Classical Conditioning

④ Extinction *10/12 caps + sc, indent 3 picas*

Spontaneous recovery

Higher order conditioning

Generalization

Discrimination

③ Interim Summary on Conditioning

② Instrumental Conditioning

③ Laboratory Equipment for Instrumental Conditioning

Kinds of Instrumental Conditioning

Measurements in Conditioning

Basic Phenomena of Instrumental Conditioning

② Summary: Simple Learning

6-18. A sequence of subheads marked up to give
each a different typographical distinction.

Table 12-3. THE EFFECTS OF CHANGE IN CLASSIFICATION LISTINGS OR TITLE IN SALES OF BOOKS

FORMER TITLE OR CLASSIFICATION	LATER TITLE OR CLASSIFICATION	ORIGINAL SALES PER YEAR	LATER SALES PER YEAR
What the Editor's Wife Is Thinking About	*Marcet Haldeman-Julius' Intimate Notes on Her Husband*	"almost zero"	16,000 copies in 1927
Poems of Evolution	*When You Were A Tadpole And I Was A Fish*	2000	7000
A Guide to Rabelais (classified: "Doors to New Worlds")	*How to Enjoy the Humor of Rabelais* (classified: "Cultural Helps")	"around the zero mark"	13,000 copies in 1927
Poems of Holmes (classified: "Poetry")	*One Hoss Shay and Other Poems* (classified: "Humorous Verse")	3000	almost 7000
Euphorian in Texas (classified: General Fiction)	*Euphorian in Texas: An Unconventional Amour* (classified: Love)	very few	sold 22,000 in 1927
Sarah Bernhardt's Philosophy of Love	*The Code of a Parisian Actress*	14,000 in 1926	29,500 in 1927
Loyola: Founder of the Jesuits	*The Jesuits: Religious Rogues*	8000	34,000 in 1927

An illustration of ways in which the labeling—the arranging of motivational context—can influence the reaction to an object is furnished by data on the effects of affixing new titles to books that had not sold well. The table above gives sales records of a number of Haldeman-Julius "Little Blue Books" before and after the indicated change of title. (From The First Hundred Million by E. Haldeman-Julius. New York: Simon and Schuster, 1928, Chapter IX, "What a Change of Scenery Will Do," pp. 163–178.)

6-19. A chart without vertical rules. The content is
especially revealing for those interested in marketing books.

HALF TITLE

The half title, if one is used, should receive the same typographic treatment as the bastard title.

PART TITLES

In books which have begun with a double spread or other unconventional title page treatment, the part titles might be laid out in a similar way, provided too many blank right hand pages do not result. Otherwise a treatment similar to the bastard title can be done, or if space is limited the part titles may even be combined with the chapter opening.

SPECIAL TEXT PROBLEMS

Subheads: If there are many descending levels of subheads the designer may be hard pressed to find adequate differentiation in the type sizes and styles for subheads. Varied indentions can indicate sublevels and flush to the right margins are occasionally useful.

Extracts: Prose or poetry quoted for more than a few lines must be set apart from the text by indention and space, about one half line, above and below. The type size should be reduced one or two points. Poetry is usually centered on the longest line, indented at least 1 em at the left except where there are several quotations on the same page, in which case, a single indention for all quotations is established.

Charts and tables: If Linotype composition is chosen for the text the simpler tables can be set by the same means, usually in a one-third smaller type size than the text. Complex tables are more often set by Monotype. With increasing frequency nowadays the matter of the tables is set by one of these methods and the lines ruled in on reproduction proofs. The complex mechanics of perfect placing and joining of rules between type lines are thus avoided. Adjustments and changes can be made in paste-up and eventually plates can be made photographically.

Where tables are too wide for the text block they can project into the outer margin or they may be side turned. A double spread side turn should begin with its top at the left-hand margin of the left page and continue down to the right-hand margin of the right page. A single chart, side turned, is often allowed to lie like a drunkard with its head or feet in the gutter, but any decent designer, to make it rest more easily, will bring it out to the center of the text block.

Footnotes: The usual prescription is to set them two sizes smaller than the text type (e.g., in 8/9 point with 12/14-point text) and place them at the bottom of the page. Often they are separated from the text by a hairline rule about 4 picas long. The superior figures in the text to which they relate are reflected as closely as possible in the footnote. Where there are few footnotes to the page the asterisk, the dagger, the double dagger, etc., can be used. The designer must specify that the printer choose a style of figure which corresponds to the text type. Footnotes that break over onto the next page are usually preceded by a hairline rule of 4 picas or the full measure of the text, or simply by ample space.

Marginal Notes and Sideheads: They should be set in italic or some other healthy contrast to the text. Ragged margins are best because of the short line. Their decorative possibilities should be considered.

Back Matter

APPENDIX

This group of documents is placed directly after the text and can be set according to its importance either in the same size as the text type, if the matter is of equal interest, or one or two points smaller, if it consists of long supportive documents. The heading should follow the same pattern as the fore-word and the preface. In the double-spread layout the appendix falls on the right-hand page.

NOTES

When associated matter is too great for footnotes it is ordinarily placed in the back matter with superior figures in the text for reference. For the notes themselves the superior figures can be avoided and the normal font figures used, probably indented 1 em or flush-and-hang style. The heading is treated like the one for the appendix. The type size is usually the same as for footnotes, but occasionally when the notes are in a discursive style for continuous reading they can be handled with the same weight as extracts.

BIBLIOGRAPHY

If the bibliography is not of great length it should be set in a type size intermediate between that of the extracts and the footnotes (e.g., text 12/14, extracts 10/12, footnotes 8/9, bibliography 9/10). If space and budget permit it is agreeable to add 2 points extra space between entries. Subheadings are best handled in the same type size as the body in a descending scale with capitals, small capitals, italic, etc. The major heading should follow the style of the appendix and the notes.

GLOSSARY

In this list of definitions of terms employed in the text, the terms are usually set in italic, or in bold face in textbooks. A flush-and-hang style can be used and there might be an additional 2-point space between each entry. The type size should be that of the extracts if the glossary is short, or that of the bibliography if it is more than a few pages; the heading should be comparable to the ones for the appendix and the notes.

INDEX

Because many entry lines are short, the index is usually set in double column style in single column books. A flush-and-hang style is used. Each alphabetical break is preceded by a capital if the list is long, or if it is short simply by a one or two line space. The type size for the index can be that of the footnotes or the bibliography, depending on how many pages are required. Since its setting is ragged in appearance to begin with, I prefer a ragged right style to avoid the wide spacing which often occurs with justified lines in narrow measures. The space between columns is at least one pica for ordinary books, or wider as the column measure and page widen.

COLOPHON

This separate unit should be harmonized with the style of the book, of course, but can carry the printer's or publisher's device, or one specially created for the book. The composition is often in italics and set in a free ragged or centered style as an indication, perhaps, of the relief that all concerned feel that the book is finished. Type size should be no larger than the text size.

6-20. A colophon page for a book published by The Limited Editions Club, New York.

6-21A. Simplest way of rendering to indicate an illustration.

6-21B. Soft pencil rendering to show weight, or dark and light values.

6-21C. Medium pencil rendering which gives both weight and suggestion of detail.

Illustration Page Layouts

The simplest way of showing photographs and art in the layouts is to draw the outlines of the shapes placed where they will be on the double spread. A certain amount of imagination is necessary to visualize the balance of weight and emphasis when the gradations of dark and light in the pictures are not shown. If the designer or client needs more definition to justify the scaling and placement, there are at least five ways of presenting the illustrations:

1. pencil outlines of major elements in the picture;
2. pencil, pastel, crayon, felt pen, or painted representations;
3. photostatic copies, either matte for economy or glossy for greater fidelity or spectrostats for color, rubber cemented in position;
4. brownline (vandyke) or blueline prints, or engraver's proofs, rubber cemented in position;
5. duplicate photographs cemented, pasted, or dry mounted in position.

PICTURE SCALING

The first decision in sizing an illustration is the degree of reduction or blow-up and the cropping needed to produce the scale desired for the layout. The illustration can be placed under a piece of tracing paper, and the diagonal lightly drawn. Or the illustration corners can be plotted on the layout and a diagonal drawn. The length of the base of the size planned is measured from the lower corner of the diagonal to a point along the base of the illustration. A perpendicular drawn up from this point will then hit the diagonal at the point which will be the upper corner of the desired rectangle. This method, which can be cumbersome when there are many illustrations, is not very precise. A better method is to use a proportion wheel. If cropping is desired, a pair of L's cut from illustration board and marked with inch or pica scales is useful. When the L's are placed as a rectangle over the picture for the image desired, one can set the proportion wheel to the dimensions where the L's cross and find any other size. A Brandt Scaleograph performs both functions at once.

One must usually provide for the fact that in the process of making the plates some of the edge of the image will be lost through masking, straightening, etc. Therefore cropping should be done with at least ⅛-inch leeway on all sides. Unless the photographer or artist has indicated a "baseline" the designer must select a vertical element near the center, or a "horizon line," in the image to determine visual straightness and crop accordingly.

ILLUSTRATIONS PRINTED SEPARATELY

Let us begin with the simplest form—the book in which the illustrations are planned totally separate from the text. There may be only a few illustrations printed on single sheets and tipped-in, or a folded section of illustrations used as an insert, wrap, or separate signature. Such pages are often conceived by the author or editor to provide a full page for one or a few pictures, and the individual images have equal weight. It is a method that can result in scholarly justice and visual dullness. The designer may alleviate the situation by suggesting evocative groupings and croppings which enhance the pictorial values. Often the illustration layouts can be standardized so that only a few representative double spreads need to be worked out. But in the rare case when the designer sees great possibilities inherent in the material that can be brought out by radical changes, he should suggest to the publisher that these be made.

CAPTIONS AND CREDITS

The placement of captions is usually made directly under each photograph. If the caption is long it may detract from the illustration. An alternative is to place the illustration at the top of the page and let the caption run at the bottom, separated by wide space and, for instance, aligned at the base with the bottom margin of the text page. Or captions can be put beside or above the illustration. It is all a matter of the designer's ingenuity and preference.

Captions should be definitely distinguished from the text matter. This can be done by (1) setting the type a size or two smaller than the text, (2) setting it in italics, in small capitals when short, or (3) in flush-and-ragged style. The last method avoids troublesome word spacing in short measures.

Some institutions and photographers insist that credit lines be placed directly with illustrations which they have supplied. For these lines not to detract from the accompanying image they should be included in the caption or set in extremely small type. Often small capitals from a 6-point font are ideal. There is no harm in running them up the sides. When crediting is not absolutely required to run with the illustration it can be included in the credit list.

IMAGES WITHIN THE TEXT BLOCK

If the illustrations are to be treated as part of the text blocks there are several ways of handling them which are economical and aesthetically sound.

1. Large illustrations should be scaled to the full width of the text block.
2. Small illustrations should be lined up with the vertical margin and the captions placed beside or beneath them. Avoid expensive text run-arounds.
3. Illustrations occurring at the top of a page or occupying a full page conflict with running heads placed above them. The running heads should then be eliminated, unless the book is so heavily illustrated that pagination is difficult to follow.

6-22. Broad felt pen rendering on rough laid paper.

6-23. Pastel rendering suitable for detailed presentation.

6-24, 25. Two spreads from Samuel Chamberlain's *Bouquet de France*, Gourmet Books, New York, 1957, in which drawings and maps project into the ample margins where there is also space for the names of intriguing restaurants, appropriately hand-lettered.

When a book can be printed by offset lithography or gravure or when the cost of letterpress plates to cover the full area of the paper is not of paramount concern, the illustrations can be allowed to go beyond the text block limits and even bleed. The whole relationship of spaces and forms becomes more dynamic. A sense of movement is automatically created. A picture coming into the page from the top left margin, for instance, creates a flow of force across and down into the text block below it. This motion can of course be negated by setting up an exact reflection of the forms on the opposite page. This is a perfectly valid plan for books in which a balance of repose is desired.

For books in which a more dynamic feeling is wanted the invasion of the margin can be handled in other ways. The balancing illustration is placed at the bottom of the page. If we increase the size of one of these illustrations, for example, the top left one, so that it bleeds off the top left and inner margins, the contrast in size creates a stronger motion. More electricity flows in the composition. Further dynamism can be created by making the column widths narrower and incorporating other balancing shapes. And the compositions within the pictures can reinforce the visual excitement, and often determine the shape the layout takes. It is the ancient vocabulary of asymmetry versus symmetry; both are valid for different ends.

To the novice or the book designer who has been restricted by minimal letterpress budgets it is a heady world indeed. Everything must go off the edges of the page. In his new freedom he often bleeds to death. The remedy is restraint: keeping most pictures within the type blocks, reserving bleeds for those photographs which are enhanced, made dramatic, or saved by this method. Small illustrations usually look chopped and violated by bleeding. When the margins around the type blocks can be made ample, many of these illustrations may be placed in them. In only the rarest cases should reproductions of works of art, fine prints, and drawings be bled. Having frequently violated this rule myself, I can only say that however bold, daring, and modern the treatment seemed at the time, a look at some of the work today reveals it as gauche, forced and a desecration. Other examples happily still seem brilliant, at least to their perpetrator!

6-26. A spread from the International Visual Series of Paperbacks, this one from *Heart: Anatomy, Function and Diseases* by the artist George Giusti and Rudolf Hoffman, M.D., edited by Frederic Ditis with overall art direction by Heiri Steiner. Dell Publishing Co., New York, 1962.

When illustrations become the dominant element a new set of considerations arises.

1. Running heads at the top become cumbersome. They should be relegated with the folios to the outer bottoms or outsides of the pages, or eliminated entirely.

2. Pictures on facing pages which go into the gutter often conflict badly. Provision for white space on the inside of one of them should be made. But occasionally they can adjoin to create fascinating juxtapositions. Experiment!

3. Large pictures which break partially across the gutter usually look sadly broken. It is not as offensive with full double spreads, but the technique is more suitable to magazines where the gutter curve is not as great or deep as in the book. Again, use discretion.

4. The use of a narrow margin of white, e.g., approximately ¼ inch, around full-page photographs is frequent in European books and works beautifully there. In America the tolerances are wider and ½ inch is barely safe to keep pages from appearing to be trimmed crooked, alas. Try ¼ inch at your own risk.

5. When old photographs and prints are used together with contemporary illustrations, there is a strong temptation to print the former with a background tint of a second color to distinguish them. Avoid it. The best solution with historical material is simply to date it properly in the caption.

6. If one has a second color available, a further temptation is to print the illustrations as duotones, in which dark tones are reinforced by the second color giving an overall effect of an in-between color. If the second color is brown it is overly reminiscent of the brown pictorial Sunday supplements of the 1930's. If it is green, yellow, or blue one goes screaming into the wings. In any case, a good rich black is preferable. If this cannot be achieved with one impression, ask for duoblack, i.e., the halftone printed as a single black with the darker areas reinforced with a second black printing.

7. The best relief from an overdose of halftone is crisp incisive line drawing. Often I have found that leading illustrators in other fields are eager to work on books, and on terms which can be managed. The sense of having one's work produced in a more lasting form than their usual fare is partial compensation. Besides, upon examining the needs of the manuscript, the designer often finds that far fewer illustrations are necessary than he originally thought. A few touches from a first-rate hand can lift the tone of an entire book, which dozens of banal illustrations can only demean.

The rhythmic beating of the heart is initiated within the heart itself by some mechanism that is still unknown. The rate of beating, however, is controlled by nerves and by chemical substances within the blood. Two sets of nerves normally control the rate: one to speed it up, the other to slow it down. These nerves act on a special tissue in the right auricle that sets the pace of the heart by transmitting trigger impulses to the heart muscle.

Waves of impulses pass to the muscles of the auricles and to a second patch of tissue located in the partition between the right and left heart, which relays the impulses to the ventricular muscle. If these impulses are blocked by disease, the heart continues to beat slowly, but auricles and ventricles beat independently and lose their coordinated rhythm (cardiac arrhythmias).

66

67

MAKING A DUMMY

Once the designer has presented and has had typical layouts approved for a heavily illustrated or pictorial book, he often discovers that the best way to proceed is not by completing the layouts but by making a paste-up dummy. Calculating the exact amount of text that will fall on a page is difficult because drastic corrections affecting the length may be made by author and editor once the manuscript is seen in type. The right of authors to change their minds still seems inalienable. Illustrations are frequently changed, arrive late, are switched, are of poor quality necessitating replacement, or just never appear. It is better to work with existing ingredients than with the unknown.

Often the mechanical matter of making the dummy will be entrusted to someone on the publisher's or printer's staff, whose job it is to organize all the material and try to carry out the designer's intentions. The designer will check the work in progress. Sometimes the job will fall to the designer and his staff, and he must know how it is done. Decisions made here are crucial. First a dummy book is prepared either with (1) separate double-spread pages on strong, erasable paper printed with the book margins preferably in light blue and with enough extra space surrounding for notations, (2) loose folded signatures of the book or, (3) a replica of the final version, sewn, but made with tougher paper to withstand repasting. I prefer the first method because of its flexibility: spreads can be exchanged, eliminated, or substituted.

First a set of revised galley proofs is marked off for pages, by simply taking the number of lines for a full text page and chapter openings and by measuring them off with a line gauge, if the leading corresponds, or a hand-drawn scale on tough paper. This will determine the number of pages the text will run. Add to this the estimate for front and back matter and subtract the total from the desired number of pages and we see how much is left for illustrations. Remembering to include an average for captions and spaces, we count the number of pictures which will impinge on the text block (others may be placed in the margins). This number we divide into the total space available (expressed in picas) and we get an average for each illustration. Another method is to go through the pictures and assign each one a temporary full, half, or quarter page depth. It will soon be obvious whether the number of pages needs to be expanded or contracted or whether the pictures must give way. It is too late to do much about the type.

Once a conclusion is reached as to the number of pages and the average size of illustrations the galley proofs and pertinent pictures are used to work out each double spread. Amounts of text are marked off on the proofs and illustrations are drawn in as rectangles. Only when each chapter, or even safer, the entire book has been divided up in this way should galleys be cut apart and pasted in. Identification should be made with the number of each galley written repeatedly over the type to keep pieces in sequence. At this time illustrations could be sketched in or photostats or blue or brownline prints ordered and pasted in.

Of course situations will arise when despite a careful record of average illustration depths, the book will not come out to the desired number of pages. What can be done? (1) Front and/or back matter can be stretched or compressed, including addition or subtraction of blank leaves; (2) space can be added or taken out around subheads; (3) chapter openings can be given one or two separate pages; (4) part titles can be introduced; (5) new illustrations can be requested or weak ones eliminated; (6) when all else fails the author can be asked to cut or add something. He should leap at the opportunity.

If an overall view of the progress of a book is required, separate double-spread sheets have another advantage over a sewn dummy. They can be hung on a wall for comparison. An ordinary chapter, however, takes a good deal of wall space. Some publishers make reduced photostats of the entire book and exhibit them in a corridor, coffee or conference room for the scrutiny of editors, production people, and management. This practice can be hard on the designer, but many errors and arrhythmias may be caught before the book appears.

If one has a complete manuscript and illustrations which will not be tampered with, because the author is departed from this earth or for any other foolproof reason, it is practical to make layouts for a whole book. Or if the author is alive and kicking he could possibly write the text as the layouts proceed. A description of such a collaboration exists in Chapter 9. In either case the designer calculates the amount of text in the manuscript, divides it up by double spreads and coordinates it with relevant illustrations. The procedure is the same as for making a dummy, except that rectangles are drawn for text blocks with the beginning and the ending phrases lettered in.

6-27, 28, and 29. Jacket and spreads for *Basne Obrazy*, including evocative settings of poems, such as Guillaume Appollinaire's rain falling. Designed by Oldrich Hlavsa, Prague, 1965.

SPECIFICATIONS

Here is a typical set of designer's specifications for a book of nonfiction. From this sheet the publisher's production office will fill out its own forms to request estimates. If more specific information is needed on indentions, internal spacing, sinkages, running heads, folios, etc., the answers should be found in the layouts. It will be noted that inner and top margins are given in picas, which I prefer, but commercial book manufacturers prefer inches. My tendency in layout work, however, is to conceive of the pages as a graph divided in picas from the top trim edge down and from the gutter outward. If necessary I convert the margins into inches.

```
Levine: WAX & GOLD

Specifications

Page Size: 6" x 9"

Inner Margin: 4 1/2 picas    Top Margin: 4 1/2 picas

Type Page: 25 x 42 1/2 picas including running head

Text Type: 12/13 Bembo     Extracts: 11/12 Bembo

Notes (end of book): 9/10 Bembo    Footnotes: 8/9 Bembo

Tables: 9/10 Bembo, except table in Notes, 8/9 Bembo

Comments and Footnotes for Tables: 8/9 Bembo

Display Type: 30, 14, 10 Solemnis (Berthold via Amsterdam
                                   Continental Types, Inc.)

Captions: 9/10 Bembo Italic

Glossary: 11/12 Bembo and 9 Foundry Ethiopic

Index: 9/10 Bembo double column x 12 picas

Paper: Warren's Olde Style, sub. 70

        Illustrations: Warren's Lustro Dull, sub. 80

Binding: 1 piece Bancroft Kennett 3912

        Stamping: Gold foil on spine and front

        Lion device: based on brick statue, photograph
                     and suggested rendering style attached

        Endpapers: Ochre Colortext Endleaf (Canfield Paper Co.)

        Headbands: Gold and Brown

        Sewing: Smythe        Back: Round

Pagination:

Flyleaf a & b blank    2      Extracts          14
Bastard Title          2      Tables             6
Title                  1      Comments           1
Dedication & Copyright 1      Footnotes          5
Preface               10      Notes             12
Contents               1      Glossary           4
Illustration List      2      Index             12
Blank                  1      Maps              10
Text                 316                        400
                              plus 16 pgs illustrations
                              as four 4-page wraps
```

6-30. Design specifications to accompany the layouts for a university press book.

Any of the following points may be at variance with the publisher's or printer's usual practices. An agreement must be reached on each of these by all concerned.

COMPOSITION

Word spacing: 4 em average in roman text and display composition; 5 em average in compressed italic (most Monotype italics and Linotype special italics); 4 em in normal Linotype italics.

Letterspacing: Capital display lines marked to be letterspaced should be optically equalized. The amount specified refers to the distance between the normal bodies of adjacent straight stems, e.g., I H L.

Do not letterspace lowercase letters unless specified.

Capital and small capital lines in text are not to be letterspaced unless specified; if so, letterspacing is to be mechanically equal, unless optical letterspacing is indicated.

In letterspaced capital lines use one-half as much space between quotes or other punctuation and adjacent letter as amount specified for letters. *Exception:* exclamation points and question marks.

Spacing after punctuation: Use close, approximately 6 em space (e.g., 2 points in 10, 11 or 12 point type) after periods within abbreviation groups in sentence—e.g., U.S.A., N.Y.C., pp.22 and 27, A.D., B.C., a.m., p.m. Use normal word spacing after periods at end of group, at end of sentence, after commas, semicolons, colons, etc.

Hyphens: Three or more hyphens at ends of successive lines are unacceptable. Do not further hyphenate already hyphenated words.

Dashes: All full dashes are to be 1 em unless marked otherwise. For omitted words use solid 2 em dash preceded and followed by normal word space.

Use 1 en dash, not hyphen, to connect figures—e.g., 1965–66.

Figures: Use figures supplied with regular font unless instructed otherwise. *Exception:* in faces normally supplied with old style figures use modern (lining) figures with capital lines if they exist and align well.

Punctuation: All marks following italicized words should be italic, unless punctuation is a question mark or exclamation at the end of a sentence.

Accents: Do not use reduced or small capitals for accented capitals. Use full size accented capitals, or cut in.

Chapter openings: In first paragraphs designed to begin in small capitals use a capital for beginning the first word, small capitals thereafter except for capitalizing proper names.

In first paragraphs designed to begin with the first words in capitals, if the word is part of a proper name capitalize the whole name—e.g., *not* JOHANN Sebastian Bach.

MAKEUP

Spacing in text: Leading within text blocks, including between paragraphs, must be consistent throughout as specified.

Spacing between subheads and text: Subheads should be placed in an approximate proportion of 2 above and 1 below unless otherwise specified, so that back up of text lines remains perfect, e.g., in 11/12 point setting use 8 points above, 4 points below.

Spacing between extracts and text: Space should be adjusted so that backup of text lines is maintained with the smaller proportion above the matter, the larger below, or equally divided.

Widows: Short text lines at tops of pages must be avoided. Append to previous page and query on proof. Never divide word over two pages.

Long and short pages: One line long or short (but not both in the same book) is acceptable to avoid a widow or bad break. Avoid succeeding pairs of long or short pages (4, 6, or more). Spacing in chapter heads or around subheads may be discreetly adjusted to avoid facing or succeeding pages of varying length.

Folios: Omit page numbers on front matter pages except in forewords, prefaces and introductions that continue more than one page.

SAMPLE PAGES

Text sample pages: These should consist of a chapter opening and text double spread including examples of various subheads, an extract, and other special requirements. They should be proofed as a four-page folder on the stock specified for the book, or close equivalent, trimmed to size and margins as specified. On page 4 the general type specifications used, the page size and margins, the printer and date should be printed.

Pictorial sample pages: In letterpress books these would consist, as above, of a chapter opening and a text double spread proof from made-up form of cuts and type. Often silverprints or engraver's proofs are pasted in when further work on the cuts may be required.

In offset books, brown, blue or black line proofs made from stripped up negatives are supplied. In gravure, continuous tone proofs of photographic and art subjects are pasted up together with type proofs.

Full-color sample pages: For letterpress these are usually type proofs with the engraver's color proofs pasted in. For offset lithography, ozalid or 3-M acetate overlay proofs combining type and cuts are shown.

For gravure, proofs are ordinarily press plate proofs made on small sheet-fed presses and at considerable expense. Therefore sample pages are often omitted, but letterpress type proofs together with full-color photographic prints can serve the purpose.

FOLLOWING THE BOOK THROUGH PRODUCTION

Once sample pages have been approved, the designer tends to relax and trust the publisher's or printer's production office to carry through. The latter, eager not to add another bivouac to its proof movements, is content to let him rest. But this is the point when he is needed most, to check the myriad details which make the difference between a well-made book and an ordinary one. Ideally the designer should see galley proofs, page proofs, revised page proofs, each press sheet, and folded sheets before they are cased-in. In offset books the steps include the mechanicals and the proofs of film stripped up in position.

It would be splendid if the designer could be on hand in the pressroom when the first sheet has been made ready, to inspect the quality of impression and the level of work. Whenever colors have been mixed he should see a press proof. Many a failure in binding has been avoided by his scrutiny of the stamped binding case before the entire edition is run off. Unfortunately, the designer's time is supposed to be devoted to more "creative" aspects, and if he is a free-lance his fees rarely compensate for the time involved in such inspections. Yet the best books have always been produced by a close collaboration between designer and printer, who were after all, historically, one and the same man.

6-31. Designer inspecting a full-color proof sheet and congratulating the pressman. Photograph by Marcia Tucker.

7 Binding

Bindings have several functions which may vary greatly in importance depending on the volume.

1. Consolidation—holding the pages together for the life of the book in a manner which makes them pleasant to open.
2. Protection—guarding the case against moisture, rough handling in shipment, wear in use; and guarding the pages against dog-ears and bookworms.
3. Identification—affording quick recognition of author, title, publisher, and, if a series, the number of the volume or matter included.
4. Attraction—providing a pleasing harmony of design, shape, size, color, and texture which attracts the buyer or reader.
5. Evocation—anticipating what the reader will find within; an establishment of mood, period, value.
6. Promotion—creating a cover which helps to sell the book, and which sometimes eliminates the need for a jacket; now accepted in paperbacks and increasingly in hardbounds.

The early "perfect-bound" paperbacks may have been excellent on the fourth, fifth, and sixth counts, depending, as they did, on nudity, but they performed poorly on the first function. The pages held together for barely one reading! For once, the public protested against built-in obsolescence, and better glues and binding methods were developed. Even sewing was brought back and made a selling-point by at least one publisher.

On the other hand, law books have been excellent on the first count, often with double endpapers and reinforcing in the joints no doubt based on an overestimate of how often they would be opened. But on point 4 they were drab indeed, running to muddy reds and browns and on point 6 they rated zero.

7-2. Contemporary design treatment for a law book series. *Trials*, an encyclopedia published by Bancroft-Whitney Company, San Francisco, and The Lawyers Co-operative Publishing Company, Rochester, New York, 1964. Design by Adrian Wilson/Douglas Nicholson.

Above:
7-1. Three-legged binding press.

7-3. Printed paper and loosely woven cloth spine in black and white for a children's book, *Havet*, designed and illustrated by Reidar Johan Berle, published by Bergens Tidende and J. W. Eides Boktrykkeri A.S., Bergen, Norway.

BINDING MATERIALS

The designer must analyze each book on the basis of its requirements before he can begin his sketches. For textbooks, the standards of the Book Manufacturing Institute (see pamphlet titled *Official Minimum Manufacturing Standards and Specifications for Textbooks*, available from Book Manufacturers' Institute, Inc., 25 West 43 Street, New York 36, New York) must be met if the book is to qualify for acceptance by state school boards. Consultation with the binder will reveal whether unusual notions are practicable. The designer should constantly examine bindings to see how effects have been achieved and how books have weathered.

The discriminating choice of materials, some testing and questioning, will add years of beauty and use to the binding. The convention of covering the binding with a paper "promotion" jacket is changing rapidly, but in trade books the designer's binding may still be concealed by the jacket for much of its life. Why should not the jacket and the binding become one, as they have in paperbacks? Any image can be printed now on the new long-wearing cloth substitutes (Linson, Kivar, etc.) or on sturdy paper, and many of the books reproduced here are hardbound in paper or synthetic materials. Plastic coatings can protect as well as jackets and, if the publisher insists, the flap blurbs, complimentary quotes, biographies, etc., can be placed inside, as they are, at present, in many paperbacks. But soon a one-piece hard binding will be developed which can eliminate separate spine and boards as well as the paper jacket.

A strong deterrent to using plastic-coated printed bindings is their cold slick texture. But I am not totally anti-shine! Gloss has its advantages. The first scholarly paperback covers were printed on matte papers to avoid offending the intellectual. It soon appeared, however, that their cellophane-laminated and plastic-coated competitors were outlasting them, and scholarship took to glossy coats without a murmur in the groves of academe. The printing is vivid, the surfaces resist becoming shopworn and the books sell more rapidly.

THE BINDING DESIGN

I usually begin with thumbnail sketches of the front at one-third scale giving the three-dimensional aspect with a simple perspective outline. The motifs, illustrations, and typographic treatments within the book are a first source of ideas. Frequent solutions are:

1. A symbol or device stamped blind or with metallic leaf.
2. An overall pattern of motifs or ornaments printed in color or blind stamped.
3. A long drawing printed around the front, spine, and back. The problem of breaking across the hinge is solved by printing the cloth before it is glued to the boards.
4. Two pieces of complementary cloth run across and around the binding.
5. Cloth spine and contrasting cloth on paper sides.

7-4. A calligraphic binding stamp designed by John Peters.

7-5. Drawing by Paul Klee printed by silk screen on black binding cloth with white ink. The title on the spine and Klee's name on the front are stamped in cerise foil. Designed by Jane Hart, University of California Press, 1964.

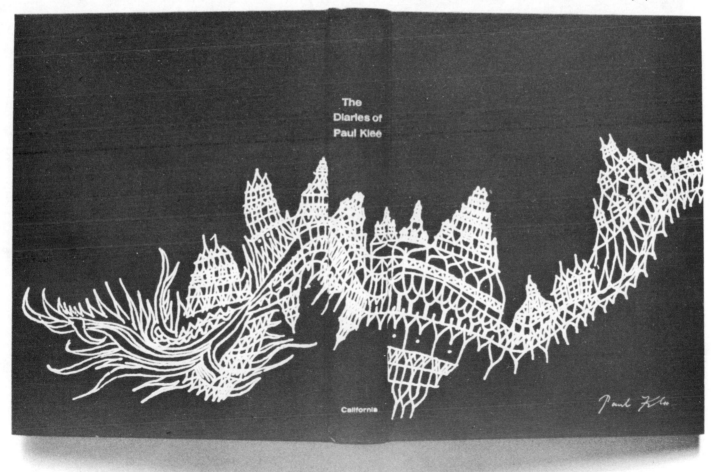

The Diaries of Paul Klee

California

The spine is a difficult design problem because of the confinement and shape of the space. I sketch it as if viewed straight on, with no attempt to show curvature. To be read across the spine the title lettering must be legible at a few feet distance and not too condensed. With a very long word in the title, there is a chance of more than one breakover and this has contributed to the running of titles up and down. The Cambridge University Press recently solved the direction question, for one of its delightful Christmas books, *Words in Their Hands*, by stamping the title twice on the spine, once each way. On the whole I prefer the title to run down so that when a book is lying face up as on a coffee table, the spine will be legible.

In laying out the spine the elements should align with the elements on the front wherever possible. Slight jogs are disconcerting even though they appear on different planes. Once the copy is assigned and the thumbnail is worked out I consider the materials and stamping possibilities. I thumb through the cloth manufacturers' sample books until some combination of color and texture strikes me as appropriate. The United States Department of Commerce Standard Specification for Book Binding Fabrics CS-57-40 grades many of the samples by letter, A through F, in increasing order of quality and strength. Usually I will find my choice in the rougher textures of the starch-filled fabrics. Several of the most interesting of these have no letter designation although they are made to conform to the CS-57-40 standards. If the book is likely to have heavy use I consider pyroxylin and vinyl impregnated varieties, much as I dislike their odor. But then presumably bookworms hate them too! They are washable, color fast, and reasonably scuff proof. The cloth varieties, which have dope loaded on the cloth and embossed with artificial leather and other patterns are best reserved for sets, encyclopedias, and religious books. I avoid them like sin.

7-6. A Cambridge University Press solution to the spine title direction problem, for a Christmas book. The spine is stamped in gold, the front in black, on heavily textured dark gray cloth.

7-7. Gold stamping on dark blue Fabriano paper for *Thus Spake Zarathustra*. The Limited Editions Club, New York, 1964.

If nothing in the medium price range appeals to me I consider the alchemy of a cheap with an expensive cloth. Two and three piece bindings cost very little more with automatic casemaking, if the quantity is sufficient to avoid penalties.

The new hopsacking, spindrift, chambray, and natural finish cloths have immense possibilities for interesting use. On occasion I have used the wrong side of the bookcloth with surprising effect, at least to the binder.

For most textbooks it must be remembered that only the pyroxylin and vinyl impregnated finishes of groups B, C, CI and certain weights and constructions of coated fabrics are allowable. Also "each book in a graded series must be found in a different color fabric," the Official Minimum Standards tell the designer. There are many points to study in this pamphlet to prevent breaking one's heart over a favorite choice.

7-8. A typographic binding design by Oldrich Hlavsa in white on black cloth, Prague, 1965.

RENDERING SEQUENCE FOR A TYPOGRAPHIC JACKET

8-1. Division into two horizontal panels of color, suggested by the wording, sketched at thumbnail size in orange and blue pencils.

8-2. Lettering sketched in white pencil on overlay.

8-3. Jacket outlines laid out at full size including flaps, spine, and back.

8-4. Orange panel on front and spine colored-in with pastel chalk allowing for overlap on back and front flap, sprayed with matte-finish fixative. Behind is a box with an ample set of pastel colors.

8-5. The lettering, traced from the type specimen sheet on transparent paper, transferred to the layout by coating the reverse side of the letters with the same white pencil used for the thumbnail to be retraced with a hard pencil. The letters are then painted on the layout with a fine brush and white opaque water paint.

THE
INTERPRETATION
OF ART

Essays on the Art Criticism of

JOHN RUSKIN

WALTER PATER

CLIVE BELL

ROGER FRY

and

HERBERT READ

By Solomon Fishman

UNIVERSITY OF CALIFORNIA PRESS

8-6. The printed jacket.

8 Jackets and Paperback Covers

If the jacket were only a small poster to advertise the book at a distance the main criteria would be those of effective publicity. But when interest is aroused by a title the book is almost immediately taken in the hand. The scale is suddenly changed, suggestions of the subject matter, the worth of the writing, the quality of the illustration, the excellence of the design and printing, all should be conveyed. The problem of the design is how to combine impact with detail. It is further complicated when the designer feels, as I do, that the graphic image, the typography, illustration style, color, and paper must relate to the content. Jacketing is much more than packaging because the product inside is not cornflakes or detergent but human thought and spirit. The book is usually the distillation of years of research and work, and like some other potent distillations deserves a label and container that subtly state its value. If the book needs attention-getting publicity in the store a separate poster can do the job.

Some of the most attractive jackets depend solely on typography, usually combined with color panels because white unvarnished or unlaminated papers rapidly become shopworn. The method of rendering such a jacket is shown opposite. (Illus. 8-1 through 8-6). Even more effective are hand-lettered designs because when a human element enters both impact and delicacy can be combined (Illus. 8-7 through 8-10). Graphic devices and black and white photography used with type or lettering can be potent and inexpensive. Choosing full-color photography and art requiring many renderings, models' fees, complicated plate making, etc., seems to me more suitable for advertising and magazine covers. Unless beautifully done the design is cheap and tawdry. Simple, clear pictorial images will best serve the jacket's function.

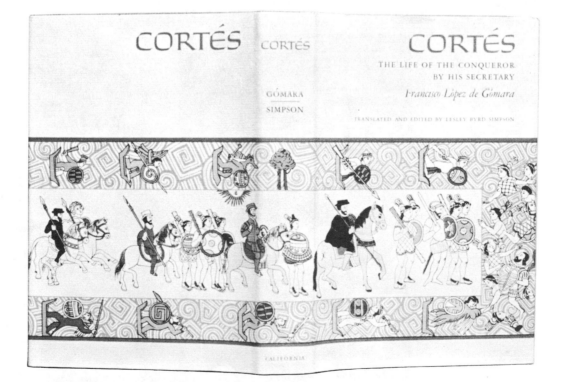

8-7. Reproduced in color on the jacket is the unique picture story of the conquest of Mexico painted by the Tlaxcala Indians about 1552. Designed by Adrian Wilson, University of California Press, 1964.

8-8. Jacket with a calligraphic flair by George Salter. Background texture is gray-blue, torn paper panel is black, and its border is vivid red. Lettering in white. Harper & Row, New York.

8-9. Suggestive scratchboard lettering by George Salter for Spengler's classic. Black background with title in white, author's name in vivid blue, other lines in yellow. Alfred A. Knopf, New York.

8-10. Dynamic paperback cover by George Salter for a trade book jacket. The ink wash panels are in dark mustard yellow, dark gray and blue. Alfred A. Knopf, New York.

$1.95

THE RISE AND SPLENDOUR

OF THE

Chinese Empire

BY
RENÉ GROUSSET

UNIVERSITY OF CALIFORNIA PRESS

MARK TWAIN & HUCK FINN

By Walter Blair

$2.75

UNIVERSITY OF CALIFORNIA PRESS

POEMS OF JULES LAFORGUE

TRANSLATED BY PATRICIA TERRY

Foreword by Henri Peyre

UNIVERSITY OF CALIFORNIA PRESS

$1.50

IMAGE FOCUS

8-11. Original drawing by E. W. Kemball from the first edition of *Huckleberry Finn* in green with Baskerville types in black. Design by Adrian Wilson.

8-12. Nuiko Haramaki's red and black linoleum block for a paperback cover. Design by Adrian Wilson.

8-13. Rubbing from a Chinese tomb in black combined with Legend and Lydian types in red. Design by Adrian Wilson.

8-14. Photograph of the path of an atomic particle overlaid with torn acetates in vivid green and blue which add a third color where they overlap. The type is Thannhäuser. Design by Douglas Nicholson and Adrian Wilson. Phoenix Science Series, The University of Chicago Press.

8-15. Overlapping drawings of archeological artifacts. Designed by Passanisi for Gyldendal, Copenhagen.

8-16. Photograms of leaf forms reproduced in black and overprinted with orange and lavender transparent ink panels. Where the panels overlap, a warm red-brown third color is created. In the rendering for the client, the effect was achieved with colored acetates. Janson types. Design by Douglas Nicholson and Adrian Wilson for The University of Chicago Press.

JAPANESE PAPERBACKS

8-17. Jacket-style paperback cover and slipcase in browns, muted pinks, and black, for a book printed by H. Setouti, Japan, 1964.

8-18. Paper-covered hardbound book with solid reverse panel in blue on pale green and slipcase with full-color reproduction of a collage, photographed in the author's garden. Both this book and the one in 8-17 have contrasting solid-color endpapers and tipped-in title pages on different stock from the book. Printed by lithography in two colors, Japan, 1964.

THE PENGUIN PARADOX

In 1956, to mark its twenty-first birthday, Penguin Books issued a paperback entitled *The Penguin Story*, chronicling its astounding growth to its majority. The Penguin case for purely typographic covers was firmly stated therein.

> The most familiar feature of the Penguin look is, of course, the avoidance of pictorial covers. In America the lurid cover is considered essential for securing mass sales of paper backed books; and in this country also, most of the cheap reprints are represented in picture covers. It has often been urged that Penguins might do better business if it conformed to this general practice; but whatever truth there may be in that supposition, the decision has been made, as a matter of taste, to reject the American kind of cover. The great majority of Penguin covers depend on clean decisive colour and on typographic patterns for their effect. There has recently been some variation of this fundamental principle by the introduction of a Penguin cover which is divided into vertical instead of horizontal panels, and on which simple line drawings are sometimes used . . .

These "simple line drawings" soon invited more elaborate artwork, then graphic and symbolic devices, and finally photography. Within a decade the pictorial cover, under the daring art direction of Germano Facetti and Alan Aldridge, was enticing the prospective buyer. Even the house identification of a horizontal color panel at the top, overlayed with "grot" type, was sometimes missing. Only a little bird remained to peep that it was a Penguin.

The earlier "Penguin look" implied a high literacy but a low graphic response in the reader, it was argued. Nor did the scholarly implication attract as broad an audience as the provocative image. The increase in cost of some pictorial covers and the loss of immediate identification was presumably offset by total sales.

It may have seemed another case of the breakdown of aristocracy and the rise of indiscriminate democratization. When every vivid paperback cover is outscreaming its neighbor, might not the greatest impact be made by the severely reticent? For the time being at least, the image makers are ruling the Penguin rookery. The striking covers are often beautiful, and sometimes intentionally and appropriately hideous.

Paradoxically, inside the covers, the texts of the Penguins have maintained their lucid and restrained typography. The reader is subtly conscious of the high standards of type selection and spacing originally set by Jan Tschichold and carried forward by Hans Schmoller and his staff. The sensitive handling and accurate ordering of all details are shown in every book issued by Penguin.

METAMORPHOSIS OF THE PENGUIN
PLAYS AND PENGUIN CLASSICS

8-21. Solid color border, decorative rule, Greek coin
and Perpetua type in classical symmetry for 1959 reprint.
Design by Germano Facetti.

8-22. Use of overprinting two transparent ink colors
to achieve a third color, plus black, for 1959 edition.
Walbaum type.

8-23. Two equally dense color panels, marquee lights
in reverse, overprinting in Helvetica type for
1964 redesign for the series. Design by Denise York.

8-24. Edvard Munch lithograph in black on gray
with Standard type in reverse. 1965 redesign.

8-25. A clever combination of stock advertising engravings. Helvetica types, spaced very tightly. Design by George Daulby.

8-26. Four-color reproduction of fourteenth-century wood carving on black background. Helvetica type. Photograph by John Freeman.

8-27. Powerful photograph by David Heath with Helvetica types in orange and white reverse, on the black background. Design by Denis Neale.

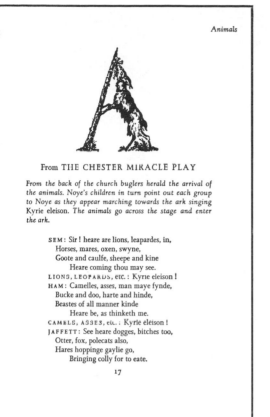

From THE CHESTER MIRACLE PLAY

From the back of the church buglers herald the arrival of the animals. Noye's children in turn point out each group to Noye as they appear marching towards the ark singing Kyrie eleison. The animals go across the stage and enter the ark.

SEM: Sir! heare are lions, leapardes, in,
 Horses, mares, oxen, swyne,
 Goote and caulfe, sheepe and kine
 Heare coming thou may see.
LIONS, LEOPARDS, etc.: Kyrie eleison!
HAM: Camelles, asses, man maye fynde,
 Bucke and doo, harte and hinde,
 Beastes of all manner kinde
 Heare be, as thinketh me.
CAMELS, ASSES, etc.: Kyrie eleison!
JAFFETT: See heare dogges, bitches too,
 Otter, fox, polecats also,
 Hares hoppinge gaylie go,
 Bringing colly for to eate.

17

8-28. Opening text page of *The Penguin Book of Animal Verse*. Initials from the Enschedé foundry, Haarlem, combined with the English Linotype's Juliana designed by Sem Hartz. Note the letter-spacing of the small capitals and other niceties of the Penguin house style. Design by Hans Schmoller and Fred Price.

8-29. "The Peaceable Kingdom," painting by the American primitive, Edward Hicks, reproduced in full color around the entire cover. Helvetica Light type.

DEATH
IN
VENICE
BY
THOMAS
MANN

Alfred A. Knopf PUBLISHER

9-1, 2. Slip case, binding, and double spread designed by George Salter as part of the fiftieth anniversary commemoration of the publication of the first Borzoi Book by Alfred A. Knopf.

Death in Venice 17

up in variations of one sort or another: he called it the conception of "an intellectual and youthful masculinity" which "stands motionless, haughty, ashamed, with jaw set, while swords and spear points beset the body." That was beautiful and ingenious; and it was exact, although it may have seemed to suggest too much passivity. For to be poised against fatality, to meet adverse conditions gracefully, is more than simple endurance; it is an act of aggression, a positive triumph—and the figure of Sebastian is the most beautiful figure, if not of art as a whole, at least of the art of literature. Looking into this fictional world, one saw: a delicate self-mastery by which any inner deterioration, any biological decay was kept concealed from the eyes of the world; a crude, vicious sensuality capable of fanning its rising passions into pure flame, yes, even of mounting to dominance in the realm of beauty; a pallid weakness which draws from the glowing depths of the soul the strength to

how whole arrogant peoples before the foot of the cross, or before the feet of weakness itself; a charming manner maintained in his cold, strict service to form; a false, precarious mode of living, and the keenly enervating melancholy and artifice of the born deceiver —to observe such trials as this was enough to make one question whether there really was any heroism other than weakness. And, in any case, what heroism could be more in keeping with the times? Gustav Aschenbach was the one poet among the many workers on the verge of exhaustion: the over-burdened, the used-up, the clingers-on, in short all those moralists of production who, delicately built and destitute of means, can rely for a time at least on will power and the shrewd husbandry of their resources to secure the effect of greatness. There are many such: they are the heroes of the period. And they all found themselves in his works; here they were indeed, upheld, intensified, applauded; they were grateful to him, they acclaimed him.

In his time he had been young and raw; and, misled by his age, he had blundered in public. He had stumbled, had exposed himself; both in writing and in talk he had offended against caution and tact. But he had acquired the dignity which, as he insisted, is the innate goad and craving of every great talent; in fact, it could be said that his entire development had been a conscious undeviating progression away from the embarrassments of skepticism and irony, and toward dignity.

9 Trade Book Design

Books for the general market, sold in book stores or through book clubs, need to be as attractive in format as they are in content, or more so. Too often in the past much effort was lavished on the jacket and almost none on the pages, but today one sees many examples of care and taste in books commercially produced within strict budgets. This is the designer's greatest challenge. On this spread and those which follow are books that have been produced for the broad market and are objects which are pleasant to hold and behold, which look effortless and unselfconscious, and which meet the reader without barriers to reading.

These books are produced under rigorous schedules to meet seasonal markets. Often there is no time for the designer to prepare more than a double spread and a chapter opening before sample pages are needed and the text must be set in type. Jackets have to be started almost simultaneously to meet the needs of the sales department. But as in the book below, careful planning can still make possible the commissioning of an artist even at great distance. Duplicate effort can be avoided by, for instance, using the same lettering on the jacket as on the title page. Occasionally publisher and designer have their reward in a special edition, such as the version of *Death in Venice* opposite, celebrating the fiftieth anniversary of Alfred A. Knopf's Borzoi books. The slip case, handsome in itself, makes possible an appreciation of the binding which is so often never seen when it is covered by a jacket.

9-3, 4. Full-color jacket painting by Earl Thollander with Monotype Bell type superimposed on the sky. Title page spread designed by Harry Ford in Monotype Bell, with the drawing by Earl Thollander. Note the refreshing tall shape, 5⅜ by 9⅜ inches. Printed by the Kingsport Press, Tennessee.

In a recent international book fair I was struck by the fact that although most books published behind "the iron curtain" were poorly made and typographically drab, the children's books often showed not only delightful art but typographical taste and knowledge as well. Full-color treatment was common, as it is for similar books in other countries, and the ingenuity of the designer-illustrator seemed to be uninhibited. The illustration of children's books today is perhaps the most free and joyous area of book art in the world, and the illustrator is very often the designer of the entire book.

Picture-dominated books for young children are newcomers to the history of publishing, but they often display the advantages of a designer-author collaboration, for the integration of the text to the picture is more important than that of the picture to the text. The double-spread visual harmony is essential, and a very meager text can be used to support delightful art work. The artist-designer is often granted a broad range of color and media: collage, watercolor, photographs, line drawings, etc., because in the United States at least, the market appears to be large and insatiable. Many of the most gifted artists, designers, and typographers are drawn away from their usual concerns for corporate or advertising design to produce picture books for children, perhaps because the field is invested with the enormous potential and gaiety of childhood itself.

9-5. Spread from *Chodzi, Chodzi Baj po Scianie,* children's poems illustrated by Janusz Grabianski in an exquisite watercolor technique reproduced by offset lithography.

9-6. Another spread from *Chodzi.* Published by PWLD (Pánstwowe Wydawnictwo Literatury Dzieciecej), "Nasza Ksiegarnia," Warsaw.

9-7. Black and white title double spread for a children's book designed and illustrated by Reidar Johan Berle, Bergen, Norway.

9-8. Full-color illustration spread for *Havet*. A reproduction of the binding of this book appears on page 96.

One winter morning Peter woke up and looked out the window. Snow had fallen during the night. It covered everything as far as he could see.

9-9. Decorative paper collage by Ezra Jack Keats for his *The Snowy Day.* Bembo type. The Viking Press, New York.

When he stopped everything turned down . . . and up . . .

and up . . . and down . . . and around and around.

9-10. Another full-color double-spread collage by Ezra Jack Keats for *Whistle for Willie*, The Viking Press, New York.

A train of travelers was approaching. Leading the procession was a magnificent sleigh drawn by three white horses.

In the sleigh rode three men, splendid figures, wearing jeweled crowns and cloaks of crimson and ermine. Men on horseback followed the sleigh and behind them trudged men on foot.

9-12. A double spread from *Baboushka*, designed by Ruth Robbins and Nicolas Sidjakov. The choice of A.T.F.'s Invitation type, hand-set, is brilliant.

the crooked lines of god

Poems 1949-1954
By Brother Antoninus
Contemporary Poets Series
The University of Detroit Press / 1959

God writes straight with crookèd lines.
—Portuguese Proverb

Gustate, et videte quoniam suavis est Dominus!

a canticle to the christ in the holy eucharist

Written on the Feast of St. Therese of the Child Jesus, Virgin and Contemplative, 1953

82
tamalpais

And the many days and the many nights that I lay as one barren,
As the barren doe lies on in the laurel under the slope of Mt. Tamalpais.
The fallow doe in the deep madrone, in the tall grove of the redwoods,
Curling her knees on the moist earth where the spring died out of the mountain.
Her udder is dry. Her dugs are dry as the fallen leaves of the laurel,
Where she keeps her bed in the laurel clump on the slope of Tamalpais.

Sudden as wind that breaks east out of dawn this morning you struck,
As wind that poured from the wound of dawn in the valley of my beginning.
Your look rang like the strident quail, like the buck that stamps in the thicket.
Your face was the flame. Your mouth was the rinse of wine. Your tongue, the torrent.

I fed on that terror as hunger is stanched on meat, the taste and the trembling.
In the pang of my dread you smiled and swept to my heart.
As the eagle eats so I ate, as the hawk takes flesh from his talon,
As the mountain lion clings and kills, I clung and was killed.

This kill was thy name. In the wound of my heart thy voice was the cling,
Like honey out of the broken rock thy name and the stroke of thy kiss.
The heart wound and the hovering kiss they looked to each other,
As the lovers gaze in their clasp, the grave embrace of love.

This name and the wound of my heart partook of each other.
They had no use but to feed, the grazing of love.
Thy name and the gaze of my heart they made one wound together.
This wound-made-one was their thought, the means of their knowledge.

There is nothing known like this wound, this knowledge of love.
In what love? In which wounds, such words? In what touch? In whose coming?
You gazed. Like the voice of the quail. Like the buck that stamps in the thicket.
You gave. You found the gulf, the goal. On my tongue you were meek.

In my heart you were might. And thy word was the running of rain
That rinses October. And the sweetwater spring in the rock. And the brook in the crevice.
Thy word in my heart was the start of the buck that is sourced in the doe.
Thy word was the milk that will be in her dugs, the stir of new life in them.
You gazed. I stood barren for days, lay fallow for nights.
Thy look was the movement of life, the milk in the young breasts of mothers.

83
tamalpais

My mouth was the babe's. You had stamped like the buck in the manzanita.
My heart was dry as the dugs of the doe in the fall of the year on Tamalpais.
I sucked thy wound as the fawn sucks milk from the crowning breast of its mother.
The flow of thy voice in my shrunken heart was the cling of wild honey,
The honey that bled from the broken comb in the cleft of Tamalpais.

9-13, 14. A book of poetry written, designed, and printed
by Brother Antoninus, O.P., using Victor Hammer's
American Uncial for display and Centaur for the body type.

9-15, 16. Two textured cloths in green and bone, with woodcuts by Fritz Kredel in green and purple printed on the sides, for *The Complete Works of the Gawain-Poet*. The title page uses Rudolf Koch's Jessen capitals, a Kredel woodcut, and Janson type. Designed by Adrian Wilson, The University of Chicago Press, 1965.

THE COMPLETE WORKS OF
THE GAWAIN-POET

*In a Modern English Version with a Critical Introduction
by John Gardner*

Woodcuts by Fritz Kredel

THE UNIVERSITY OF CHICAGO PRESS
Chicago & London

AUTHOR-DESIGNER COLLABORATIONS

To work directly with the author is probably the most efficient and satisfying way to design a book, if you like the author and his work. When the association begins before the text has been written or the photographs chosen the results are likely to be the most harmonious. The designer can include flexibility in the layouts with variable column depths and illustration sizes; the author can achieve perfect coordination between text and illustration. The designer can also control the quality of illustration and integrate the various parts of the book as the author evolves them. When the manuscript, captions, illustrations, layouts, and specifications are sent to the publisher they can sometimes, after editing, go directly into production.

The first conference of the author and designer should include a member of the publisher's production staff who is conversant with the needs of the firm and its objectives. At this meeting the content, the promotional methods, the page size and number, color plates, and all elements which will control the retail price per copy must be clarified. The publisher's instructions for preparation of the manuscript according to the editorial style of the house will be presented. If great distance separates the collaborators the wonderful conference telephone can prevent false starts, misunderstandings, and reams of correspondence. Confirming letters are advisable for the sceptical.

Once a schedule is agreed upon the designer and the author meet to examine whatever illustrative material is already on hand, to establish picture quality, and to plan for the acquisition of other art work. There are corporations that maintain archives and that sometimes supply prints gratis; there are consulates, libraries, museums, universities, national information services, and companies that specialize in the search for photos and old prints. Some of these are listed in *Literary Market Place*. Another good reference is *Picture Sources, an Introductory List*, Helen Faye, ed. (Special Libraries Association, New York, 1959).

9-17. An author-designer collaboration. Lawrence Halprin, the author, seated at the writing table, Su Yung Li Ikeda coordinating illustrations, and the designer rampant. *Freeways*, Reinhold, New York, 1966. Photograph by Joseph Ehreth.

9-18. Jacket design in three colors by Barbara Stauffacher, in red and dark gray, and black for the type.

9-19. A drawing by the author of *Cities* spanning the double-spread title page. The type is Hermann Zapf's Optima, used throughout. Designed by Adrian Wilson.

When the text is not complete it is up to the designer to decide how much space is to be allotted to fit into the number of pages established by the publisher. Sample layouts should determine this. The space ratio of pictorial size to text should be fairly consistent throughout.

For example, such a collaboration occurred when I designed the book *Cities*, (Reinhold, New York, 1963) by Lawrence Halprin, environmental planner and landscape architect. In his vast collection of color slides, made all over the world, were the potential illustrations. These would have to be converted to black and white prints since full color was not in the budget. A tentative outline of the contents had been made and some of the material assembled.

The publisher suggested a horizontal format of 10¼ by 8¼ inches. Many of the slides were square while others were in the 35 millimeter proportion of 10 to 7. I decided to establish a modular grid, like the grid of a city itself, using two rows of squares, 18 picas each with 1-pica space between. For the 35 millimeter shapes a grid of three rows of the same width and proportionately shallower depth occupies the same space. Combinations of the two could be made to fit perfectly into the grid. The whole grid could be raised or lowered on the page to balance the design.

I chose Optima as a typeface for it seemed to provide a bridge between old and new on which to enter the city. It could be set to the modular width of 18 picas, with 10/12 Linotype for the body and 8/9 for the captions. The heads were hand-set in 18-point Optima capitals, generously letterspaced.

Our experience with the modular grid in *Cities* was that it gave the author every opportunity to expand or contract text and captions and concur-rently simplified the publishing problems of cut-scaling, type mark-up and costs.

In the next Halprin book, titled *Freeways*, using the same page size, a less complex module was established. The page was simply divided into two rectangles in a proportion of 2 to 3: 20 picas for the outside block which usually carries caption and illustration, 30 picas for the inner text block which was also often used for illustration.

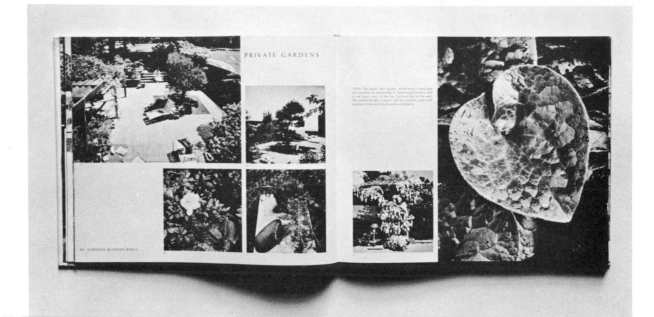

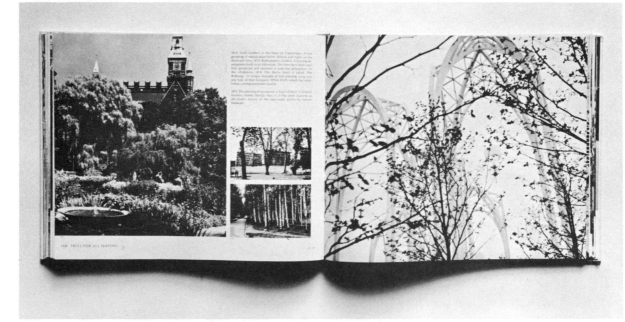

9-20. A combination of photographs of private gardens in black and white moving from general view to detail. *Cities* by Lawrence Halprin.

9-21. Trees in various moods from the same book.

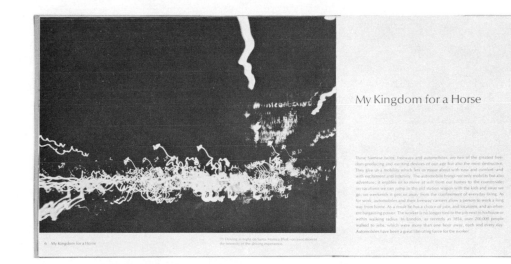

9-22. First chapter opening for *Freeways* by Lawrence
Halprin, designed by Adrian Wilson. Reinhold, 1966.

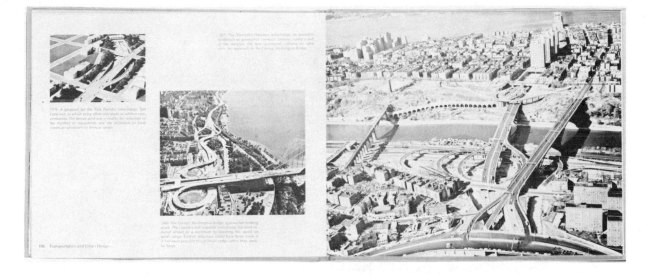

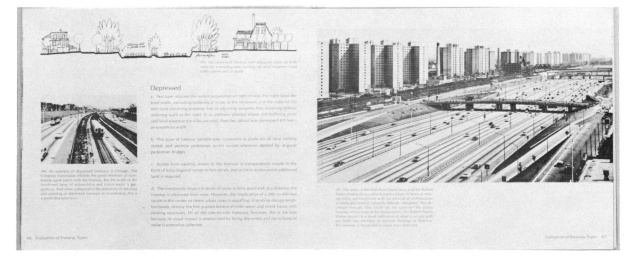

9-23, 24. The simple module grid in use provides
flowing lines and variety of image shapes and sizes.

9-25. Jacket and title page for a catalogue book of Morris Graves' retrospective exhibition. Designed by Adrian Wilson, University of California Press, 1956.

Another stimulating collaboration with the author which produced a successful book was for the retrospective exhibition of the paintings of Morris Graves organized by the Art Galleries of the University of California, Los Angeles, and exhibited throughout the United States. Issued as both a hardback and a paperback, the book was a publication of The University of California Press. Frederick S. Wight, the author of the book, was also the organizer of the exhibition and he had the happy thought of convincing the owners of the various paintings to contribute the cost of producing color plates in exchange for the eventual ownership of them. Furthermore both *Vogue* and *Time* magazines had printed color reproductions of Graves work, the plates for which they were willing to lend. It was possible then to have a generous amount of full color and a stunning jacket in gold, *Spirit Bird Transporting Minnow from Stream to Stream*. The metallic iridescence was achieved by running a special gold ink over a printed yellow plate. Fortunately Imogen Cunningham let us use her poignant photograph of Graves opposite the contents page.

For Graves' work the arrangement of bleeding the paintings seemed appropriate. His work suggests the Oriental scroll paintings which are not necessarily seen with proportioned margins. The book was set in type and, in collaboration with the author, the galleys and illustration proofs were pasted up. For the headings I chose widely letter-spaced Trajanus capitals and for the text, Caledonia.

9-26A. Contents spread using Imogen Cunningham's sensitive portrait of Morris Graves.

9-26B. A double-spread chapter opening with full-color reproduction of a painting by Graves. The types are Trajanus and Caledonia.

MORRIS GRAVES, *a photograph by Imogen Cunningham*

CONTENTS

WOUNDED SCOTER, No. 2, 1944
The Cleveland Museum of Art. Gift of Gamblers in Modern Art.

MORRIS GRAVES

ON MEETING

Morris Graves is more poet than architect, which sets him apart from most of the painters of his time. He inflicts a difficult standard upon himself, for the work of the builders has only to stand up, but Graves's art must create a world remote from the world of gravity; the builders extend the living process, but Graves illuminates it. The objects he draws are not birds, but the bird after it nests in the mind, and his minnow is the stuff of the soul. We think with figures of speech, he thinks with images. If the skull is a shell, the bird is the thought.

Graves is an experience in the uncommonplace. He speaks to the imagination, and you wonder inevitably about the man. He is needed to connect two worlds, that of his painting and that of daily existence. To be sure, too dogged an account will miss the man altogether, and he cannot be tramped after by a biographer or he will not be there. But it tells as much to see the man as to talk paintings.

He comes from the Pacific Northwest, an exceedingly tall thin figure, with large transfixed, rather alarmed eyes. Graves wears a close-trimmed full beard, and there is something of D. H. Lawrence, grown double height in the Northwest climate. He is shy and self-aware to a degree, aloof, yet (you suspect) ruthless in his self-determination. He seems devoid of the secret embarrassment of being born an artist, and has no desire whatever to be like anyone else. "Making your own life" is a recurrent phrase.

His privacy is defended by many hurdles and warnings. Purposeful ruts are left deep in the road by which you approach his house, and signs say no trespassing, no peddlers, no unauthorized persons, in short: No. The final hurdle is Graves's ritualistic politeness, a self restraint which is limited by his sense of farce. In short, he is very *birdlike*; receding, private, mobile, and migratory. He is birdlike with his different, yet natural, control over the space we share, but mostly, on reflection, he has the willful steely quality of a bird — its capacity to survive.

You are meeting him in the region north of Seattle from which he comes,

1

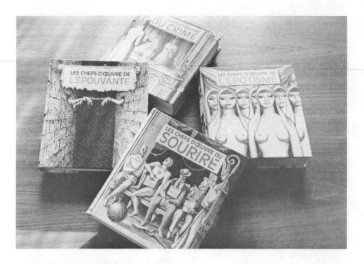

9-27. Bindings for a series on humor, horror, eroticism and crime published by Editions Planète, Paris, under the artistic direction of Pierre Chapelot, with covers by Jacques Noel.

9-28. Endpapers for *Les Chefs d'Oeuvre du Sourire* showing the reverse side of the cover.

9-29. The double-spread title page of *Les Chefs d'Oeuvre du Sourire* with a running strip of cartoons which continue through the front matter.

Right:

9-30. Editions Planète series on art and history, issued at moderate prices and widely distributed. Artistic direction by Pierre Chapelot.

9-31. The cinematic style credit page of *Cathédrales* provides ample white space to set off the photograph.

9-32. *Les Êtres Doubles* contrasts sculptures from pre-Columbian America and from Egypt. *La Barbarie.*

9-33. La Paix et La Guerre, another spread from *La Barbarie.*

9-34. A chapter opening from *Cathédrales*. Helvetica Bold type.

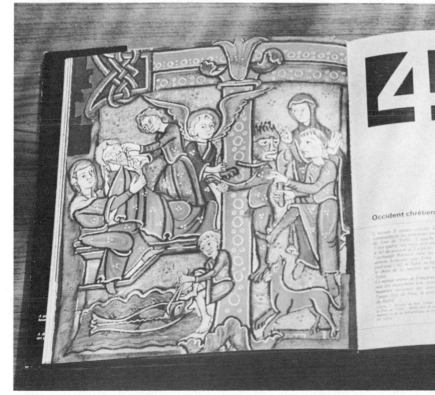

THE SIERRA CLUB EXHIBIT
FORMAT SERIES

Ranging through such titles as *"In Wildness Is the Preservation of the World"*; *Ansel Adams: The Eloquent Light;* and *Kauai and the Park Country of Hawaii,* the Sierra Club Exhibit Format Series is one of the greatest achievements of American bookmaking. They combine the finest photography of nature (sometimes including man), both in color and black and white, with informative and often moving text. The photographs are generally printed on cast-coated papers with the addition of varnish or lacquer coating, giving them much of the brilliance of original prints. The typography has been uniformly in Centaur and Arrighi, set in San Francisco, but the printing and binding have been done on both the West and East Coasts. Edited and designed by the Club's Executive Director, David Brower, they have vividly dramatized the need for conservation of natural resources and scenic areas.

9-35. Double-spread title page for one of the Sierra Club's Exhibit Format Series. Edited and designed by David Brower, San Francisco, 1964.

9-36. A special method of color separation developed by the photographer Richard Kauffman, produced great fidelity of reproduction. Printed by H. S. Crocker Company, Inc., San Francisco.

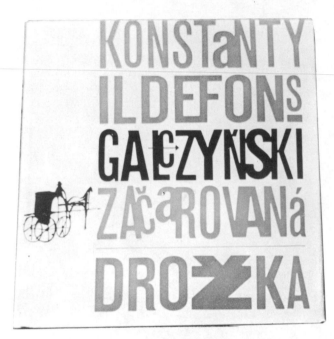

9-37. Jacket for a witty Czechoslovakian trade book designed by Oldrich Hlavsa.

9-38. Jacket flap, phonograph record and endpaper for the book above.

Right:

9-39. Double drozkas for a double-spread title page. The tangled typography repeats the jacket design.

9-40. A section opening from the same book.

9-41. Teatr Polski playbill spread. Prague, 1963.

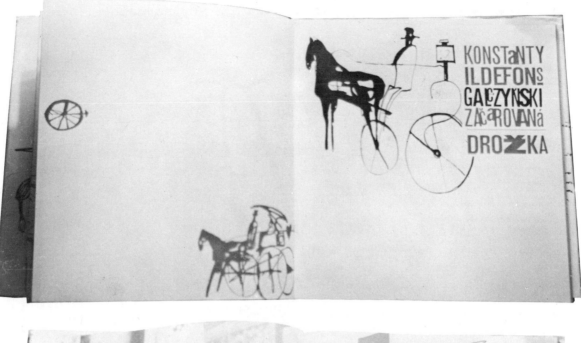

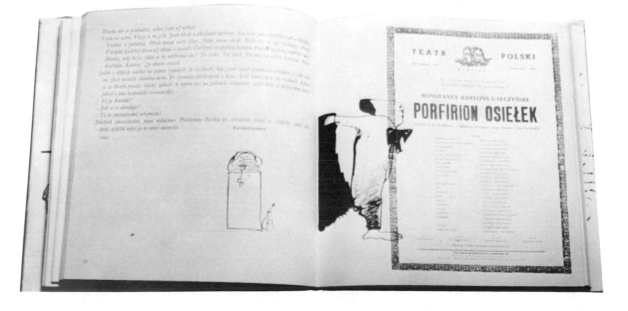

10-1. Cover of a text concerning the composition in type of mathematics, designed by Oldrich Hlavsa for Nakladetelstvi Ceskoslovenské Academie, Véd. Prague, 1963.

10-2. Chapter 2 opening on the use of roman and italic. Each chapter heading maintains the same separation of horizontal black rules regardless of the length of the title.

10 Textbooks, References, and Manuals

The special design problems of textbooks are covered in the chapter on "Design Approaches." The same principles of taste and balance and clarity apply. Yet in the United States today textbooks are the most hideous group of any in the book publishing field. Presumably as a reaction to the meagerly illustrated and typographically rigid schoolbooks of the last generation, the fashion has swung over to volumes bulging with loud and extravagant visual elements. The crude graphic style is probably intended to keep the student alert and convinced that study is as alluring as comic cartoons (which they also quite often contain)—as though learning would be discouraged by an atmosphere of graphic repose.

The bindings are nearly all plastic-sprayed cloth, guaranteed to skid off the desk or out of book-laden arms pushing through the crowded corridors. Very likely some research team graded the substance scuff-proof. For me, as a designer and a teacher, the most unfavorable aspect of these current textbooks is their enormous weight. The very thought of the student, possibly undernourished and weary, having to tote four or five of these objects along ivied halls for a full semester is appalling. Since it is very probable that the latter parts of textbooks will not be used until months have passed, why not issue the books in two or three volumes, paper covered and printed on lightweight stock, and provided with a sturdy slipcase for shelf-storing the set?

In any case collaboration between designer, author, illustrator, and publisher is of the greatest importance and all are concerned with the competition for acceptance by teachers, school boards, department heads and professors. The designer is also concerned with the Book Manufacturers' Institute standards for school books. If the designer were allowed to assist in selecting illustrative material the frequent combination in one text of widely disparate styles of image could be avoided. Complete collaboration on textbooks is already common in some parts of the country with good effect. The fact that some of the textbooks illustrated here are examples of good European design is not meant to imply that there are no handsome and well-designed textbooks produced in the United States. There simply should be more, considering our affluence and our market.

A GEOLOGY TEXT BY FRUTIGER

The brilliant Swiss designer of Univers and other types, working in Paris, also puts his hand to book design. Here is an example of his orderly and practical approach to a textbook. All spreads were laid out at the paste-up stage after the type had been set and photographs made to a few standard widths.

10-3. Binding of paper covered boards, in three color panels, light blue, green and dark gold, using illustrations from the text. Designed by Adrian Frutiger. The type is Frutiger's Méridien. Editions Hermann, Paris, 1964.

10-4. A double spread combining a photograph
and a diagram in two colors.

10-5. The chapter opening head here is in the second color,
a burnt orange, used throughout the book in the diagrams.

A spectacular case for good format in my experience was the redesign of *The Sunset Cookbook* published by the Lane Book Company in 1960. Ten years before, Lane had issued a volume called *Sunset Cookbook of Favorite Recipes* containing 1252 recipes which had appeared in *Sunset, the Magazine of Western Living.* The pages were an unappetizing potpourri of slap-dash line drawings surrounding insipid chapter title types, "wash" effect reverse panels for subheads, bold and light types without leading for the recipes, plus the magazine logotype as part of the running head on each left page. The stock was glossy coated, the binding was an easily soilable cloth printed with gross elements from the title page, and the jacket sported a full color photograph of a casserole dinner contributed by the Olive Advisory Board.

The Lane Book Company had decided to try a new format with one-third the number of recipes, a large page size and total redesign. I was called in with the artist, Earl Thollander, to discuss the project at the outset. Limitations were outlined by the production manager: 216 pages, 8½ by 11 inches, with full-color offset lithography on one side of the sheets and black only on the verso. Nine full-page paintings and many full-color and black and white spot drawings, decorative and stylized for periodic repetition, were possible.

Thollander first sketched his ideas for the paintings and art spots in pastel crayons for approval by the publisher. Concurrently, in developing the text page typography, I placed the ingredients and instructions of the recipes side by side on a wide page. I selected Times Roman because it usually retains its crispness through the photolithographic process, and combined it with Cochin Italic for recipe headings in a harmonious weight. I felt that the idosyncracies of the missing horizontal serifs would give the concoction flavor. A few of Thollander's spots were incorporated in my layouts and the basic scheme was approved.

There is one detrimental aspect about four color

10-6. The title page double spread, with full-color art spots created for the interior pages by Earl Thollander.

process when it is used for vignettes in relation to type: black surrounding lines tend to be soft in contrast to the crispness of type. To counteract this Thollander agreed to render the finished art for the spots as separated black outlines within which the color would be printed with only the three process colors used. First he established the surrounding black forms painted on prepared transparent acetate. Then their outlines were transferred by carbon tissue tracing to illustration board on which he painted the multicolor fill-in. The printed effect was that of stained glass and on the alternate pages the black outlines were used without color.

The book was printed as three 72-page sheets, 36 to a side, on the five color presses of the Stecher-Traung Company of San Francisco, presses usually devoted to the printing of food can labels. Careful supervision of the presswork resulted in a richness of color unusual in offset books. The paper contributed the the effect; a special making by Champion of its laid finish Garamond Text. As a cookbook is intended to withstand the spatterings of the stew pots it was decided to use the same binding design as the jacket—a painting by Thollander, repeated on the back. The cover material chosen was white Linson which, when printed, had little of the shine associated with full-color printed covers. It has been extremely serviceable in a kitchen containing stew pots with which I am most familiar. Whether as a result of the direct mail campaign, the arrival of a new generation of cooks, or the design and art, the book sold phenomenally well: 100,000 copies in the first two years. Its selection as one of the Fifty Books of the Year affirmed also that strong artistic control can have rich rewards.

10-7. The spicy Cochin Italic combined with trusty Times Roman and ample white space to set off the Thollander color spots for *The Sunset Cookbook*.

10-8. Varieties of Espagnole Sauce continued from the previous page, followed by basic vinous sauces. Book design by Adrian Wilson, Lane Book Company, Menlo Park, California, 1960.

A colorful sequel along the same pattern published by Lane was *The Spice Islands Cook Book* illustrated by Alice Harth. In this case only one sheet of the book was budgeted to carry full color and would be cut apart to distribute the color pages throughout the text, but two-color pages were allowable elsewhere. Again, there were full-page paintings with decorative patterned backgrounds and stylized spots which could be repeated in various appropriate places. The specially made paper was toned to evoke the quality of exotic seasonings.

In the array of problems that the designer might not be trained to anticipate I now add two gems. I was courteously called in to check the full-color sheet on the press and found that it was printing beautifully, but on the wrong side of the paper. It was my painful duty to order the huge stacks turned over. Two men spent an entire night shift lifting and flopping the paper, layer by layer, 60,000 five by six foot sheets. Gem number two: when the presses started to roll, small blanks precisely the size and shape of a birch seed appeared in the image. Apparently an errant windstorm sweeping through the paper mill had broadcast at random its seminal gift on the wet pulp. In an instant the tiny seeds pockmarked the giant plates beyond recovery.

The publisher had questioned the extravagance of the hand-set recipe headings in *The Sunset Cook Book*. I therefore chose for the Spice Islands book a Ludlow typeface which is machine cast even though the matrices are hand-set. The client was thus mollified and the spiciness of the Eusebius Open contributed to the concoction. For the endpapers the outlines of the spot drawings were printed in persimmon ink on curry-colored paper.

10-10A. Alice Harth's decorative color spots for the text used to spark off the title page spread.

10-9. Rendering by Alice Harth of the multicolored jacket for *The Spice Islands Cook Book.* The type lines were proofed on acetate and tentatively placed as shown.

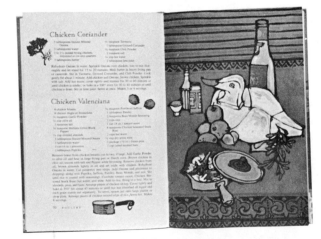

10-10B. One of the seven full page, full-color paintings extended into the facing page by the color spots. The types are the pungent Eusebius Open and the basic Times Roman.

10-11. Binding of a conveniently small cook book. A chapter head drawing by Harry Diamond has been blown up to create a lively pattern for the cover paper.

10-12. Double spread from *Some Oyster Recipes.* Designed and printed by Grant Dahlstrom, The Castle Press, Pasadena, California.

10-13. Double spread from *The Hawaiian Cookbook.* Linoleum blocks by Mallette Dean. Set in Cochin. Designed by Jane Grabhorn, The Colt Press, San Francisco.

10-14. Another unusually shaped and handy sized recipe book, *The Chafing Dish Cookbook,* by Helen Evans Brown. Janson types, with recipe heads in Bembo Italic. Designed by Ward Ritchie, The Ward Ritchie Press, Los Angeles.

The problems involved in the design of multi-volume encyclopedias are extremely complex, and their formats, often necessarily the accretions of many previous versions, are not within the control of a designer. It is rare that a designer has the opportunity (and the chore!) of laying out such a set of volumes from manuscript. Few encyclopedias are well designed. However, recently nine internationally known designers were commissioned to make a detailed analysis and critique of the format of the *World Book Encyclopedia*. Criticisms were elicited and the designers were then brought together in a culminating conference with the executives of the publishing house.

Our approaches to the problems varied from careful redesign of sample pages to questions of educational and graphic philosophy, to the concept that the encyclopedia as a form is obsolete and must be replaced by computers and images on television screens, to the proposal of a system in which the "reader" simply dials for information. When that time comes, of course, books such as this one will not be needed and the space on the shelves now covered with encyclopedias will be a polka dot pattern of buttons and dials laid out by a new type of designer.

We will, I think, still have encyclopedias and other information in book form for some time to come, and the functional problem of the mass of fresh data which must be included in reference works becomes a problem of design too. One outgrowth of the *World Book* critique and conference has been the decision to issue an annual science year book in the same page size as the encyclopedia, with a cover which parallels the encyclopedia for identification, but which is redesigned throughout. The commission was given to Bradbury Thompson, one of the panelists, and the cover and two spreads are reproduced. With the new web offset presses which yield superb color reproduction used, the Science Annual is a striking example of what intelligent re-evaluation of design and production can accomplish. Meanwhile the *World Book Encyclopedia* will be printed on the new presses also. It is planned that the leaven of the analyses will gradually raise the design and production quality of the whole series.

10-15. Binding for *The World Book Science Annual*, 1965, designed by Bradbury Thompson and related to The World Book Encyclopedia binding format in a fresh way.

Right:
10-16, 17. Two spreads from the *Science Annual*. The printing process is web offset lithography. Field Enterprises Educational Corp., Chicago.

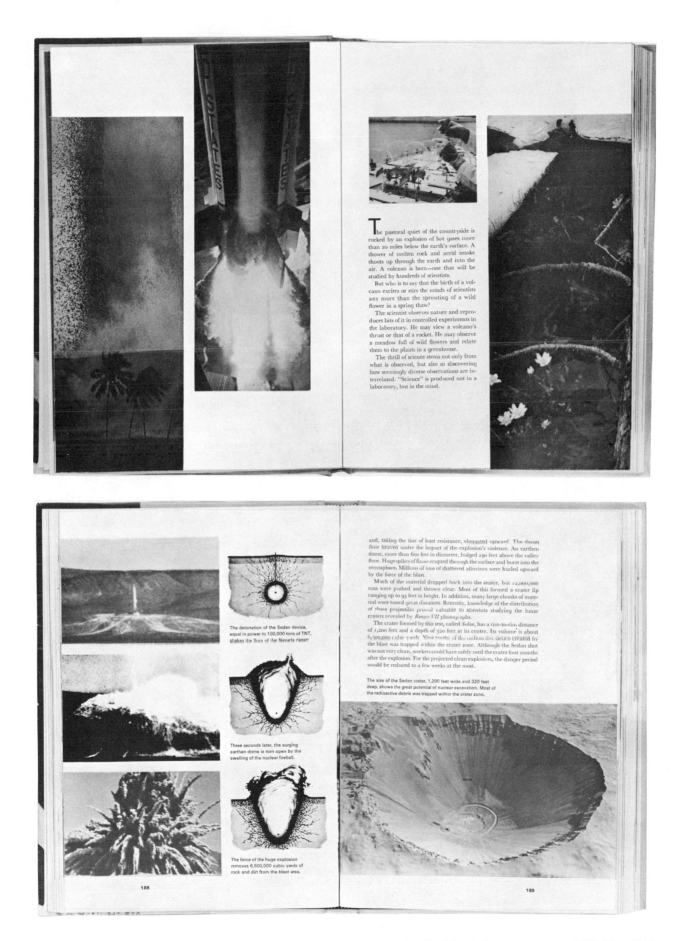

The pastoral quiet of the countryside is rocked by an explosion of hot gases more than 20 miles below the earth's surface. A shower of molten rock and acrid smoke shoots up through the earth and into the air. A volcano is born—one that will be studied by hundreds of scientists.

But who is to say that the birth of a volcano excites or stirs the minds of scientists any more than the sprouting of a wild flower in a spring thaw?

The scientist observes nature and reproduces bits of it in controlled experiments in the laboratory. He may view a volcano's thrust or that of a rocket. He may observe a meadow full of wild flowers and relate them to the plants in a greenhouse.

The thrill of science stems not only from what is observed, but also in discovering how seemingly diverse observations are interrelated. "Science" is produced not in a laboratory, but in the mind.

ant, taking the line of least resistance, elongated upward. The desert floor heaved under the impact of the explosion's violence. An earthen dome, more than 600 feet in diameter, bulged 290 feet above the valley floor. Huge spikes of flame erupted through the surface and burst into the atmosphere. Millions of tons of shattered alluvium were hurled upward by the force of the blast.

Much of the material dropped back into the crater, but 12,000,000 tons were pushed and thrown clear. Most of this formed a crater lip ranging up to 93 feet in height. In addition, many large chunks of material were tossed great distances. Recently, knowledge of the distribution of these projectiles proved valuable to scientists studying the lunar craters revealed by *Ranger VII* photographs.

The crater formed by this test, called *Sedan*, has a rim-to-rim distance of 1,200 feet and a depth of 320 feet at its center. Its volume is about 6,500,000 cubic yards. Nine tenths of the radioactive debris created by the blast was trapped within the crater zone. Although the Sedan shot was not very clean, workers could have safely used the crater four months after the explosion. For the projected clean explosives, the danger period would be reduced to a few weeks at the most.

The size of the Sedan crater, 1,200 feet wide and 320 feet deep, shows the great potential of nuclear excavation. Most of the radioactive debris was trapped within the crater zone.

The detonation of the Sedan device, equal in power to 100,000 tons of TNT, shakes the floor of the Nevada desert.

Three seconds later, the surging earthen dome is torn open by the swelling of the nuclear fireball.

The force of the huge explosion removes 6,500,000 cubic yards of rock and dirt from the blast area.

188

189

DICTIONARIES

Probably the last thought that occurs to the publisher of a dictionary is the design possibilities of the pictorial and typographic material. The Librarie Larousse in planning new editions of their dictionaries wisely commissioned Robert de Beaupré to redesign them completely. In the *Petit Larousse* shown here he has developed a scheme in which the type is set in two narrow columns occupying three-fourths of the page. The outer margins are left free for pertinent pictorial material. The form has the great advantage of not breaking up the text with illustrations that create the runarounds common in many dictionaries, and there is enough white space around each picture to make it a decorative element in the design. The choice of art material throughout is careful and tasteful.

The key words are set in sans serif demi-bold capitals, a type that emphasizes them clearly. From time to time extremely handsome full color pages are inserted, such as the *Poissons Exotiques* reproduced. Wherever illustrations appear in the text column they are scaled to its full width, or to the full width of the page. Finally, the white space left in the outer margins prevents the over-packed cluttered look of the usual dictionary.

10-18. Robert de Beaupré's redesign of the French *Petit Larousse* dictionary, combining full-page color illustrations and black and white images in the ample margins.

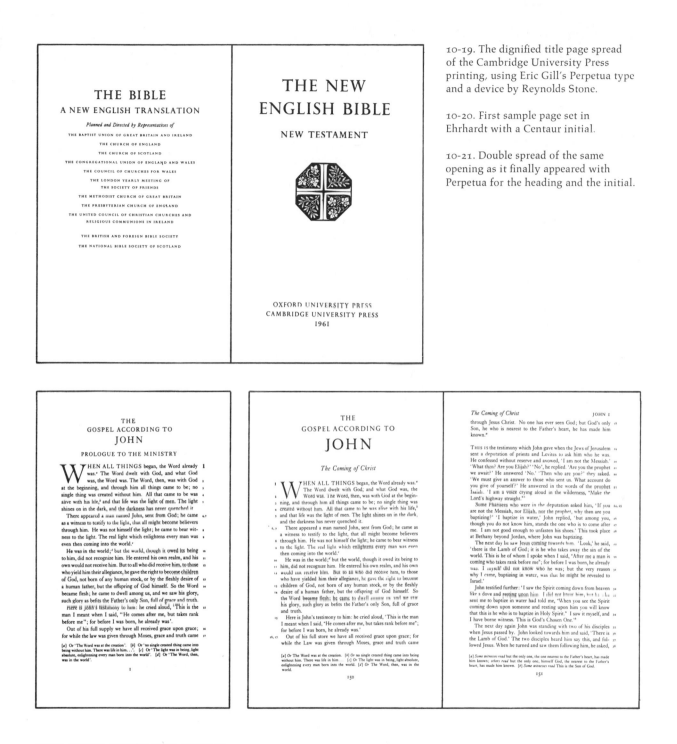

10-19. The dignified title page spread of the Cambridge University Press printing, using Eric Gill's Perpetua type and a device by Reynolds Stone.

10-20. First sample page set in Ehrhardt with a Centaur initial.

10-21. Double spread of the same opening as it finally appeared with Perpetua for the heading and the initial.

THE NEW ENGLISH BIBLE

When a new authorized translation of the New Testament was completed in 1957, both the Oxford and Cambridge University Presses agreed to publish it jointly and two different editions were planned, Oxford to produce a trade edition of 250,000, and Cambridge a "limited" edition in a larger format of 30,000. Sample pages of both were prepared and exchanged for criticism and both editions appeared in due course. But the attractive format and typography of the Cambridge version, combined, perhaps with greater global acceptance than anticipated, caused it to be successful beyond expectation. At this writing 7 million copies have been sold.

11-1. The binding in blood red leather and cloth, stamped in gold, of the monumental *Oresteia* issued by The Limited Editions Club, New York, 1961. A matching slipcase was provided. Designed by Adrian Wilson with an original lettering by the designer and Herbert Marcelin.

11-2. The title page with the frontispiece by Michael Ayrton. Printed by A. Colish, Mount Vernon, New York.

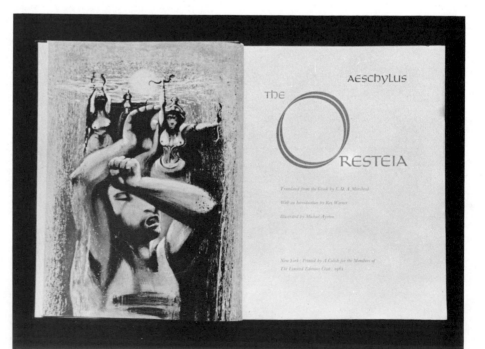

11 *Limited Editions*

A book designer can learn much from the work of the presses that produce limited editions, although he may never be involved in their production. He may find concepts and procedures that can be applied to all book design. Since the time when William Morris' Kelmscott Press initiated a revival of interest in the mystique of fine printing and the book as a work of art—in total conflict with the industrialization of printing—small private presses have exerted a strong influence on the standards of the commercial book. Furthermore, the fine limited edition is valid in its own right as a lasting product of craftsmanship and design. Because the lure of total production and control of a book is irresistible for many designers, there are countless basement and barn presses producing small editions, set up by men intoxicated by the craft. In-

dividual scholar-designer-printers have produced books in our time which stand as hallmarks for the field of bookmaking.

There are also publishing houses which have created a larger market for fine editions such as The Nonesuch Press, The Golden Cockerell Press, The Limited Editions Club and The Heritage Club. In addition, such distinguished presses as the Cambridge University Press and other major houses annually issue a Christmas book which is a limited edition in every sense. In France one finds the *editions de luxe*, the very summit of art press production with artists' prints that are exquisite. There are also book clubs in England, on the Continent, and in the United States which publish limited editions on a regular basis in the very best traditions.

11-3. The complete alphabet for the original Oresteia lettering with the headings pasted up, as reproduced in Erik Lindegren's *A B C of Lettering and Printing Types*, Volume A, Museum Books, Inc., New York.

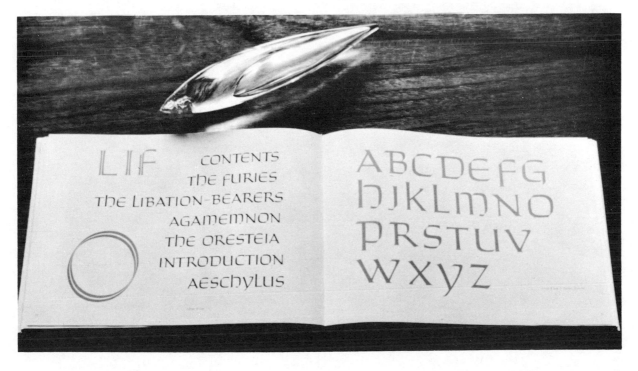

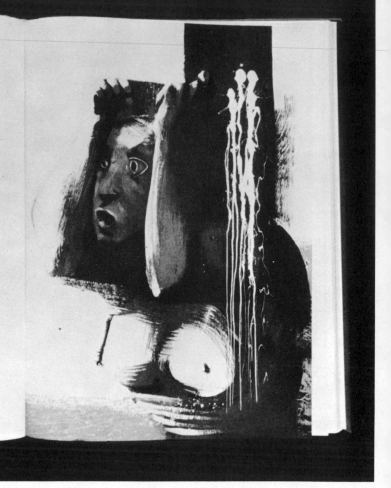

11-4. A full-page illustration in dark red, black and white, by Michael Ayrton, facing a page of special 18-point Monotype set Janson, developed for The Limited Editions Club's Shakespeare series. The running head and folio are in Victor Hammer's American Uncial.

11-5. Michael Ayrton's version of the three-readers device used on the colophon page of most illustrated Limited Editions Club books.

11-6. Binding for *Christopher Marlowe: Four Plays.* The spine is olive green leather, gold stamped, the front blind stamped with the designer's devices cut in wood by Fritz Kredel. Designed by Adrian Wilson. The Limited Editions Club, New York, 1966.

TAMBURLAINE THE GREAT

TAMBURLAINE Come, happy father of Zenocrate,
 A title higher than thy Soldan's name.
 Though my right hand have thus enthralled thee,
 Thy princely daughter here shall set thee free;
 She that hath calmed the fury of my sword,
 Which had ere this been bathed in streams of blood
 As vast and deep as Euphrates or Nile.
ZENOCRATE O sight thrice welcome to my joyful soul,
 To see the king, my father, issue safe
 From dangerous battle of my conquering love!
SOLDAN Well met, my only dear Zenocrate,
 Though with the loss of Egypt and my crown.
TAMBURLAINE 'Twas I, my lord, that got the victory;
 And therefore grieve not at your overthrow,
 Since I shall render all into your hands,
 And add more strength to your dominions
 Than ever yet confirmed the Egyptian crown.
 The god of war resigns his room to me,
 Meaning to make me general of the world:
 Jove, viewing me in arms, looks pale and wan,
 Fearing my power should pull him from his throne.
 Where'er I come the Fatal Sisters sweat,
 And grisly Death, by running to and fro,
 To do their ceaseless homage to my sword;
 And here in Afric, where it seldom rains,
 Since I arrived with my triumphant host,
 Have swelling clouds, drawn from wide-gasping wounds,
 Been oft resolved in bloody purple showers,
 A meteor that might terrify the earth,
 And make it quake at every drop it drinks.
 Millions of souls sit on the banks of Styx
 Waiting the back return of Charon's boat;
 Hell and Elysium swarm with ghosts of men,
 That I have sent from sundry foughten fields,
 To spread my fame through hell and up to Heaven.
 And see, my lord, a sight of strange import,
 Emperors and kings lie breathless at my feet:
 The Turk and his great Empress, as it seems,
 Left to themselves while we were at the fight,
 Have desperately despatched their slavish lives;

68

11-7. Spread from the above volume for Tamburlaine the Great, Part the First, with an illustration engraved in copper by Albert Decaris and prints pulled by M. Beaune in Créteil, France. Text was printed by The Thistle Press, New York.

11-8. Title page in red and black using the Carolus type by Karl-Erik Forsberg, Bembo Monotype and a partitioned box of the devices for the four plays developed by the designer.

11-10. A half title for one of the plays.

11-9. A play opening, set in Carolus and Bembo.

11-11. Paper cover for the Gaberbocchus Press' *Aesop*, with the eagle blind embossed and the fox printed in red, both decapitated. Illustrated by Franciszka Themerson, London.

11-12. Title page of the first book of The Vine Press, Hemingford Grey, Huntingdonshire, England, with Perpetua type and a hand-lettered title by John Peters.

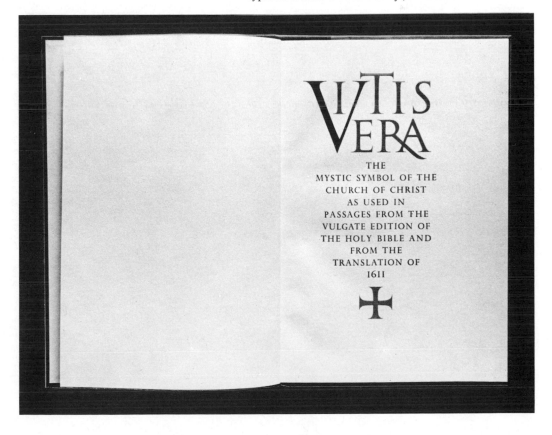

11-13. Portfolio binding for *Bridges on the Backs*. The Cambridge University Press Christmas Book, 1961.

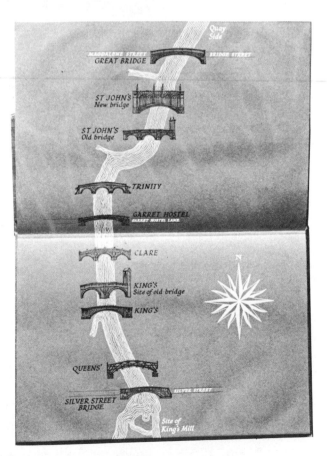

11-14. The endpaper in white and black on gray-green.

BRIDGES ON THE BACKS

A SERIES OF DRAWINGS BY DAVID GENTLEMAN
INTRODUCED BY PETER EDEN

CAMBRIDGE
PRINTED FOR HIS FRIENDS BY THE UNIVERSITY PRINTER
CHRISTMAS 1961

11-15. The title page using Castellar type with a drawing by David Gentleman.

→ GARRET HOSTEL ←

Finished only last year, to the designs of Guy and Timothy Morgan and at the expense of the Trusted family, members of Trinity Hall. An elegant composition, the bold effect of which has lost a little from the mishandling of the balustrade. Its Tudoresque forerunner in cast iron was by William Mylne and constructed by the Butterley Iron Company in 1835-37. There had been some half-dozen rebuildings since Elizabethan times. The bridge is a public one, although Trinity Hall was anciently responsible in part for its upkeep.

11-16. A spread for one of the bridges with the previous incarnations printed on die cut sheets and bound in.

11-17. Binding for *Janson: a Definitive Collection*, with a parchment spine and textured brown paper sides. The label is in a recessed panel. The Greenwood Press, San Francisco, 1954.

11-18. The title page with a charming use of a printer's type case rack from the appropriate period. The book was written, designed and printed by Jack Werner Stauffacher.

11-19. A foldout from the Janson book using the original Stempel foundry version of the type, hand-set.

11-20. Slipcase of specially marbled paper in green and dark blue, and title page of a book designed and printed by Will Carter, Cambridge, England. The type is Bembo and the paper is a gray-green toned handmade.

11-21. A double spread with the engravings separately printed on a subtle background of green. The side heads are in a different green.

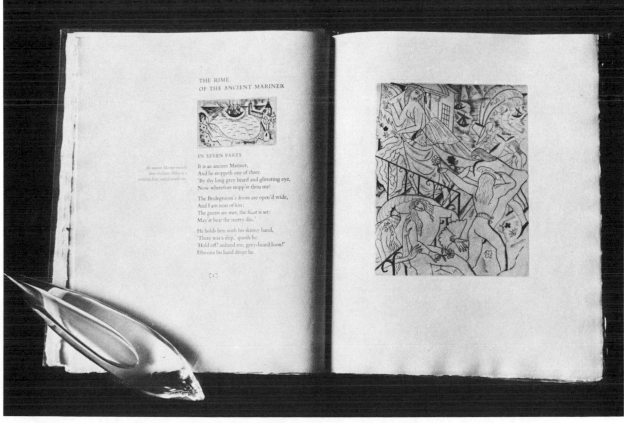

11-23. Two of the bindings of the Japanese Prints series.

11-24. A triptych Japanese print reproduced as a foldout.

THE GRABHORN PRESS
JAPANESE PRINT SERIES

As a culmination of its production of hundreds of noble limited editions the Grabhorn Press of San Francisco has printed a series of books in which part of the Grabhorn collection of Japanese prints is brilliantly reproduced. The complicated process involved first having the blacks in the originals printed by collotype at The Meriden Gravure Company. The Grabhorns cut separate linoleum blocks for each color and printed these with transparent inks over the blacks to recreate the effect of the original technique. For the iridescent mica grounds the old formulas were procured from Japan. The first three volumes have been published by the Book Club of California, San Francisco.

11-25. Binding of handwoven Belgian linen printed in green with four linoleum blocks by Nuiko Haramaki who also did the title page and chapter opening blocks.

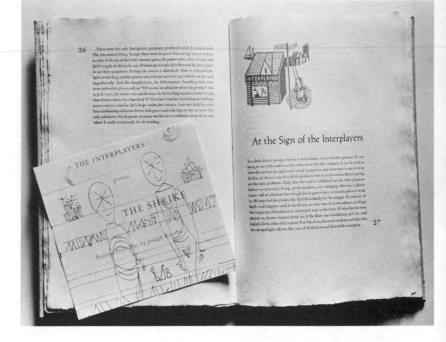

11-26. A chapter opening spread and one of the separate programs, with drawing by Peggy Conahan, and Garamond type, included in the binding pocket.

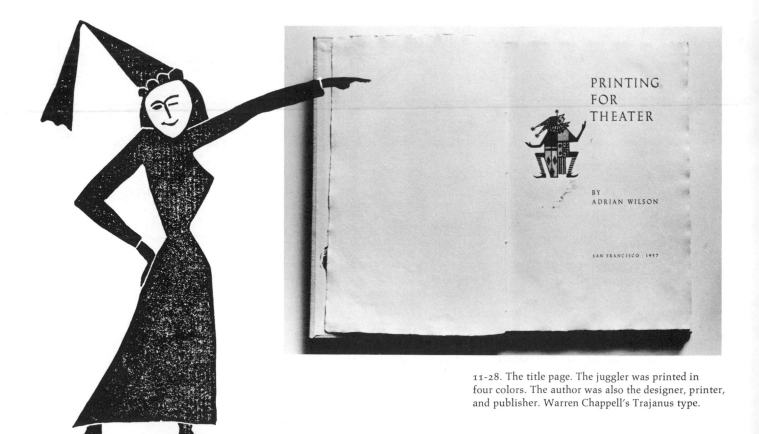

11-27. The winking witch cut in linoleum by the author in a moment of desperation when an artist failed to materialize.

11-28. The title page. The juggler was printed in four colors. The author was also the designer, printer, and publisher. Warren Chappell's Trajanus type.

11-30. An actual program, of which enough copies were left over to serve as endpapers. The coincidence of its size to the dimensions of the book was a miracle. The linoleum blocks are by Mel Fowler and the types are Libra and Trajanus.

PRINTING FOR THEATER

To clear out the stacks of leftover programs and posters which the author had printed for a San Francisco theater, he decided to write and print a book about the joys and trials of their production. The size of the edition was determined by the fact that about 250 copies of many of the programs were remaindered. These were tipped in as illustrations or inserted in a pocket in the binding. A 10 by 15-inch folio format accomodated the largest of them without folding. Caslon type in 18 point was used for the text and Warren Chappell's Trajanus for the headings. The copies were subscribed in advance and the complexity of the processes and the amount of time involved were totally dependent on the whim of the producer. It took almost forever. An enormous spectrum of ink colors was employed to display the work of the fifteen artists who had decorated the programs. The book was printed on a monstrous Kelly B cylinder press which alternated between spitting up and swallowing the Tovil handmade paper.

Index

Colophon

This book has been designed by Adrian Wilson,
San Francisco.

The types are handset Palatino and Linotype Aldus,
designed by Hermann Zapf, and set by Grant
Dahlstrom/The Castle Press, Pasadena, Cali-
fornia.

The printing and binding is by Malloy Lithograph-
ing Inc., Ann Arbor, Michigan.

Postscript

"Of the making of books there is no end," says the prophet. In the making of one about the design of books there should be no end. I could not have imagined three years ago when I began writing the text of this book that a wave of resurrected Art Noveau combined with anti-legibility in lettering would be the mode of this moment. I even toyed with the notion of designing the jacket in the "psychedelic" idiom. Why not! Out of the outrageous and absurd a new clarity might evolve . . . if the reader could decipher it.

Yet well-made books have a life far beyond the artistic period in which they are created. And so certain conventions continue to be observed not because they are fashionable or proper, but because they facilitate production and reading. The function of the design of books is to provide the economy of manufacture, the graphic order, and the attraction which bring reader to author and buyer to publisher.

I wish to thank here some of the many persons in the world of bookmaking who have shared with me their knowledge and inspiration, and now that the work on this book has had to come to an end, especially those who have contributed directly.

Ansel Adams, Carmel, California

Lewis and Dorothy Allen, The Allen Press, Kentfield, California

Brother Antoninus (William Everson), Kentfield, California

Pierre Berès, Éditions Hermann, Paris

Will Carter, The Rampant Lions Press, Cambridge, England

Brooke Crutchley, University Printer, Cambridge University Press, Cambridge, England

Grant Dahlstrom, The Castle Press, Pasadena, California

Mallette and Vivien Dean, Fairfax, California

John Dreyfus, Cambridge University Press, The Monotype Corporation, and The Limited Editions Club

Joseph Dunlap, The William Morris Society, Leonia, New Jersey

Alvin Eisenman, Yale University Press, New Haven, Connecticut

August Frugé, University of California Press, Berkeley

John B. Goetz, formerly University of California Press and The University of Chicago Press

Edwin Grabhorn, The Grabhorn Press, San Francisco

Robert and Jane Grabhorn, Grabhorn-Hoyem, San Francisco

Carroll T. Harris, Mackenzie & Harris, Inc., San Francisco

Harold Hugo and John Peckham, Meriden Gravure Company, Meriden, Connecticut

Lawton Kennedy, San Francisco

Wallace Kibbee, Corte Madera, California

Lester Lloyd, Mackenzie & Harris, Inc., San Francisco

Helen Macy, Max Stein, and David Glixon, The George Macy Companies (The Limited Editions Club and The Heritage Club), New York

Saul and Lillian Marks, The Plantin Press, Los Angeles

Massin, Éditions Gallimard, Paris

James Moran, London

Dr. G. W. Ovink, Lettergieterij Amsterdam, Amsterdam

John Peters, The Vine Press, Hemingford Grey, England

Imre Reiner, Lugano, Switzerland

Ward Ritchie, Anderson, Ritchie & Simon, Los Angeles

George Salter, New York

Hans Schmoller, Penguin Books Ltd., Harmondsworth, England

Jack Werner Stauffacher, The Greenwood Press, San Francisco

A. R. Tommasini, formerly University of California Printing Department

Dr. L. Voet, Plantin-Moretus Museum, Antwerp

Charles R. Wood, Cardinal Company, San Francisco

Hermann Zapf, Frankfurt am Main

In addition I am grateful to Jean Koefoed, Maryanne C. Colas, and Myron Hall III of the Reinhold Publishing Corporation; and to my wife for editing innumerable drafts, and bringing clarity and calm where there were sometimes confusion and chaos.

ADRIAN WILSON

San Francisco, August, 1967